Painting the Word

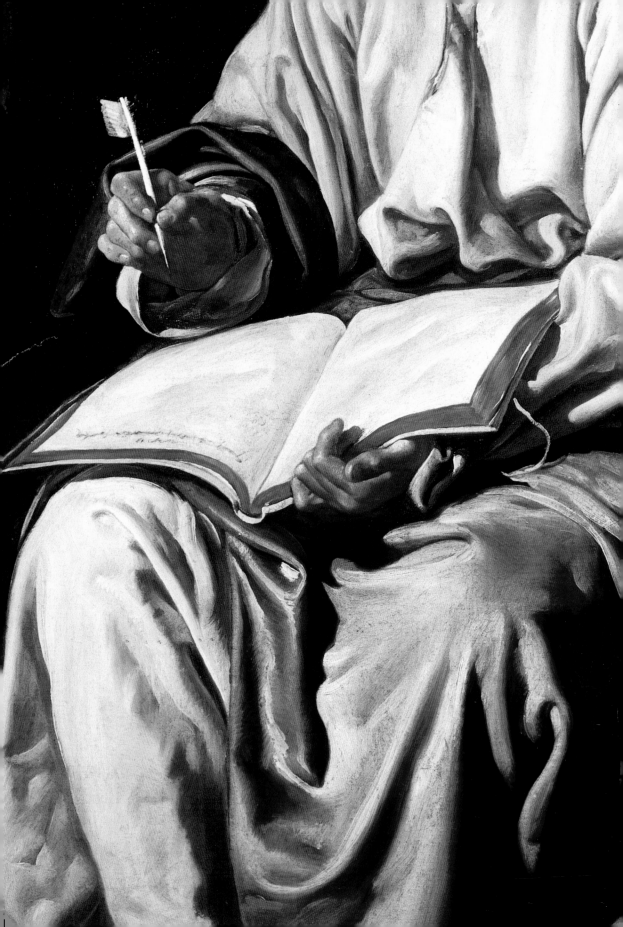

Painting the Word

Christian Pictures and their Meanings

John Drury

YALE UNIVERSITY PRESS
New Haven and London

in association with

NATIONAL GALLERY PUBLICATIONS LIMITED
London

Designed by Gillian Malpass

Printed in Singapore

Library of Congress Cataloging-in-Publication Data

Drury. John. 1936–
Painting the word : Christian pictures and their meanings / John Drury.
p. cm.
Includes bibliographical references and index.
ISBN 0-300-07777-7 (cloth : alk. paper)
1. Painting, European.
2. Christian art and symbolism–Medieval, 500–1500–Europe.
3. Christian art and symbolism–Modern period, 1500–Europe.
4. Jesus Christ–Art. I. Title.
ND1432.E85D78 1999
246–dc21 99-25840 CIP

A catalogue record for this book is available from
The British Library

Frontispiece Velazquez, *St John on Patmos* (detail from pl. 155), c.1618, National
Gallery, London

For Clare, Jessica and Susannah

CONTENTS

facing page Detail from Poussin, *The Adoration of the Shepherds* (pl. 46).

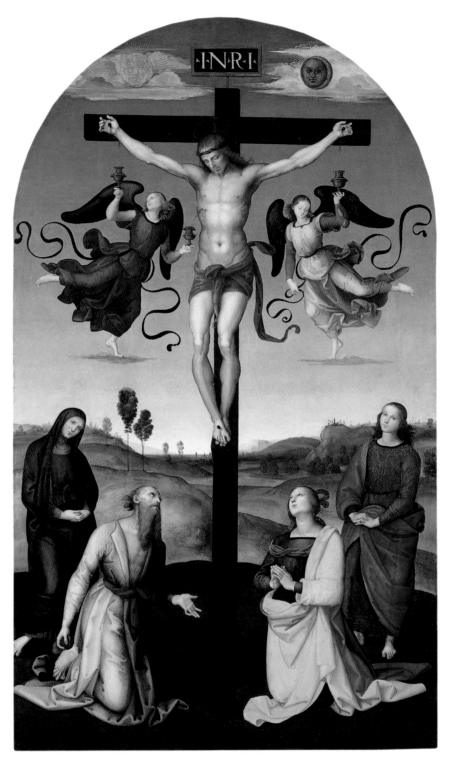

Raphael, *The Crucified Christ with the Virgin Mary, Saints and Angels*, c.1503, National Gallery, London.

PREFACE

This is a book about how Christian paintings convey their messages. It takes on whole paintings. It is not content with just picking symbols out of them for identification. Composition, colour, contents (including architecture and landscape as well as figures) and the ways in which the paint itself is handled – all are treated as part and parcel of their religious meanings. The reason for this outright and holistically religious treatment is historical: these pictures come from a time, stretching from Duccio to Velazquez, when western civilization was Christian. During that time, our own kind of western European civilization – secular and pluralist – was coming to birth. It was a process that impinges strongly on the last chapters of this book and will be discussed there. But the painters whose work we shall be scrutinizing were Christian and lived in Christian societies – none more positively than Velazquez's senior contemporary, Rubens.

Marking the pitch out like that brings us sharply against a big and pervasive fact. We are visitors to this Christian world. Even if we are Christians (and this book is addressed to those who are not as much as to those who are), the kind of Christianity that one of these paintings holds and presents will not be exactly our own – though we, Christian or not, may be able to make it our own by means of informed and sympathetic imagination.

This is likely to be difficult as well as enjoyable. If we put ourselves in front of a major example, Raphael's *Crucified Christ with the Virgin Mary, Saints and Angels* of around 1503 in the National Gallery in London, and try both to be frank about our reactions to it and to stay in front of it for longer than people usually do, we shall find out much of what is entailed.

Enjoyment and difficulty meet us straight away and in strength. Here is a loveliness of colour, line, forms, landscape and human bodies to give immediate delight. But – and the 'but' is very big – the mention of bodies – which are all that we have, or can bring to a picture or anything else – points up the difficulty. Having and being bodies, we can only be distressed, even appalled, by the central body in this picture being hung on a cross: an atrocious form of public death by ignominious torture which any body can see only with feelings of horror. Being caught like this in a collision of pleasure and pain is a ferocious challenge to contemplation. Are we meant to enjoy this? If so, how? Not, at any rate, with the cruel glee that

actual crucifixions evoked from some of the bystanders – including this one according to the Gospel accounts. We understand immediately why people generally do not look at this picture for long. Since it is a religious picture, the religion that it presents looks suspiciously unwholesome, even perverse. Yet the attitudes of the figures around the cross deny this and speak of a meditative reverence which we feel unable to match. Time is short, so would it not be better to go and look at something by Monet, who has got himself clear of such rank ambiguity?

There are considerations for postponing that departure. Having taken the trouble to be candid about our first impressions, we may well prefer not to throw away that small achievement but to make the best of it. First impressions can be good and true impressions, in principle no better or worse than any others, and for the time being they are all that we have. This picture is, very deliberately and just as we have seen and felt it to be, a unity of pleasure and pain. What we need is confirmation to steady us and information to accompany us in the face of it so that we can contemplate its truth and its beauty intelligently and not merely wander off, dissatisfied.

First and above all, it is simply true that pain and pleasure are the constant reality of our lives. Horrible things happen in lovely places and beauty dies in torment. We do what we can to keep these opposites apart from each other. But at the same time thoughtful people want to know how it can be that they are never far apart and often coincide. The 'Why?' of every sufferer is aimed at this same, elusive target. And so is art – or why do powerful minds put themselves to making great tragic dramas, poems and pictures; and why do we enjoy them at least as much as we enjoy comedy and possibly more? It may well not, then, be perversity or unwholesomeness that holds us in front of this picture by Raphael if we can manage to stay here. It is a search for some inkling of a fundamental unity beyond or within contradictions: a wish answered by Raphael with the unity of contradictions which is his picture. And this, of course, is what religion has always been about with its symbols and stories, doctrines, rites and monuments. Hence its claim on our attention.

A more low-level way into the problem is by means of that sheer curiosity that has achieved so much in human affairs. Here the question is not so much the anguished 'Why?' as the coolly critical 'What is going on here?' It has similar value in keeping our eyes on the picture. The obvious thing to do is to buy a book, say the National Gallery's *Giotto to Dürer* which has a reproduction of Raphael's picture opposite a discussion of it (p. 366). This starts by confirming our intuitions so far. This is 'an image of [Christ's] sacrifice upon which we can [but can we?] meditate as the saints do in the painting.' Then it settles our minds about a curious and unrealistic feature of it, the flying figures collecting Christ's blood in goblets: they 'reinforce the sacramental character of the image.' After which the saints are identified and

the painting's history succinctly told with attention to its physical qualities. In the course of this we learn that its sheer elegance, which we found so disconcertingly at odds with its ostensibly horrible subject, is due to Raphael's close association with the tirelessly elegant Perugino around the time of its painting. After the intuitional heat and generality of the previous paragraph, this cooling and precise information is welcome in itself and as an aid to contemplating the picture in a more authentic, because more historical, way than we could do without it. But the meditation to which we were invited at the outset seems to have turned into a helpful history lesson – not quite the same thing.

This book is continuous with that kind of historically iconographical, or picture-describing, approach. But it extends it, by means of historical sympathy, into meditation. For example, in front of this picture it might take a cue from the flying figures with their goblets, by noticing that these denizens of the sky or heavens were, in the Christian cosmology of Raphael's time, just a small indication of the host of wondrous and divine beings that were believed to have their home there. So the sky, which we moderns enjoy for it sheer lambent beauty, was implicitly still richer and more wonderful for the painter and his contemporaries. We need to know, and if possible feel, more about that. Then 'the sacramental character of the image' indicated by these airborne beings with their cups was noticed in the passage quoted above: it is integral and important because it relates their native heavens with our native earth. The blood that they reverently collect is given to the worshippers at the altar (for which this picture was made) as a spiritual benefit by the means of wine. We need to know, and if possible feel, more about that rite too if the original purpose of meditation is to have some kind of fulfilment.

So it is at points like these that a modern need begins to emerge. Most of the people who nowadays look briefly at this picture are, unlike its first beholders and unlike people who looked at it over the three subsequent centuries, unfamiliar with this way of looking at the sky and this world of sacraments, sacrifices and altars. They might need something more than brief notes of them – not just to understand them fully, which would be over-ambitious, but to understand them enough to have a more vivid sense of what they are about. If this can be done, it must be because there are deep and constant features of being human that survive all the great changes in under-standing ourselves and our environment which make the past a foreign country to us where things are done differently. Differently, certainly – but so as to cope with hopes and fears and experiences that are quite alien to us? Obviously not, or we should not have the least interest in Homer or Chartres Cathedral or Bach's cantatas unless we were antiquarians with time on our hands – whereas, in fact, they penetrate us instantly with (once again) their pleasure and pain, which we recognize as our own.

They did so when we first paused in front of Raphael's picture, though there we had difficulty in owning them. So presumably what we lacked was an appropriate frame for them to settle into. Such a frame would be a structure of thought and feeling, embedded within us by our upbringing and social formation. There would be institutions, art and customs outside ourselves which corresponded to it and interacted with it. Here is a slightly outrageous example which is not irrelevant to the case in hand. We live in a society in which the erotic flourishes differently, more variously and more permissively than it did in Raphael's Christendom. Psychology has made us aware of it and the media at large make the most of it. So the erotic, which is constantly within us, has particular external images and doctrines that correspond to it, invite and form it. They are a good deal less high-minded and more candid than they once were. The old Christian frame for desire, founded in celibacy, chastity and the spiritual fulfilment of love, has become vestigial. These comparisons are exactly that: comparative and not absolute, as the present power of the erotic passages in Chaucer's *Troilus and Criseyde* or of Titian's nudes testify. But they are important comparisons because they show us why, in front of Raphael's picture, we may have had thoughts which were unlikely in the extreme to have occured to its painter, who lacked the frame for the erotic that we possess – thoughts that this image was in some way perverse, perhaps even masochistic if we we ventured so far. No wonder that, rightly sensing that our intuitions were getting out of hand and off the point, we felt like going off in search of pictures that suit them better.

Intuition and the intrinsic meanings of pictures (which draw on many humanistic disciplines, not least history) have been lucidly discussed by Erwin Panofsky in his magisterial essay 'Iconography and Iconology: An Introduction to the Study of Renaissance Art', first published in 1939 and still available in his *Meaning in the Visual Arts*, published by Penguin. He generously and encouragingly allowed that '*synthetic intuition* [a sense of the meaning of the whole picture] may be better developed in a talented layman than in an erudite scholar' (p. 64). But he wisely warned against trusting intuition pure and simple. A work of art is a symptom of 'something else which expresses itself in a countless variety of other symptoms, and we interpret its compositional and iconographical features as more particularized evidence of this "something else"' (p. 56). This coincides with the 'something more than brief notes' that we felt the need of earlier. Panofsky called it 'intrinsic meaning or content.' It is something 'apprehended by ascertaining those underlying principles which reveal the basic attitude of a nation, a period, a class, a religious or philosophical persuasion – unconsciously qualified by one personality [a painter, for instance] and condensed into one work' (p. 55). This is a richer and more nuanced description of what I have called 'frames'. Panofsky confirms what we have discovered: that there is constitutive truth in the discoveries of untutored intuition (of pain and pleasure in

Raphael's picture, for example) which the learned often miss or skip; but that if it is to flourish into truthful meditation and not go astray along paths that are strange to it, it must be set in the particular human world to which it belongs – and which we may hope to enter by right of our humanity, but also to find surprising and odd because the mandate of history means that we come to it from a different context, both internally and externally.

The best way of getting the multifarious historical information that lets us apprehend the intrinsic meaning and content of pictures is the same as the way in which we have begun to get at the principles involved: by looking at pictures, and only occasionally on an excursion from them. Superficially, this is because unsolicited information is not as good as information that helps and has somewhere to go. More deeply, it is because the very business (an unfortunate word in the context) of looking at these pictures entails a contemplative waiting upon them which puts us alongside those who painted and viewed them so devoutly by putting us in the realm of prayer, with its passive expectancy, its active opennness. This came readily to the first spectators of these paintings. For us it entails reading, which is why this book has been written.

Why do I consider myself to be the person to do such a job? While the first person singular is usually to be avoided in critical prose, a certain amount of egocentric narrative is the obvious way to explain the genesis of an unusual sort of book. It begins in an impasse. The Dean of Christ Church, Oxford, always preaches on Christmas Day. Preparing a sermon for the fourth time round, I was depressed by the all-too-familiar and all-too-doctrinal assertions that got onto the paper. They did not look like much of a present for people enjoying a popular and cherished festival. Nor did all these words look apt to a festival of incarnation, of Word made flesh. I had given the occasional lecture on Christian art and much enjoyed the freedom it gave from the endless wrangling about fact and fiction that dogged my work on the New Testament Gospels, which I had come to believe to be works of imagination and often forcefully fictional. This was not an issue here and one could just get on with things. Nobody would suppose that Raphael's picture adds to our information about what in fact happened outside Jerusalem one Passover nearly two millennia ago (understanding it is another matter). Vivid memories of Poussin's *Adoration of the Shepherds* in the National Gallery in London suggested a different kind of sermon. Postcards of this picture were put into people's hands as they came into the cathedral and the sermon consisted in an analysis of its structure and contents – a sort of unwrapping of the present. This went down well. I sent a copy of it to Neil MacGregor, the National Gallery's Director, who had given me the golden chance of lecturing there in a series on 'My National Gallery.' He proposed this book. Other sermons on other postcards have followed, also four Hussey Lectures on the Church and the Arts in Oxford which became the draft for Chapters 3 to 7 of this book.

What had happened in the cathedral on Christmas Day was, on reflection, a small-scale exercise in the contemporary search for 'authenticity' in the arts. A religious picture was restored to its native context of worship. And, as it turned out, I had been well served by my formation as both a priest and a critic of the New Testament Gospels. The first gave me, through many celebrations of the Mass or Eucharist, repeated, attached and intuitive experience of the sacrament of the altar over which so many great pictures had stood – not least when I was Dean of King's College Cambridge and officiated under Rubens's glorious *Adoration of the Magi* there, taking occasional opportunities to defend it against its detractors. The second gave me experience of trying to exercise a kind of criticism that is detached and historical. New Testament criticism is a child of the early Enlightenment, not least of John Locke. A philosopher with less than fully orthodox Christian beliefs like him could expound the scriptures beyond the reach of the Church's ancient and official authorities by basing himself on the modern authority of empirical fact. This was the charter of liberty of modern New Testament criticism and enabled Locke to write about both Jesus and St Paul in terms of their historical environments and aims rather than in terms of the orthodox Christian doctrine of his day. That other great movement of the European mind, Romanticism, brought a further shift. Locke was no friend of mythic imagination, but romantics like Coleridge (warily, where the scriptures were concerned) and David Friedrich Strauss (headlong and unwary in his notoriously myth-based *Life of Jesus Critically Examined* of 1835, translated into English by the young George Eliot) fell upon it with enthusiasm. This second phase in biblical interpretation, reading the Gospels as a kind of poetry, has yet to be assimilated by the community of Gospel critics who still prefer the Enlightenment approach, though they lament its religious dryness. But off the sacred territory of the Bible and at large in the picture gallery it pays wonderful dividends. Indeed, readers of this book will often find a piece of poetry put before them as a key to a picture by virtue of its subjective power and objective precision.

Worship and looking at pictures require the same kind of attention – a mixture of curiosity with a relaxed readiness to let things suggest themselves in their own good time. And the exile of religious pictures in secular galleries is not such a drastic break as may appear at first. The covetous instincts which fill the air of commercial galleries and auction rooms are excluded. Pictures really belong only to those who have nourished themselves on them, trusting in their value. Other kinds of ownership are empty. In a public gallery with free admission, that fact is made as ineluctable as it should be; and the job of a book like this is to subserve it. So I have made my prose as light, lucid and subsidiary to the pictures it describes as I can – an aim which has been greatly assisted by Erika Langmuir's shrewd and sympathetic reading of it.

In shape, the book is something like a triptych. The story of Christ, from conception to resurrection, is its central panel (Part II). That is predictable but indispensable for an exercise like this. The wings are each a couple of chapters. The first two (Part I) are about how the world was imagined and looked at by people for whom Christianity was completely coterminous with it – and about the demands and rewards of the act of looking itself. The last two (Part III) are about how the world was seen by people whose Christianity was turning into a way of looking at it for its own sake. So there is a narrative line running through all the book and touching the threshold of our modern world in which the heart of Christianity still provides, I believe, an exemplary way of looking at things and people and pictures of them. That heart is marked by sacrifice – a mysterious, even repellant, business to modern minds and one much abused or obscured by ancient and religious ones. Yet it, too, has something of that readiness to let go and give the self over to some other, which the contemplation of a picture entails for the spectator and the contemplation of reality for the painter. And in Christian pictures sacrifice is often the subject, or inherent in it. So I have tried to thread its intricacies and terrors in a chapter (6) which comes between Christ's death and his resurrection, the darkness in the middle of the drama. It will have been so often referred to before and is so basic to what follows, that a short discussion of it at that point seemed called for. Other themes and topics such as this shuttle to and fro between these 'panels'. They turn up all over the place because, as John Ruskin taught, Christian art is closely connected with perennial, universal and practical matters of how we live and die and survive and behave.

Among those whom I would like to thank for their help are Caroline Barron, Kate Bennett, Christopher Brown, Michael Clarke, Sir John Elliott, Gabriele Finaldi, John Gage, Dillian Gordon, Francis and Larissa Haskell, the late Michael Jaffe, Sir Frank Kermode, Neil MacGregor, Sir Denis Mahon, Jean-Michel Massing, Henry Mayr-Harting, Nicholas Penny, Jessica Rawson, Richard Rutherford, Neil and Jenny Stratford, Robert Tear, Ron Truman, Catherine Whistler, Lucy Whitaker and Christopher White. The National Gallery, London, has been generously supportive, particularly (again) Neil MacGregor, Patricia Williams of National Gallery Publications, Erika Langmuir, who is really this book's godmother, and the staff of the library there. Gillian Malpass's skilful design has got text and images together beautifully. At Christ Church, the Senior Common Room and the Cathedral congregation have heard me out and cheered me on. Without my own family's encouragement and interest in this project, nothing much would have come of it at all. So I have dedicated it to them.

John Drury
Christ Church, Oxford

Part I

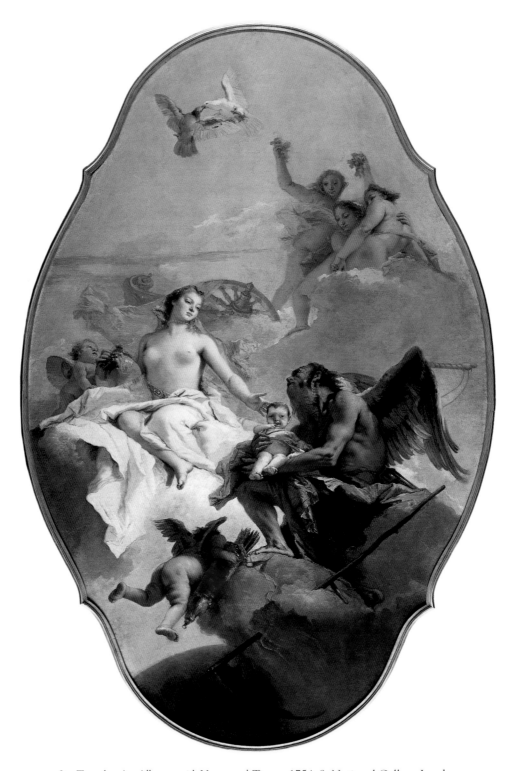

2　Tiepolo, *An Allegory with Venus and Time*, c.1754–8, National Gallery, London.

1

Worlds and Times

Tiepolo, *Venus and Time* and
The Vision of the Trinity appearing to Pope St Clement;
Veronese, *The Vision of St Helena*

It is the loveliest of mornings. Up above the clouds two doves bill and flutter
in courtship. They are about to couple. On the highest clouds three *jeunes
filles en fleurs*, the Graces, fool about happily. Following their gazes, our eyes
continue to descend in a series of diagonals which Tiepolo has hung in space
as if he were making a mobile. As we zigzag down to the darkling arc of our
earth below, we must pass through a series of problematic events which
provoke progressively sadder thoughts. Venus, goddess of love and fertility,
has left her expensive chariot to have a baby on a cloud. She holds the water
jug used at the birth, supported by a little attendant with the butterfly wings
of the Hours. With her left arm she consigns her baby to Old Father Time
for fostering. She, the eternal teenager, is not much moved by this aban-
donment, just a little sad. But Time, his weather-tanned body slumped on a
heavier cloud like a tired wayfarer, is deeply worried. He seems imploringly
to ask "Do you realise what you are doing?" The baby is frightened and mis-
erable. He is Aeneas, Venus's only mortal son, fated to leave the burning
ruins of his home in Troy and found Rome. As a mortal man, Aeneas will
have to live as best he can in a different and less predictable kind of time.
He is at the start of his projection onto the wobbly and risky line of his
destiny, into Old Father Time's world of historical and biographical time
where there is irrevocable loss, momentous contingency and a continual and
unstoppable journey into an unknown future. The sufferings that he will
endure along this way are plenty to cry about – above all his love and betrayal
of Dido. And that tragic affair is provided for already. Cupid is scrambling
onto Time's cloud and his quiver is full of the arrows of desire. Desire leads
to courtship, which takes us back to the doves at the top. If courtship works
it results in copulation, followed by birth – and so on and so on, round and
round, from heaven to earth and back again.

The sort of endless cycle which we see here is characteristic of the kind of
time which belongs to the worlds of nature and of myth. Human history is

different, linear rather than cyclical, yet it is never beyond their reach. The seasons go round and round. Birth, copulation and death tread on one another's heels and we are caught up in them as in an everlasting circle of recurrence. Similarly, the eternal gods – whether we think of them as real or as personifications of forces, principles and ideals – go on and on, forever renewing their lives and doings, and our human lives are lived under their sway.

Their world is usually invisible to us, but sometimes it is disclosed in the dreams or visions which visit the inward eye of imagination and can be captured and frozen in paintings. So Veronese showed St Helena dreaming of Christ's cross which she was trying to find. Lost and buried at that time to the world of human beings, it was preserved under the protection of God until she unearthed it, later on, in the Holy Land. Veronese relates the two worlds, temporal and eternal, to one another with studied tricks of ambiguity. Helena is sleeping on a window-seat and the end of her robe is folded over the window-sill. So the sky beyond is, apparently, an ordinary, natural Venetian sky. Yet the mouldings of the window frame lack the depth of perspective which we would expect to see in a window cut in a thick outside wall. It is as if the sky were the sky of a picture, let into the panelling of an inside wall. This fits the fact that Helena is asleep and so cannot see the natural sky, which is irrelevant to her, but can and must see the sky in which the cross is brought to her by angels. It must be the sky of her dream or inward picturing, aptly represented as a picture. The ambiguity – natural sky or dreamed heaven – refuses resolution, and Veronese compounds it by making the heaven-borne, visionary cross such a heavily all-too-material object that the two angels have to struggle and strain to support it and bring it to the sleeping saint. In St Helena's sleeping form the worlds of dream and daylight converge. There is a religious point here which makes these confusions positive and strongly significant: in Christ's cross the heavy weight of earthly suffering and death is felt in the immortal weightlessness of heaven, the light and happy realm.

In Christian belief, Christ's cross has the sacrificial status of a bridge between time and eternity and joins them to one another. From one point of view, about which Christian writers have always been very emphatic, Christ's sacrificial death happened once and only once. That is to say that it happened in historical time and is unrepeatable – determined, dared and done. But with an ambiguity as deliberate as Veronese's in relating world to heaven, the writers are just as insistent on its eternal and universal efficacy. It is always and for ever. He died once, but 'once for all'. In terms of doctrine, it is a disclosure of the eternal purpose of God to redeem all humankind of all centuries by an ultimate sacrifice. Sacrifice comes under the category of ritual, and it is as ritual, rather than doctrine, that its ambiguous mixing of mythical and historical time has most commonly been made public. Day

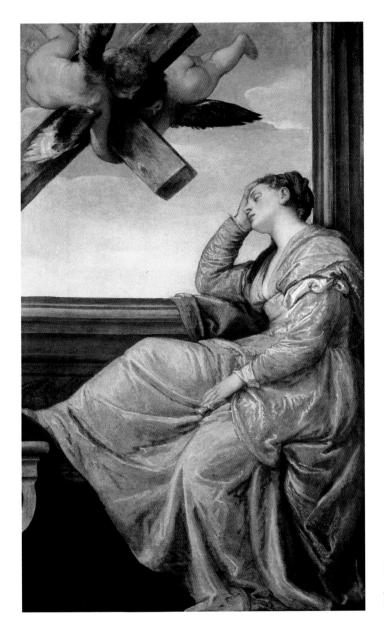

3 Veronese, *The Vision of St Helena*, c.1560–65, National Gallery, London.

by day, the Christian people gathered round the altars where the sacrifice on the cross was repeated by means of the offering of bread and wine, Christ's own way of representing his body and blood. The paintings which stood above these altars were rich and vivid commentaries, using more complex means, on the simple ceremony which took place below them. They could explore and extend it in remarkable ways.

Tiepolo's *The Vision of the Trinity appearing to Pope St Clement* is a *modello* for an altarpiece for a grandee of the *ancien régime*, the Archbishop Elector of Cologne. What would it be like, the church-goer sometimes wonders, if the prayers offered by devout mortals at the altar were to be concretely and visibly answered from the world of the divine immortals? In our historical world it could only happen as a vision granted to a saint or mystic, or as a picture made by an artist's skill and imagination. Here are both. An altar-piece has burst from its frame into life. To the ancient Pope's amazement, the round world and the triune divinity of Father, Son and Holy Spirit with angels in attendance are all surfing over him. They are borne on a cloud which glows behind them with Venetian incandescence. But this is not any old cloud, serving as celestial furniture, as in Tiepolo's *Venus and Time*. It is the *shekhinah* or glory-cloud of scripture which guided the Israelites when God redeemed them from captivity in Egypt (for Christians, colonising Judaism as usual, a prophecy of the redemption brought to all humanity by Christ) and which enveloped Moses on Sinai. In Jewish lore, this was all that mortals could expect to see of God. The ripe and shameless brilliance of Tiepolo's representation of his divinities may stimulate a lingering respect for that more austere tradition. The Holy Spirit is a dove fluttering in active energy and warm light. God the Father leans sympathetically towards the old Pope below, whom he very much resembles: they share a burdensome life of admin-istration, cosmic or ecclesiastical. Christ reclines with a languid nobility, touched with hauteur, which reminds one of the point made by a preacher to an aristocratic audience: that not only was he the Son of God, he also came of an excellent family on his mother's side. Appropriate enough as that may be to a picture from the *ancien régime*, it can hardly be what Tiepolo wants to announce by Christ's relaxed bearing in this sacred context. More seriously, and more probably, it proclaims that his work is done. 'It is finished.' And the cross on which he uttered those last words is now a trophy he carries easily – much more easily than the struggling angels in Veronese's *Vision of St Helena*. His sacrifice is complete. And its instrument, the cross, juts out below the heaven where he reclines and into the world and church below. St Clement could touch it if he stretched up a hand. Once again the point is made that it is a sacrificial bridge, a threshold between worlds and times.

* * *

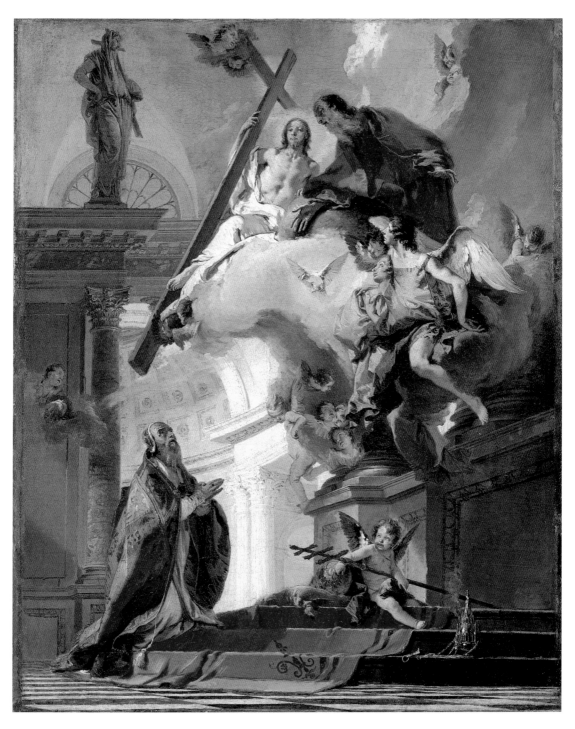

4 Tiepolo, *A Vision of the Trinity appearing to Pope St Clement*, c.1735–9, National Gallery, London.

Excursion: Christianity, Apocalyptic and Mundane Time

Perfect balance is rarely struck in human thought and feeling – or in religion, which depends upon them. Usually we swing from one side to the other, exaggerating one pole or extremity of thought or feeling in response to the needs of the time or to redress a momentary balance which has been upset. Christianity is deeply marked by one such response: the development of Jewish apocalyptic thought in the centuries before Christ.

'Apocalyptic' means 'disclosure', the opening up of the hidden. The ancient Jews' faith in historical process as the enacted will of the benevolent God who directed it – a strong feature of their religion – was shaken by mass deportation to Babylon in the sixth century BCE and by the religious persecution of the Greek king Antiochus Epiphanes when they were back in their homeland in the second century BCE. Apocalyptic prophecy steadied their spirits by invoking the greater but unseen powers of heaven against the hostile powers on earth. Exile and persecution were part of God's secret – but all-embracing and ultimately positive – plan for his people. It was made known to favoured prophets in dreams and visions, their obscurities often elucidated by heavenly angels or voices.

All this was readily taken over by Christianity in its first centuries as a religion, descended from Judaism, but of suspect reputation and subject to episodes of persecution. Indeed, historical existence being perplexing even at the best of times, it proved a strong stayer – as the Christian pictures which we have just looked at witness. In their earliest days, Christians – not least St Paul – set Christ and his death in apocalyptic categories and imagery. Christ crucified was 'the wisdom of God', not understood by 'the rulers of this age' but 'revealed to us through the Spirit' (1 Corinthians 1 and 2). This focal example gave Christians the courage to 'consider that the sufferings of this present time are not worthy to be compared with the glory which is to be revealed to us' (Romans 8). Before long Christians started to get on better terms with mundane historical time. It was a process which reached its goal in the conversion of the Emperor Constantine in 325, but it began with the writing of Christian historical narrative in the form of the New Testament Gospels. The earliest of these was St Mark's, and it is deeply coloured by apocalyptic categories of secrecy and revelation, suffering and glory. These never disappeared, but St Mark earthed them by mixing them in with anecdotal folk-tale, and the process was continued by St Matthew. In the later Gospel of St Luke there is a robust confidence in mundane historical process as the enactment of God's will, which marginalises the apocalyptic and goes along with a warmly positive attitude to mundane human affairs in general. This made it, and his supplementary Acts of the Apostles, a great resource for later Christian painters.

The combination of apocalyptic and folk-tale to make a vivid story is exemplified by some little parables of hiddenness and revelation which St Matthew put into the mouth of Jesus in order to explain the apocalyptic view of historical time in a nutshell. The Kingdom of Heaven – an exalted, arch-apocalyptic category – is compared to a seed, concealed in the earth, which sprouts up to be a great tree; a treasure hidden in a field and uncovered; a net full of fish pulled out of the sea; the discovery of a pearl of great price (Matthew 13). These are images with the excitement of discovery, like St Helena's unearthing of the buried cross. St Matthew even saw himself, as an evangelist, as 'like unto a man that is an householder, which bringeth forth out of his treasure things new and old' (13.52). 'Treasure' here translates the Greek word *thesauros*, which denoted a casket or strong-box for valuables and, by metaphorical extension, the treasures in the mind or a book. The Latin Vulgate of Western Christianity used the same word, *thesaurus*. A better English translation would be 'treasury' or 'jewel-box'. It lands us conveniently before a fourteenth-century picture-box with jewelled contents.

The Wilton Diptych

This anonymous masterpiece is now on continual public display, open and fully visible. In its early days it was not so easily available, being kept under quite different conditions which were part of its context and its meaning. As the property of some royal or noble person, it would have been stored in one of the strong-boxes in which such people stored their treasures and which they lugged about with them on their travels. To unlock the box, the presence and assent of its keyholder – a sort of mundane St Peter with the keys of the kingdom of heaven (Matthew 16.19 – his preoccupation with opening up, yet again) – would have been necessary. Inside, the closed diptych would have been wrapped in a bag of cloth or leather. Carefully untying that, you had in your hands a box richly emblazoned with Richard II's badge and arms. Opening this box would add a little to the increasing wear on the gilt frame which is still visible. This third and final opening would reveal, as in a moment of apocalyptic dream or vision, the jewels and glories of the double picture, climaxing in the display of ultramarine blue on the right. The New Testament's most completely apocalyptic book, the Revelation of St John, includes a vision – much pondered in the Middle Ages – of the heavenly Jerusalem, made entirely of precious stones and metals.

5

5a and b (*following pages*) The Wilton Diptych, c.1395–9, National Gallery, London.

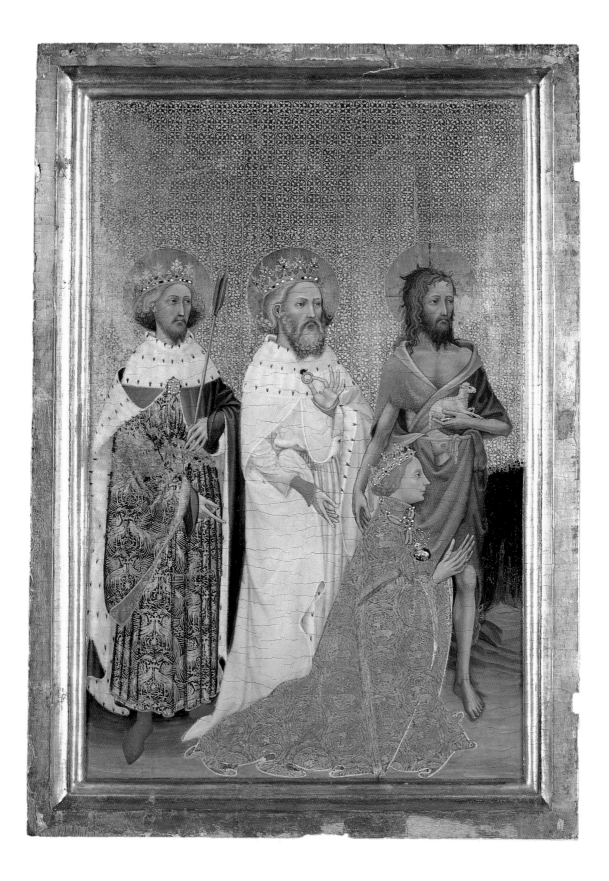

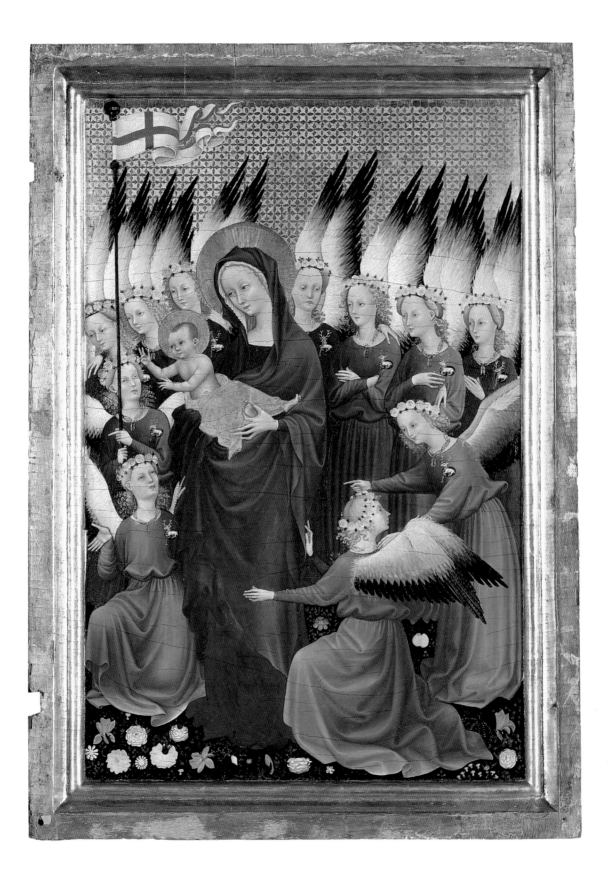

A poem of the diptych's own time confirms the religious excitement and fulfilment which could be associated with the opening of a treasure box. 'Perle' is the tale of a bereaved father and his consolation. He refers to himself as a jeweller and to his dead infant daughter as a precious pearl which he had lost in the grass by her grave – another echo of St Matthew, mixing the Gospel's parables of the pearl of great price with the treasure hidden in a field. Jewellery was then much more highly esteemed than painting for reasons that spanned earth and heaven: its makers were highly skilled, the great and powerful competed in the display and giving of their wares, and the high market value of the materials was enhanced and spiritualised by the authority of St John's vision of heaven. Jewelry had a quasi-sacramental status, a preciousness which was more than secular.

Mourning at Perle's grave one day, her poet-'jeweller'-father fell asleep. His grief was changed into joy by a dream of her in paradise, beyond the river of death. There she lived in concord like that of the happy angels in the *Diptych*, one of a host of virgins who were all brides of Christ, the Lamb at the centre of paradise in the Revelation of St John. Little Perle tells her father about the secrets of heaven and the wrongness of his own disordered feelings. They include the assurance that the garden of paradise is like a box, a 'cofer' or 'forser', in which the heavenly beings, like jewels, are kept ('clent') perfectly safe – and which he has been privileged to see for a while.

> Sir, ye haf your tale mystente.
> To say your Perle is al awaye,
> That is in cofer so comly clent
> As in this gardyn so gracios gaye.
>
> Here were a forser for thee, in faye,
> If thou were a gentyl jueler.*

Unlike a triptych (see Duccio's in Chapter 2), a diptych does not have a central panel. Its centre is a hinge – in a sense, nothing at all. So the eye cannot rest. With no centre to return to after roving, it must shuttle from one panel to another across the divide, travelling back and forth between two worlds as the angels do. A triptych, even when it was made for private devotion, had some of the centralised order of public worship and seems to expect a celebration of Mass. A diptych is a more decidedly private thing.

* Contrast Wordsworth on his dead Lucy four hundred years later:

> No motion has she now, nor force;
> She neither hears nor sees,
> Roll'd round in earth's diurnal course
> With rocks and stones and trees.

A world has gone, or been lost.

Made for private (often lay) use, it usually had a portrait of its owner at prayer on one side and an image of the heavenly being to whom the prayer is offered on the other. So its content was the relation between the two, the infinite dialogue of prayer made visible in its sustained tension.

On one side, the Wilton Diptych shows King Richard II at prayer, supported by his patron saints and heavenly advocates: King Edmund of East Anglia, King Edward the Confessor and John the Baptist. Once inhabitants of his own world, they have now crossed back over from the other side to help him. On that other side are the Madonna and Child surrounded by angels. Exactly what is going on between these two groups is a question which art historians dispute, so it would be rash to go at it head on. A warier way into whatever meanings this treasury hides and displays, and a way which will train the eye in the movements required by its double structure, is by sizing up the formal contrasts and echoes between the panels.

First, space. On the left, nearly half is unoccupied. A large expanse of golden sky is diapered with a quiet pattern of buds. Below it, there is rocky earth and a forest. On the right, less than a quarter of the space is unoccupied. The golden sky is diapered in a bolder and more vibrant pattern, like open leaves or petals. The figures stand on a bed of flowers which attracts the eye by its richness, yet takes up slightly less picture space than the barren landscape on the left. So there is fuller and more fruitful content on the right. This is apt, since it is the place of fulfilment: heaven, the paradise garden, with its contented inhabitants. The earth on the left is an emptier place, whence all eyes look to heaven. In heaven they look at one another as well as at the earthlings opposite.

6, 7

Secondly, colour. No difficulty here. On the right a shimmering expanse of precious ultramarine floods the panel and ravishes the eye like a blue sky in June. It has slight echoes on the left in the sleeves of the two royal saints and the more nocturnal blue of St Edmund's tunic. Christ's legs are wrapped in cloth of gold. This is the sole exception on this panel to the blue robes of heaven, and matches the colours on the other side, particularly Richard II's cloak. Over there the pervasive and dominant earth colours play a much more sober tune. John the Baptist's camel-skin coat is brown. St Edward's robes were originally a warmer, pinkish colour, now faded. St Edmund's cloak is green. Richard II's cloak is an earth red, broken by intricate golden patterning. Last of all, there is the bold scarlet of St Edmund's boots. It has no equivalent in its own panel, but answers the scarlet cross on the banner in the opposite panel, via the diagonal shape and transitional red and gold of Richard II's cloak.

Meanings impinge. Compared with the ethereal glory of the simple, heavenly blue, earth is various but drab. It has its richness. Richard II's cloak and accoutrements are a marvellous example of painting imitating the jeweller's craft – particularly the pearls made of drops of white which encrust the antlers

6 and 7 (*following pages*) Details from pl. 5.

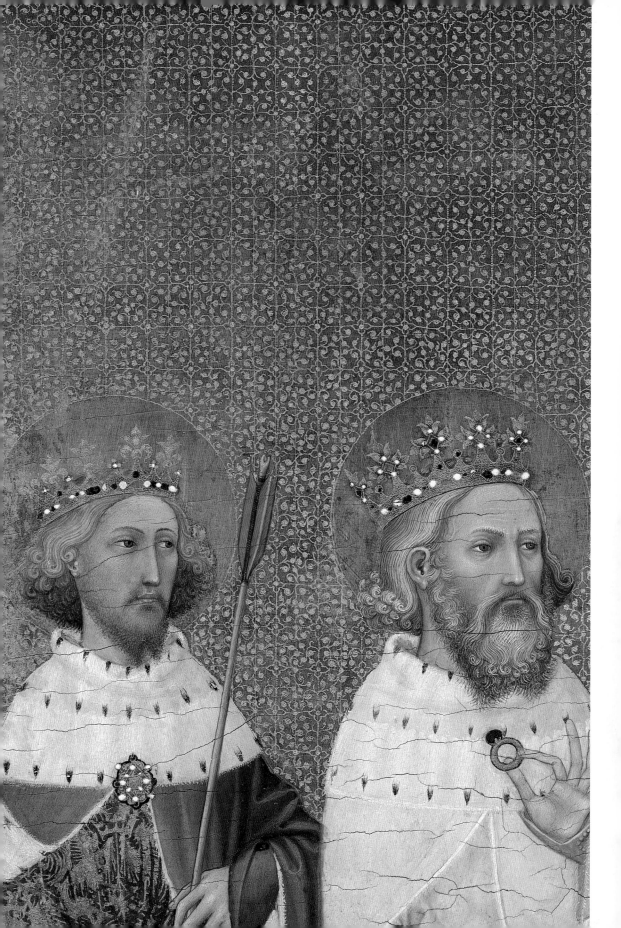

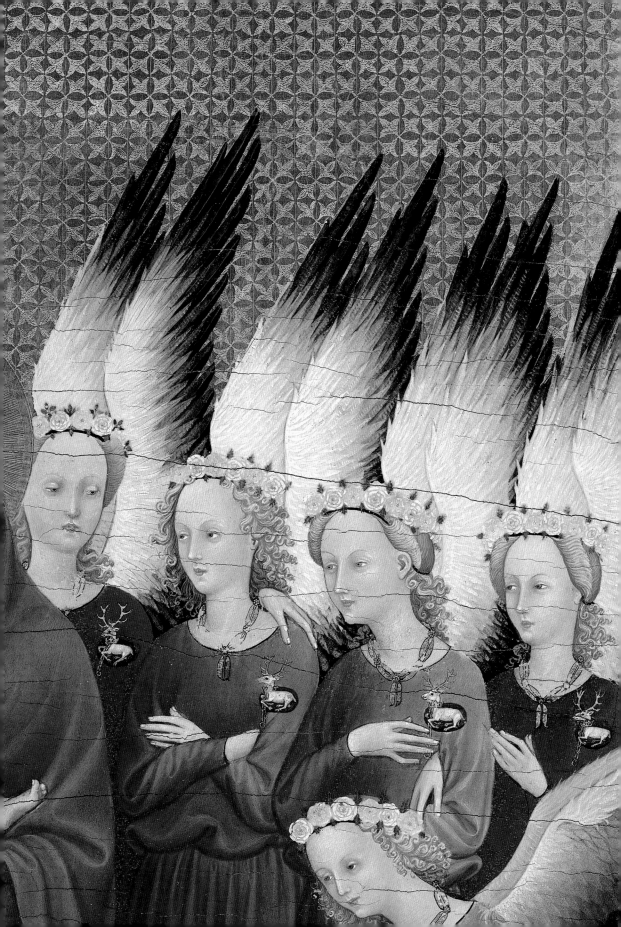

8 (*right*) Detail
from pl. 5a.

9 (*far right*) Detail
from pl. 5b.

8, 9 of his white hart brooch. The angels opposite all have similar brooches. They are his retinue as well as the Madonna's, perhaps coming to welcome the Lord's anointed into paradise, as in the Requiem Mass, *chorus angelorum te suscipiat*, 'may the band of angels receive you'. But their brooches are without pearls. On earth, value is art and adornment. In heaven it is the place itself, all blue; and the people, all linked in concord. Again, contrast carries subsidiary similarities between heaven and earth which allow exchange over the central barrier – as the 'Perle' poet conversed with his daughter over the river. He knew Dante's 'Paradise' and it was a strong influence on him. Dante too had written out of the grief of bereavement and been consoled by seeing his beloved Beatrice in paradise, beyond the river of death. Like Perle, she dominated her male mourner, instructed and rebuked him. She showed him the

> *bel giardino*
> *che sotto i raggi de Christo s'infiora.*
>
> *Quivi e la Rosa, in che il Verbo divino*
> *carne si fece.*
>
> XXIII 70–74

'the fair garden that flowers under the rays of Christ. Here is the Rose in which the divine Word was made flesh.' The rose is the Madonna, supreme in heaven. In one of Dante's most breathtaking images she is heaven itself:

> *il bel zaffiro*
> *del quale il ciel piu chiaro s'inzaffira*
> XXII 101–02

'the beautiful sapphire from which the brightest sky is dyed sapphire.' Her strong association with blue, so spectacular in the *Diptych*, is repeated in 'Perle' where she is

> the quene of hevenes blwe
> That all this world schal do honour.

The world of the diptych is the world of the poets in which apocalyptic is turned to beauty: the tender ceremony of the pervasive courtesy, the worship of the Virgin, her blue and her flowery garden, the sweet concord of heavenly beings, the jewels. In the painting as in the poetry, the glory of the invisible world was made visible by means of a craft at once ingenious and ingenuous, with a jeweller's skill which turned precious material to spiritual value.

The spiritual value of the feminine in the diptych is both noticeable and delicate. The late fourteenth- and fifteenth-century world was dominated by men, so, appropriately enough, we see only them on the left. Women were kept on the edge of that world, in a negative and depressing sense of that phrase. Religiously, however, the edge of the world was awesome. It was the threshold of the other world with all its power and glory, reached at death and touched by sacraments and prayer. Marginalised in the ordinary way of things, women were also – and even perhaps, therefore – idealised in conditions of extremity. One of these was the passion of love. A ceremonial jousting shield in the British Museum with similarities to the diptych shows an armoured knight kneeling to his lady. He is supported by death rather than patron saints and exclaims 'vous ou la mort' – you or death. He has come to

10 Jousting shield, *c.*1460, British Museum, London.

17

the edge of the world which he controls and is ready to go over it to the richer world of the object of his desire. In religion, the cult of the Virgin enjoyed the popular and affectionate dominance which the diptych reflects magnificently. The virginity under which this reverence stood – and which was expected of such religiously dedicated persons as clergy, monks and nuns – was a stern assertion of the ideal separation of such devotion from the world of human generation. At the positive pole of the ambiguous value-status of medieval woman stands that signal of religious fervour, a positive and exalted sense of the phrase 'the edge of the world'.

In the diptych the world's extremest edge lies precisely between the panels and along the hinges. On the left-hand panel a forest is adjacent to it, reminding us of the forests in Dante's 'Paradise' and in 'Perle'. These were places where men got lost – places of awe, anxiety and vision. Medieval Europe was much more wooded than it is now, and its woods were (like virginity) a sort of beyond in the midst of normal life. Fairy tales as well as poems testify to it. The placing of the forest in the diptych is deliberate. It depends on the still more deliberate division between the panels, a margin between worlds which is equivalent to the river of death in the poems. It is the axis upon which the actions and transactions of the whole picture turn. What exactly are they?

The answer is plural rather than single and draws on the central features of Christianity's treatment of time and space, life and death, humanity and divinity – all concentrated on Christ himself. The red-cross flag is the banner of Christ's resurrection. He was customarily shown carrying it as he rose from

11 Detail from pl. 5b. 12 Detail from pl. 79.

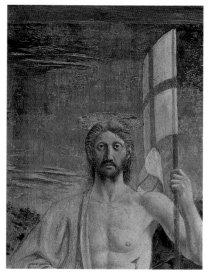

18

13 Detail from pl. 5b.

the tomb or ascended into heaven. Thus he bridged the two worlds and the
flag was the signal of his triumph. Christians could hope to go from earth to
heaven because he, their pioneer, had blazed the trail by a sacrificial death,
suffered on earth, followed by a resurrection which first restored him to his
followers, then took him into the eternal life of heaven, which he could
thereafter bestow on humanity, dead and living. His crossings-over had joined
the worlds together. Although he is shown here as a child, his whole recon-
ciling career is symbolically implied. As the banner signifies his resurrection,
so the nails and thorns inscribed in his halo symbolise his sacrificial death.
It is the whole Christ that we see, not just the infant. Myth and symbol allow
such telescoping of history.

13

It is important to notice that symbolic representation of Christ's achievement is not confined to the right-hand panel. Christ's great work depended on his being human as much as on his being divine, and his humanity is revealed by his navel showing that he is born of a woman. Strikingly, the painter has taken pains, resulting in the only awkward passage in his picture, to uncover the navel of St John the Baptist and thus mark Christ's physical kinship with the human saint – and with humanity at large. John the Baptist also carries the sacrificial lamb which symbolised Christ in the Revelation of St John and countless subsequent paintings. The Baptist had coined that metaphor with his proclamation of Jesus: 'Behold the Lamb of God!' (John 1.29 and 36). So Christ is symbolically present on the left-hand panel. And its connection with the right-hand panel is fastened by the fact that the resurrection flag was often shown carried by the lamb in the popular symbol, surviving on inn-signs, of the lamb and flag. Christ is therefore shown commanding the angel who carries the flag to pass it over to the left, where it will be re-united with the lamb. The angel's attentive eyes and pointing finger show that she has understood the order and the gift will be made.

The knob at the top of the flag-pole is the subject of recent discoveries during restoration, which suggest yet another mode of exchange between the two panels. There was originally a gold cross there, but at some early point it was covered by an orb with a tiny picture of an island of earth set between sea and sky. A lost altarpiece in Rome once showed Richard II offering the

14

14 Detail from pl. 5b.

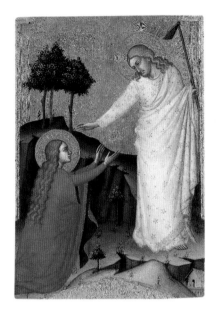

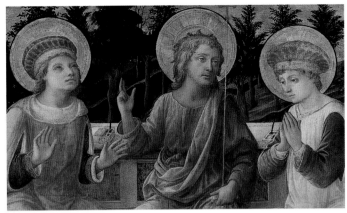

16 (*above*) Filippo Lippi, *Seven Saints* (detail), *c*.1448–50, National Gallery, London.

15 (*left*) Master of the Lehman Crucifixion, *Noli me Tangere*, *c*.1370–75, National Gallery, London.

Virgin 'the globe or patterne of England' and bore the inscription 'This is your dowry O holy Virgin, therefore rule over it, O Mary.' If this motif of England as Mary's dowry is included in the diptych, Christ is commanding the return to Richard of the kingdom which he had dedicated to Christ's Mother. The return is the more authoritative for Richard's previous surrender of his kingdom to Mary, for he can now receive it back, not just as his right by human pedigree, but from the heavenly source of all power and dominion. By the same token, Christ's life had been restored for ever because he had laid it down in sacrifice – and that motif of resurrection is the flag's most explicit signal.

Whatever, and however many, things the flag may mean, Richard's hands are open, ready to receive it. The gesture is not just acquisitive, as neighbouring pictures in the National Gallery testify. Mary Magdalen recognizing the risen Christ, and St Cosmas seeing a heavenly truth in the course of theological conversation both make the same gesture. The opening of the hands is triggered by visual and intellectual delight – a moment of happy seeing when the overwhelming beauty of the world beyond breaks into the present. And that is something utterly uncomplicated which the diptych can still bring about for its spectators.

2

Kind Regards

A spectator needs to bring to pictures something like the quality of looking which their painters brought to their making. They had all the resources of training and tradition at their backs, but at the moment of setting to work they were alone, dependent on their eyes for what they, and only they, could do. For the painter, as for the spectator, the quality of individual looking was all. Two constitutive and contrasting activities of the eye are deployed: analysis and admiration. The gimlet eye must probe and separate, prising the subject open into its component parts. The bedroom eye must fondle every contour and drink in every colour, not wishing to change anything but rather to enjoy it as it is. As these metaphors imply, it is all a quite physical business, as much a posture of the bodily self as receiving a serve at tennis, and demanding the same sort of alert and open attention. Like many bodily movements and postures, it is most readily learned by imitation. The beholders whom painters often put in their pictures can serve this purpose. They are a kind of surrogate of the painter, and can be the same for us.

The Wilton Diptych again

Richard II kneels in prayer, kneels to look. It is the posture of humility, a lowering of the self before something or someone better and desired. It is a hobbling or disabling of the self, for once on one's knees one can hardly wander about in the footloose manner of people in galleries. But it achieves the settledness and stability which is essential to attention. The passivity which it imposes is of the deliberate kind that Keats called 'Negative Capability, that is, when a man is capable of being in uncertainties, mysteries, doubts, without any irritable reaching after fact and reason' (letter of 21 December 1817). Richard II's posture of subjection actually allows him to be alert and active in a sustained and steady way. His body is vertical, straight-backed and slightly tilted towards the heavenly beings whom he sees. His hands, with their excitedly parted fingers, are lifted in an open and expectant gesture. Above all, his eye has a bright and attentive vivacity which is confirmed by the happy set of his lips and is a little wider and

18

18 Detail from pl. 5.

more animated than the relatively subdued gazes of everybody else in the diptych except the Christ child. The mutual ocular exchange of these two does much to fasten the two panels together across the frames.

So Richard serves us outside the picture as the person inside it with whom we can identify, and from whom we can learn how to look at it. This kindly connection is not merely adventitious. It has historical and pictorial groundings. If the diptych was not painted for Richard himself, then it was done for someone very close to him, such as his wife. Its first owner would certainly have felt closest to his figure, held in that passive-cum-active pose of sustained delight. He would have been his or her neighbour within the frame. Pictorially the painter has assisted this kinship by making Richard the nearest figure of all to the spectator (in space as in time): even a little nearer than the kneeling angel on the right, whose robe does not touch the bottom of the picture space as his does.

Once admitted by this courteous association, the spectator is in a world where harmony is made by the kind regard which each person in it has for somebody else, waiting on them and enjoying their presence with quiet and

24

happy looks. It is a harmony which is often represented by music – singing or the playing of instruments. But there is always a certain ineluctable incompleteness in the visual representation of music-making, and this is negative when completeness is itself the subject. The painter of the Wilton Diptych kept within the bounds of the paintable and made pure looking the integrating factor of his work, the source and cement of his ideal society.

Titian, *The Vendramin Family*

The ages of man was a favourite theme with Titian. The very young, youthful, middle-aged and old members of the Vendramin family, without the women, are shown before the miraculous cross with which they had long and proud associations. For them, very clearly, that cross is the thing to look at – or be distracted from – according to age and disposition. For us it is the

19

19 Titian, *The Vendramin Family*, 1543–7, National Gallery, London.

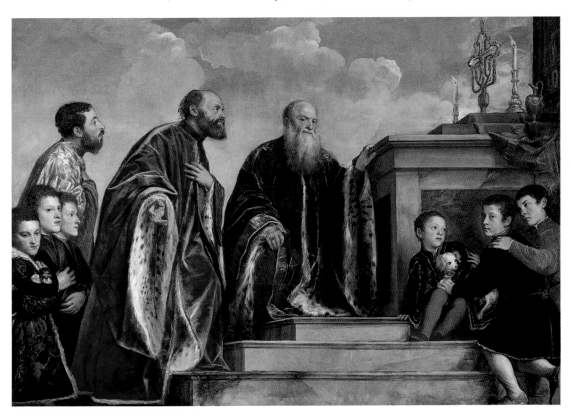

Vendramins themselves. This is a discrepancy which will need looking into, along with some consideration of the cross and its place in their social lives. But if we start with the Vendramins as we see them from outside the frame, we will not be going against the current of Titian's poetry. For he uses them to explore his preoccupation with the ages of man in terms of how people use their eyes at the different stages of their development.

The children's gazes are lively, but with a fidgetiness that can tip over into boredom if they are kept hanging about by adults who are preoccupied with something in which they are a lot less interested (we know it from watching families in galleries). The three on the right have found a space round the

20

20 and 21 Details from pl. 19.

side of the altar in which they can enjoy some liberty and play. Their eyes dart hither and thither, their concentration spans being only a little longer than that of the spaniel puppy which one of them is cuddling – while looking at an older boy, who in turn looks at the adults in the middle and has his hand on the shoulder of another boy, who is looking out of the picture at something (not us) which interests him in the world beyond. The three boys on the left are less happily placed. They are hemmed in by their elders and, as a result, two have lapsed into bored abstraction while the third has virtuously joined his elders in contemplation of the cross on the altar. He is a child who is just entering the adult world of steady contemplation. This

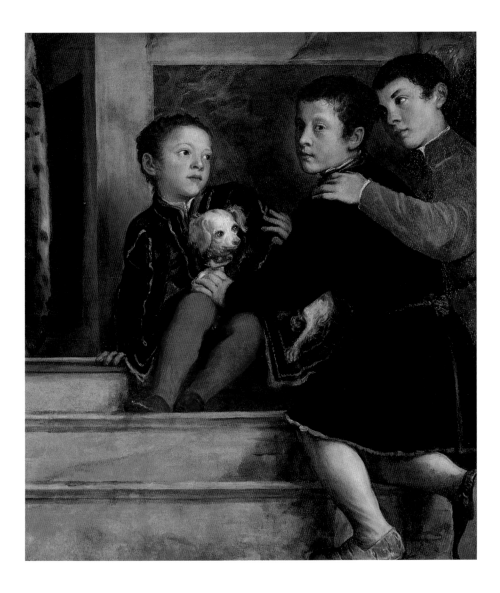

coming-of-age is exemplified by the young and the mature man in crimson robes, the first a little more uncertain in his prayer than his senior. Their fervent gazes dominate the picture majestically and movingly. They span the picture space from left to right across the magnificent Venetian sky, and come to rest on the cross which surmounts the outdoor altar. But another gaze, set at ninety degrees from theirs, acts as a counter-balance and an anchor for

the action in our world of spectators outside the picture. The old man in his dark purple robe occupies the very centre of the picture and his limpid, friendly eyes are on us. We should feel honoured. This senior Vendramin seems to have made his life and settled his account with God – something which the younger men are still working on by their intent gazing. He does not hesitate to steady himself, though a layman, with a hand familiarly and unself-consciously grasping the sacred altar – which even priests are not really meant to do. So, as good old people can be, he is free from self and seeking and happy to give himself over in welcoming attention to strangers like ourselves.

The two men in red are obeying the first of Christ's two great commandments, to 'love the Lord thy God with all thy heart, and with all thy soul, and with all thy mind, and with all thy strength.' They adore the cross by which God reconciled himself to women and men. The old man in purple is obeying Christ's second and similar commandment: 'Thou shalt love thy neighbour as thyself.' His eyes welcome us into the family group. His balding brother cannot take his eyes from the cross, but at the same time he extends

22 and 23 Details from pl. 19.

a beckoning right hand towards us through the picture plane, and so confirms his older brother's hospitality. Transcending their pomp and dynastic pride, the Vendramins present Christian obedience as something learned through the stages of life and unerringly manifested in the various qualities of their looking. Love is active among them, love of God and love of neighbour. As in the Wilton Diptych, its chief mode is looking. The young will learn it in time.

It is to be expected that such learning will be acquired by imitating their elders' veneration of the cross. On this subject, the modern spectator is not so easily at home as with Titian's exploration of the human gaze. We have to enter a world of more primitive and objective piety. We cannot see it (which is itself an interesting indication of Titian's own attitude to his subject), but within its goldsmith's work of gold and crystal, there is a holy relic, a piece of the very cross of Christ. Nothing could be more valuable. When, two hundred years before, an ancestor of these Vendramins had received this treasure as a gift from the Chancellor of Cyprus and in his capacity of Guardian of the Venetian Scuola of St John the Evangelist, the hierarchy of value for religious objects was clear.

First came relics, the actual and material things which connected the present to the sacred past by being still available, still infused with the power of their redemptive origins. They were unique and extraordinarily active – we could almost say radio-active. Then came jewellery, the material of the heavenly city in the Revelation of St John. The painter of the Wilton

24

24 Detail from pl. 19.

Diptych took pains to imitate the jeweller's superior craft. Jewelry, as next after relics, was the appropriate thing for setting, preserving and adorning them for veneration. Third and last came painting. It was not the thing itself, like a relic, and it was cheaper than jewelry. But it was to prove the liveliest and most resourceful sibling of the trio – a process well advanced by Titian's time, for all the veneration of relics and estimation of jewels which still went on and which he commandeered for this picture. Even in his century, the sixteenth, and even in our own when scientific medicine has taken away most of their public, relics assisted sacraments, paintings and scriptures with the great Christian aspiration of gaining access, across the barriers of time and space, to Christ, who in the body had done so many miracles in Galilee. The cross had borne that body for its arch-miracle of salvation. It had been the instrument of the ultimate sacrifice.

Venetian society was strongly relic-based. Its foundation legend told how the body of St Mark came, by divine will, to rest in the cathedral there which bears his name and was the centre of the city's whole life. The cross in Titian's picture was a much later arrival, but enjoyed a distinguished and acclaimed career in Venetian society. Its portability was an advantage. It was taken around the city in procession, an aspect to which Titian refers

27

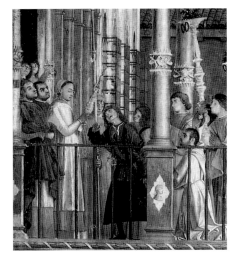

25 (*above left*) Gentile Bellini, *Miracle at the Bridge of San Lorenzo* (detail), 1500, Accademia, Venice.

26 (*above right*) Carpaccio, *Healing of the Possessed Man* (detail), 1494, Accademia, Venice.

27 (*left*) Gentile Bellini, *Procession in the Piazza San Marco* (detail), 1496, Accademia, Venice.

by setting it in the open air. Vast canvases by Carpaccio and Bellini in the Accademia at Venice, transferred there from the Scuola of St John the Evangelist where the cross itself still resides, record its miraculous feats in the course of these outings: how it was dropped into the water of the Rio di San Lorenzo but hovered above the surface until a Vendramin plunged in and rescued it; how it cured a madman; how it made its displeasure felt by becoming unmanageably heavy when forced to attend the funeral of a cleric who had held it in slight regard. In view of its achievements on its expeditions into the canals and lanes of Venice, it is fitting that it should be shown here in the open with the flames of the candles which flank it blown in the sea breeze and undimmed in the Adriatic light.

25

26

Yet such anecdotes possess little religious value for reflectively sophisticated minds, and it has to be said that Carpaccio and Bellini padded them out with a wealth of charming genre detail, bringing forward the sort of busy, everyday scenes which are glimpsed in the background of Northern paintings to fill the entire foreground – it takes some scrutiny to pick out the miracles from their surroundings. But they testify to the socially cohesive power of physical totems in religious life. The cross which Titian's Vendramins behold with such rapture belongs to an older and more primitive world in which painting came a poor second to relics and jewellery. There is continuity, by virtue of the two facts that the Vendramins are still under the spell of the relic, and that paintings also appeal to the physical sense of sight. But in face of Titian's picture we are made aware that a huge change has come about. If, for the people within the painting, the cross is the thing to look at, for us outside the painting the valuable content is the spectacle of its devotees. Devout seeing itself is now a religious subject. It was so in the Wilton Diptych, but with Titian the capacity of paintings to mediate more religious value than relics and jewellery, and to do it more richly, is resoundingly triumphant. Paintings proved capable of representing Christ's body more richly and resonantly than relics. They could show it whole and eloquent, in the course of its redemptive work. They could also show human beings like ourselves contemplating the actions and traces which God and the saints have made in the world's fabric, and so draw us into their contemplation by example. They had the vivid power of poetry to interpret the world and give it meaning, rather than being merely another object within it, however unique and precious. As a result, they are not a prey to the disenchantment which has overtaken relics and so much of the furniture of religion in the modern world. With great painting, looking comes of age and achieves a self-consciousness and a self-forgetfulness which conquer time. Titian's mastery humanises religion by digesting its primal objectivity into the multifarious subjectivities of his patrons, interpreted as types of humanity. Religion lives more richly from such creative use of its resources. And in the enlivening process a little of what it had once held in exclusive control is consumed into a wider humanity.

Duccio's Triptych, *The Virgin and Child with Saints*

Like the Wilton Diptych, Duccio's triptych is first a box, then a picture. But to consist of three panels rather than two makes a great difference, both in the closed and in the open states. When it is open it will have a resolved centre, unlike the endless criss-crossing over a hinged axis which integrates a diptych. Before that, and while it is still closed, its shape has grander and

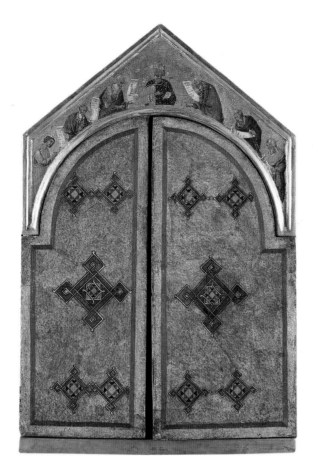

28 Duccio, *The Virgin and Child with Saints* (shutters closed), *c.*1315, National Gallery, London.

more religiously eloquent associations than a box (though even boxes, as we saw, have their religious resonances). The triptych's doors resemble the great double doors in the western wall of a church which form its chief entrance, admitting the faithful, often in ordered procession, into the building along the central axis of the high altar. The closed triptych's church-like shape is accentuated by the gable over the doors, suggesting a roof above. Here it has become a kind of balcony for the seven prophets. A further resemblance would have struck a contemporary looking at the closed triptych. Precious relics, such as the bones of saints, were often kept in shrines which were boxes shaped like houses or churches with ridged and angled roofs. So the triptych's church-like and reliquary-like shape when shut heightened expectation of some high religious value to be disclosed by opening it.

The seven prophets on their balcony increase that expectancy. King David in the middle (Christ's ancestor, as well as his prophet in the Psalms that he

29 Duccio, *The Virgin and Child with Saints*, c.1315, National Gallery, London.

is said to have composed) looks at the spectator. The other six are craning over in earnest expectation of the glory to be revealed by the opening of the doors. The texts in which they prophesied it flutter up from their hands like little flags waved at a great procession. But it is the intentness of their looking, the crouching of their bodies to see something below them, which most pitches up the excitement.

When the doors are parted, their prophecies are fulfilled and the heaven which they glimpsed in episodic visions is at last open and revealed, their texts and oracles made flesh. And time stands still in its fulfilment. Historically, the prophets were BC, before Christ. On the opened doors stand two saints of our own era, AD, *Anni Domini* or years of the Lord. They are the only figures to be visibly and certainly standing on the ground. They show their place in our era within the Christian scheme of time by means of a

29

spatial or ocular device. They turn their eyes outward to either side – thus including the Christian world around and beyond the triptych. The mediation of the saints between mortals and the divinity makes their placing on the wings as appropriate to their function as their gazes, which look around for their clients – the inclusive gaze, as with that senior Vendramin. On the left is St Dominic, founder of the Order of Preachers. He is a decidedly male figure, stiffly erect in his habit of severe black and white and holding a clasped red bible. On the right is St Aurea, the obscure virgin patroness of Ostia near Rome. She is decidely female, her rich pink and green robes draped in softer curves over her more flexible pose and hemmed by sinuous lines of gold. She is veiled and holds a slender cross with one hand while raising the other in greeting. They make an antiphonal pair and are a kind of visual equivalent to the music in church when the simple voice of the cantor is answered by the richer harmony of the choir, united in worship.

At the centre is eternity, framed by the BC people above and the AD people to the sides. It is neither BC nor AD but the resolution of both in myth's everlasting realm. The Virgin and Child are for ever. Yet far from this making them remote, they are dramatically nearer to us than any of the other figures. Perspective here obeys the ideal and serves what matters for the purpose of prayer. The prophets are small, half-length figures from a distant and superseded past and on the same scale as the four little angels. Neither prophets nor angels were as commonly invoked in prayer as saints. Saints Dominic and Aurea are larger and full-length – more fully and objectively realised members of our own world and times who matter a great deal as constant advocates of the faithful and hearers of their petitions. But the Virgin combines the spatial indeterminacy entailed in the half-length treatment of the prophets, with a spectacular increase of scale which makes her and the Child she carries very near to us indeed. Perhaps, as is said of God, she is nearer to us than we are to ourselves. She seems to come towards us out of the picture and impinge on the interior world which is the source of the prayers which the whole triptych invites: 'Hail Mary, full of grace, blessed art thou among women and blessed is the fruit of thy womb, Jesus. . . . Pray for us sinners, now and at the hour of our death.' In Christian devotion, prayer to Mary and, through her, to Jesus transcends all other kinds in degree and scope.

The significance for 'us sinners' of the relation of Mary and her son must, in a picture, be a matter of looking and being seen rather than of utterance and hearing. Duccio's central achievement is to present the heart of the triangular relation Jesus–Mary–ourselves in entirely visual terms. It is done with a profundity, delicacy and ordinariness which makes this triptych something which still addresses us at the roots of our souls. Jesus is lifting Mary's veil to gaze at her face. It is the centre of the whole carefully ordered work and brings to mind the game of peekaboo which mothers and babies have played everywhere from time immemorial. The face is covered, then smilingly

revealed, in repeated moments of 'now you see me, now you don't.' The mother does it first, then the baby does it back. Here we see the latter, as is fitting to the Christian scheme of things, in which Jesus is Mary's lord as well as her child. This simple game never fails to bring hilarity. Psychologists take it seriously as a fundamental learning of the ordeals and fulfilments of looking, and within that, of learning to love by bearing both absence and presence. It is love playing happily and trustfully with time, showing that presence will become absence, that absence will become presence again, and that love can bear it all. By putting the unveiling of the face at the centre of his triptych, Duccio reaches the inmost climax of the openings and gazings that form the scheme of his whole contraption and makes a connection between the focal point of the Christian heaven and the primal source of individual human well-being. And we have a clue to the conundrum of why it is that looking and being recognised can be the source of such profound happiness.

It undoubtedly can. Which being so, we might take the further step of suggesting that mutual regard, in its obvious and physical form of looking at other people and its moral form of looking to other people, is the source and cement of human society. Some political theorists, for example Richard Hooker, endorsed by Locke, have got near enough to such a view by basing society on mutual regard and neighbourly love: the inward, intellectual aspect of the kindly look. Others prefer legal covenants or even business deals for this important role. Yet ordinary, physical looking is a primary form of grace, and if grace is to be part of social life (which is not worth living without it), it has strong claims. They are presented to us by the angels on the Wilton Diptych and by the senior Vendramin. In the relation of mother and child, on which so much depends, the mutual gaze takes over from dependence on mutual touching to lead life into a more free, expressive and trustful – not to say hugely richer – world. The first picture which an infant will react to is a piece of paper on which two dot-eyes are set over an upward curve for a mouth. In a quite verifiable and everyday way, looking is. the source and cement of society, the glances which show the 'regard' by which person gives value to person. The quality of it is all-important, and preoccupation with visual art is not necessarily the languid pastime of a degenerate society, but can be a way of learning the ropes of community. Christianity has always believed that exchange is at the centre of life. God as Trinity is its doctrinal heart. But the image of the Madonna and Child has always, for obvious and deeply human reasons, been more popular. It has therefore been more painted – which entails that the exchange in such pictures should be by means of looking.

At the very least, looking intelligently and sympathetically at pictures of people is useful practice for looking intelligently and sympathetically at people themselves. Simone Weil believed that the best sort of attention

which we can give to pictures, no more and no less, is also owed to the truths of faith and the sufferings of humanity:

> Those who are unhappy have no need for anything in this world but people capable of giving them their attention. The capacity to give one's attention to a sufferer is a very rare and difficult thing; it is almost a miracle; it *is* a miracle.
>
> <div align="right"><i>Waiting on God</i> (1951)</div>

Part II

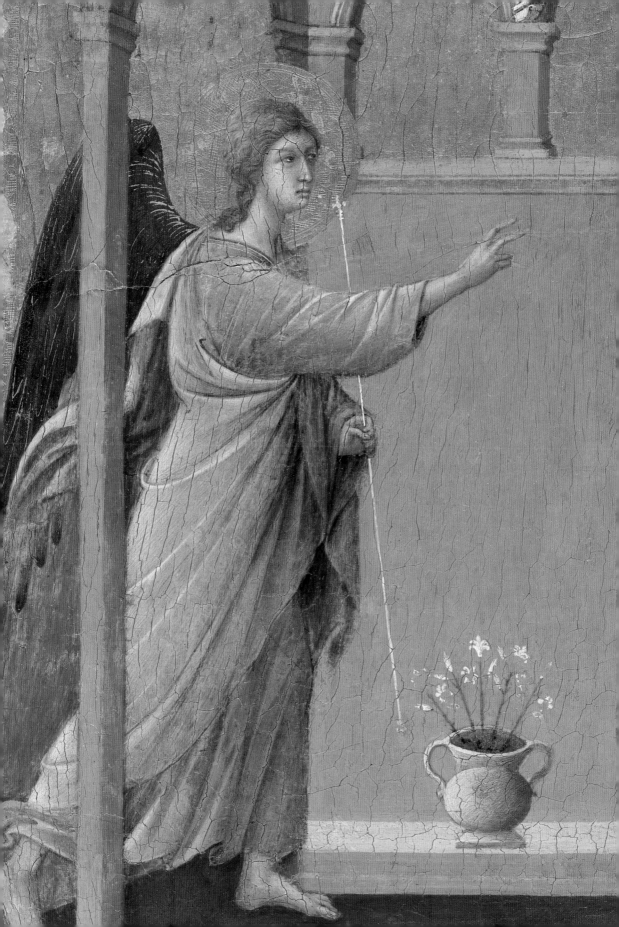

3

The Incarnation of the Word and the Words

In the sixth month the angel Gabriel was sent from God unto a city
of Galilee named Nazareth, to a virgin espoused to a man whose
name was Joseph, of the house of David; and the virgin's name was
Mary. And the angel came in unto her and said, Hail, thou that art
highly favoured, the Lord is with thee: blessed art thou among
women.

Luke 1. 26–28

St Luke's imagination twisted eternity together with our historical world
of times, people and places. He was an historian who delighted in circum-
stantial details and a fabulist who enjoyed making the impossible actual
and palpable. In the fabric of his work the two are woven together.
Mundane existence is shot through with the golden threads of divinity. His
gospel is a work of historical fiction, its sober realism as much the product
of his imaginative powers as the flight of fancy which here shows the angel
Gabriel entering the house in Nazareth.

A dialogue between Mary and the angel follows. It can only be imaginary,
but it is controlled by a firm and delicate sense of the incongruity of its two
participants, held together over a respectful distance by their mutual regard.
This being a book and not a picture, words are the medium of their exchange.
Gabriel tells Mary: 'thou shalt conceive in thy womb, and bring forth a son,
and shalt call his name JESUS.' When Mary asks him 'How shall this be, seeing
I know not a man?' he tells her that 'The Holy Ghost shall come upon thee,
and the power of the Highest shall overshadow thee; therefore that holy thing
which shall be born of thee shall be called the Son of God.' Mary consents:
'Behold the handmaid of the Lord; be it unto me according to thy word. And
the angel departed from her.'

So the words hover around an event: promising it, questioning it and
explaining it in a courteous confluence of the practical and the miraculous,
the domestic and the strange. They are exhausted when Mary finally gives
the consent which allows it to happen and become flesh. No more words

now, and no more angel. All is resolved in her womb, which contains the embryo which unites the possibilities of both divinity and humanity. We have incarnation.

This moment is crucial for Christianity – thanks not only to the religious imagination of St Luke but also to that of St John, whose mythic vision of the descent of the divine Word into the world as Light spirals down into the magnificent definition 'And the Word was made flesh and dwelt among us, and we beheld his glory' (John 1.14). John's myth has the same deliberate movement from sound to sight and from word to flesh that we traced through Luke's more homely tale. We hear of the Word at the beginning, and there is nothing for our pictorial imaginations to grasp. But then the image of Light shining in darkness is strongly pictorial in the majestically semi-abstract way of myth. Finally we have a visible body: divine word made human flesh so that we can behold his glory.

Seeing has come into its own, into the world of the ideal and the divine as well as the world of appearances – since both have now converged and are united. Although that puts it in the distinctly and positively Christian terms which we have been using so far, it is appropriate to painting at large and in itself, and whether it is Christian or not. Christianity has got hold of a truth which operates beyond its borders as well as within them. For paintings, and even photographs, are not the redundant reduplication of reality, giving us facsimiles which are exactly like what is there already. They are powerful because they infuse and metamorphose the visible with the invisible. The world of appearances is so steeped in the thoughts and feelings of painters (even their religion in the wide sense of their whole attitude to life) that these invisible things – thoughts, feelings, theology – are made as available by means of sight as the people and things in the pictures. St John's 'the Word was made flesh . . . and we beheld' is a resonant motto for painters. It speaks of the sort of transubstantiation which is their work, which challenges their imaginations and results in meaning and value.

Christian painting itself has a commanding motivation and a firm point of imaginative departure in the transforming moment presented by St Luke and St John. It guarantees that the representation of the body – Christ's body focally and other bodies by association with it – is the representation of all that can be meant by the elusive word 'God'. The incarnation of the Word is a charter for the painter's task of transforming the words of scripture into figures. St Luke's imagination produced the dialogue which makes up his story of the Annunciation. Painters of it will have to find ways of transubstantiating the talk into silence and frozen action. They will have to consume the words so that they can be flesh again and so be plain to see.

* * *

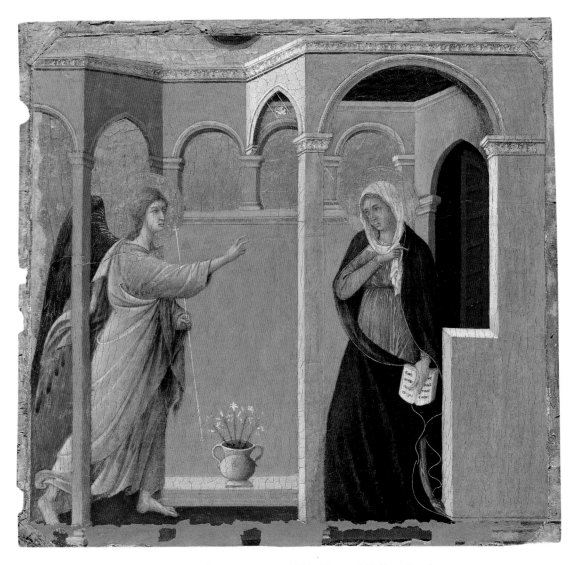

32 Duccio, *The Annunciation*, 1311, National Gallery, London.

Duccio, *The Annunciation*

32

Duccio's painting presents the first movements in the drama: Gabriel's entry and greeting and Mary's perturbation. Gabriel, with the usual spring in his step, comes in from the left. His entry is given kinetic energy by the way his right leg and wing move across behind the red pillar, its stable verticals setting off his conventionally slanting advance. He projects his right hand in a gesture of blessing which makes his greeting visible. The blessing seems to

43

33　Detail from
pl. 32.

carry his arm and the whole of the rest of his body along behind it. It is the
spearhead and forward propulsion of his movement: a sign that Duccio's forms
follow Luke's words. The blessing is followed by narrative: 'And when she
saw him, she was troubled at his saying and cast in her mind what manner
of salutation this should be.' Mary's seeing of Gabriel is a gift to the painter
and Duccio makes Mary lift up her eyes shyly and intently. But how her trou-
bled spirit and her casting in her mind (interior matters) can possibly be
depicted – these are difficult problems.

33

She is divided from Gabriel by the white pillar in front of her. Far from
crossing beyond it, like Gabriel boldly crossing beyond his red pillar towards
her, she shrinks behind it as if it were some sort of defence. And she raises
her right elbow in a warding-off movement, which makes her cloak take the
shape of a protective shield. Duccio has made her troubled emotions, put in
words by St Luke, into a bodily recoil. Her left hand drops down into the

34

agitated flourish of golden lines edging her cloak. It holds the book which is
open at Isaiah's prophecy of her destiny: *Ecce virgo concipiet et pariet filium et
vocabitur*, 'Behold, a virgin shall conceive and bear a son, and shall call his
name Emmanuel' ('God with us'). Again, we notice the power of the words,
the text, within the image. What is written is, in scriptural parlance,

ineluctable and unavoidable fate. It cannot but come to pass in the world of time and bodies. So her withdrawing movement is blocked and contradicted by the book, backed up by the bright, hard rectangles of the wall behind. She is in real trouble – 'casting in her mind' and visibly trapped.

Her only exit is by the way of obedience. She indicates it with a long finger, pointing beyond the panel to the right. Here we must imagine the panel restored to its original place on the left of the predella which supported the vast main panel, still in Siena, showing the Virgin and Child centrally enthroned with angels and saints from different centuries on either side. Below this vision of eternity, with Mary's destiny settled and resolved, the predella panels showed its evolution in the world of time and in narrative sequence. First came this Annunciation, then the Nativity, then the Visit of the Magi and so on, for seven panels in all. Between each of them stood a prophet whose inspired proclamation-in-advance had made them inevitable. The whole predella is a realisation of the biblical idea of history, driven not by human causality but by divine providence. So the divine messenger, Gabriel, sets the series going. And next comes Mary, whose perplexity can only be solved by her assent to the divine plan announced by Gabriel and by the unrolling of her destiny. In history, after all, the solutions, for better

35

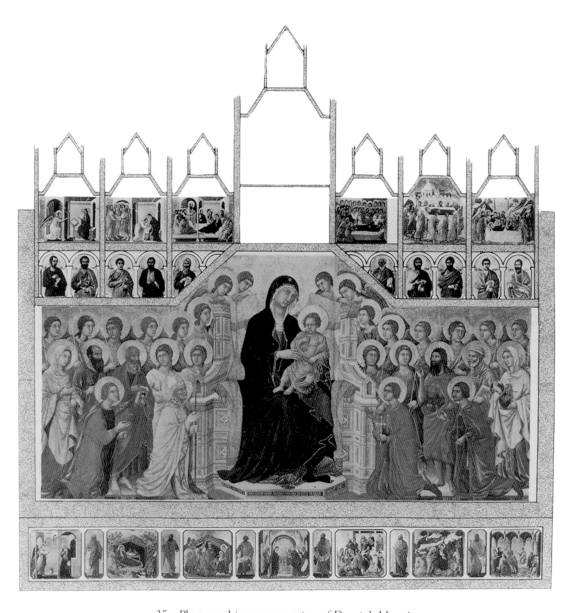

35 Photographic reconstruction of Duccio's *Maestà*.

or worse, are not so much ideas as what actually happens next. So her finger
points to the prophet Isaiah who holds the 'original' text which she has been
reading in her Bible. It is the long-ago cause of this critical moment. Its
effects, to which that finger also points, carry over, through forty panels of
Christ's story on the back of the altarpiece, to conclude with six set above

the great main panel and the predella below it, which narrate the last scenes in her own story.* Her pointing gesture is the modest little index, made by her index finger, to the whole wonderful thing, justly known as Duccio's *Maestà*.

By these bodily movements and gestures Duccio makes words and feelings into silent spectacle. The drama is set in architecture which assists it, and does so more impressively than the descent of the Holy Spirit as a dove. This bird was already a conventional way of representing Gabriel's promise 'The Holy Ghost shall come upon thee' by borrowing from the accounts of Christ's baptism in which the Holy Spirit descends upon him like a dove. Perhaps it is precisely because it is conventional and does not challenge Duccio's imagination that it is so uninterestingly handled. It is a tiny white bird, no bigger than a wren, which has come down through a hole in the golden sky. It is at the picture's central axis and canopied by an emphatic arch,

36 Detail from pl. 32.

but is drawn in an emblematic or heraldic manner. The building, by contrast, makes a powerfully significant contribution. In plan, it is open to the sky on Gabriel's side and roofed with coffered timber on Mary's side. But the boundaries and separation thus marked are warmly and vividly violated. The vital Sienese pink from Gabriel's outdoors invades Mary's virginally white enclave, even curling around her to include the wall with the doorway at her back. The white arches in front of her dignify and protect her virginity. There is maidenhood and fertility. Through one of the white arches the dove enters to impregnate her womb without changing her purity. The rectangular projection from the white wall at the right is a particularly telling instance of Duccio's way with his scenery. Squared, bright, simple and strong, it cuts off Mary's retreat and lends a needed stability to her drooping figure with its bending knee. Virginity, it suggests, is not a mere negative; not just a white absence of the stain of generation; and certainly not a weak timidity. It is a robust and sharp support which can steady and support humanity under the impact of the divine. In a mythical and spiritual sense – and myth and spirit are very much part of what we are dealing with here – it is the precondition of fertility. The 'clean heart' is ready for the creative spirit, the clear mind for true conceptions, and the simple, pure eye for the invasion of light. These are intimations which are developed in the next picture.

* According to John White's reconstruction in *Duccio: Tuscan Art and the medieval Workshop*, 1979, p. 84.

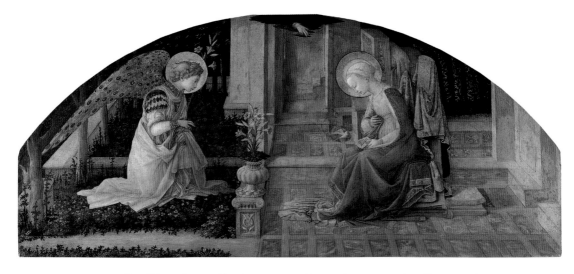

37 Filippo Lippi, *The Annunciation*, late 1450s, National Gallery, London.

Fra Filippo Lippi, *The Annunciation*

A house is a kind of extra, or surrogate, body which dignifies the body we have already – extends it and makes up for its shortcomings: 'someone's idea of the body/that should have been his' (W. H. Auden, *Collected Poems*, 1991, p. 689). In this picture, Lippi has carefully designed an architectural setting which is a mixture of enclosure and openness, seclusion and availability to the world outside. As such, it is a poem of the focal body in the painting, Mary's. As virgin she is closed, inviolate. To be the mother of God's son, she is open and submissively available in her inmost self, heart and soul. The buildings which surround her frame and echo these aspects of her body.

The picture is divided, not quite in half, by a wall. It is solid and buttressed at the back. As it comes towards us, it is pierced by a large opening. Then it drops down a step and becomes very low. It stops at the plinth supporting the usual vase of lilies. In the foreground there is no barrier at all. So we have a diminuendo: from complete separation, through a piercing, to a very slight barrier, and finally the total availability of the whole mystery to us as spectators.

Having read the lay-out from back to front, let's now read it from side to side. On the left there is an enclosed garden. As it is written in the Song of Solomon, 'A garden enclosed is my sister, my spouse' (4.12). Such is Mary in Catholic Christian myth, a *hortus conclusus*. In front of this there is an open garden with a path into the house. But Gabriel does not use this ordinary way. He comes by way of the gap in the low wall behind him (appar-

ently there in the first place to admit him) and lands so lightly on the turf that he does not crush a flower. The two kinds of garden on the left are answered by two kinds of building on the right. At the front is the open, paved courtyard where Mary sits. But up the step beyond her is her bedroom, open to the enclosed garden through the doorway in the wall. Beyond that there is a more mysterious feature: the bottom steps of a staircase. Where does it lead? The answer jumps us from domestic architecture to God. From the middle of a cloud, representing the overshadowing in the text, God's hand reaches down in blessing. Its wrist is the picture's absolute centre, and it despatches the dove which drops steeply down past the staircase to the level of Mary's womb. This descent and Mary's response to it answer her question 'How shall this be?' But before we look into it, we should notice that the stairwell, like the rest of the scenery, is an accompaniment to the drama of bodies, to which this descent of the spirit and the Virgin's response is central. And the stairwell has a depth of spiritual significance which is apt to its spatial depth. As the most secluded and inward part of her house, it suggests the intimacy of Mary's relation to God as spouse.

38

38 Detail from pl. 37.

49

But still, 'How shall this be?' We have got an answer of some general value. A human body is like a house. Private and public life, inward and outward worlds, meet there. It, not banks or money, is the primary place and means of exchange. It encloses our inmost thoughts and feelings. It also lets them out and reveals them. It 'deals out that being indoors each one dwells' (G. M. Hopkins, 'As Kingfishers Catch Fire'). Lippi has taken care, with the setting of his figures, to enable an exchange between the most secluded self, the Virgin, and the open world of space and time. The fruit of this exchange will be the body which is uniquely central in Christian devotion, the means of exchange between humanity and divinity: Christ's. And this reminder brings us back to Mary's question 'How shall this be?' We need rather more than a similitude of houses and bodies to answer it.

Luke's own answer, from the mouth of Gabriel, is less than adequate to the physicality which the question implies. The 'coming upon' of the Holy Spirit and the 'overshadowing of the Highest' have the majesty of mystery, but its vagueness too. Many Christian teachers warded off attempts to pry further into the 'how' as irreverent. There are mysteries which we are not meant to see into, from which even the angels veil their faces. But when theologians use this ploy it is all too often a signal that they are in difficulties which they want to escape under the cover of theological smoke. This is particularly hard on painters commissioned to depict the moment of the incarnation, and it is hardly appropriate that divine self-disclosure should be answered by ecclesiatical or academic obfuscation. Painters have to show things physically, as God did in Christ, and therefore need to know exactly what they must show. We have already seen how they had got used to borrowing the dove from Christ's baptism to help them out. Leo Steinberg, pioneering the understanding of this picture, made the point deftly:

> Of all Christian mysteries none demanded more tact in the telling. [Figures and types were deployed] to shield an unsearchable secret from too diligent investigation. Accordingly, in traditional exegesis, inquisitiveness was deflected, and the sensuous imagination was disoriented, by citing successively the types of the Virgin's conception prefigured in the Old Testament: her womb, it was said, was bedewed like Gideon's fleece; enkindled like the burning bush seen by Moses; budded without cultivation like Aaron's rod, and so forth.

> But painters must make decisions which more modest Christians are spared; and it is remarkable to see Fra Filippo Lippi . . . emerge as the keenest in seeking to visualize what previously had been veiled and misted in figures of speech.*

* Leo Steinberg, '"How Shall This Be?" Reflections on Filippo Lippi's Annunciation in London', *Artibus et Historiae*, 1987.

The moment in Luke's story which Lippi depicts relieves him of Duccio's problem of representing spoken dialogue by silent figures. He shows the end of the story. Everything has been said. Mary has uttered her 'be it unto me according to thy word.' So the mouths of both participants are firmly closed. The painter is free to work in purely visual terms on the great problem 'how shall these things be?' His imagination provides more than a brilliant figural solution of that pictorial and theological problem. It is a profound description of seeing at its purest and most dedicated.

Gabriel looks at Mary. And Mary looks at the dove just above her knees. Clearly this is where we should look too, and the hand of God at the top of the picture points to it decisively. That hand and the dove are connected in a way which has been obscured by the damage of time. We can see that the dove is contained in an airy, transparent disk, and that there are more such disks overlapping one another above and behind it. They originally formed a continuous spiralling chain, like a loosened spring, which connected the dove to the divine hand which despatches it. This is how Lippi's contemporaries in the fifteenth century believed an image of a form to travel, through the air, to the eye of the beholder. Roger Bacon of Oxford's theories about

39

39 Detail from pl. 37.

40 Detail from pl. 37.

optics and vision had been retailed in Florence by Ghiberti, Lippi's contemporary. Bacon believed that an object or form 'produces a likeness of itself in the second part of the air, and so on' (third, fourth, fifth . . .), until it reached its destination. These intermediate images had no dimension of their own but were 'produced according to the air'. So Lippi paints them with the transparent delicacy which was one of his particular skills.

So far, so good. The chain of airy images tells us that Lippi imagines the medium of the Annunciation to be light and sight rather than sound and hearing: a poetic coup based in confidence in his own calling. And it has brought the dove closer to Mary's body than was customary in Annunciation pictures – it was usually put in the air above her head – and there is a new intimacy. But there is still a gap. What happens there? The answer will resolve Mary's great question 'How?'

Careful inspection reveals a spray of golden particles issuing from the dove's beak. At their centre, one little jet of them carries forward horizotally and meets – contact at last! – an answering golden spray from Mary's womb, issuing through a tiny slit in her tunic. The word 'tunic' in fifteenth-century ophthalmological parlance was borrowed from everyday dress to denote the layered membranes which surround and protect the eye's central *humor crystallinus*, which received the image through a parting of the tunics called *il foro*, the opening or doorway. (We recall Lippi's architectural parable of this, the opening in his central wall.) Perfect vision occurred when the image came in level with *il foro* and the *humor crystallinus*. That is why Lippi brings the dove right down to be level with the centre of Mary's womb, where there is a little parting of her tunic. Her womb is like – very like – an eye. The eye

does more than receive. It is active and out-going. So out of the aperture in Mary's tunic comes a golden spray which meets the emission of golden light from the dove's beak.

The Florentines called seeing 'noble', the noblest of all the faculties. In Lippi's understanding the eye is not inactive, passively receiving signals. It is an agent which 'makes something', and possibly something more or even better, of what it is given. When we see, is it the outside world coming to us, or us going out to the outside world? The question has interested people for ages. A reasonable answer seems to be that it is something of each. So noble, so receptive yet creative, is our faculty of seeing, that it goes out, like a courteous host to a welcome guest, to meet and dignify whatever comes to it. For the incarnation itself to occur, divinity (being love and not tyranny) waits for that little moving-forward in consent,

41 A diagram of the eye from Witelo, *Opticae libri decem*, Basel, 1572, III, p. 87.

that slight but momentous action of Mary's in saying 'Be it unto me according to thy word.' Light rather than speech being Lippi's medium, this has become 'Be it unto me according to thy light.' Mary's momentous response, just made in words, is decisively and pictorially 'uttered' by the little spray of light from her womb/eye and the slight forward tilt of her body.

It is a wonderful answer to her question 'how?' It makes the creation of natural light at the beginning of Creation continuous with the conception of Christ, the spiritual light of the world. By making the womb like the eye, Lippi does justice both to Mary's perpetual virginity and to her willing part in the scheme of salvation. And all the careful mixing of openness and enclosure in the setting which surrounds the two quiet figures – the outdoors and indoors, barriers and access – find their definition and resolution in the meeting of the two golden sprays.

It is all imagination. Not just Luke's story, which Lippi himself believed to be factually true, and the optical science of Bacon and Ghiberti which he believed in the same way. Also his lovely picture. But that is to say that it conveys truth about experience, available to enlighten us in hundreds of similar experieces of encounter and exchange. Outdated science can become poetry when it already holds symbolic value.

Taking our cue from the liquid interchangeability which symbols and poetry allow, we may reflect that, when someone looks well at a picture, an inner purity, which does not get much exercise in the ordinary way of things because it has something of the virgin about it, becomes receptive and active. The eye begins to take in the picture and to go out to it in active response and exploration. When such an annunciation and conception has occurred, it leaves a quite physical sense of enlightenment and fruition. 'The light of the body is the eye: if therefore thine eye be single [pure in concentration and response] thy whole body shall be full of light' (Matthew 6.22).

Poussin, *The Annunciation*

It takes a great picture to put a beautiful and deeply interesting one out of our minds. In Poussin's *Annunciation* there is no complex theory of light. It just floods in from the left to illuminate the two figures. There is no meticulous planning of a finely articulated architectural setting, just a wooden platform and a large looped curtain which all but conceals a bed. Poussin is like those theatrical directors who concentrate so severely on the dramatic action that they have no use for expensive and distracting scenery. Light, bodies and a few necessary bits of furniture can tell it all. And they can tell it better by cutting the frills and going only for what is done. Hence a robustly physical representation of the workings of spirit, an austere unity packed with vital and inexhaustible significance – infallible signs of the masterpiece.

Poussin's great friend Cassiano del Pozzo, a man who shared his passion for painting and history, died in 1657. This is the date on the *trompe l'oeil* label at the bottom of the picture. Its illusionism suggests that it was meant to fit into a sculptured setting, such as a tomb. If it was Cassiano's tomb, Poussin would have given it his all. The label reads, in translation,

POUSSIN MADE (THIS)
IN THE YEAR OF SALVATION 1657
IN THE REIGN OF POPE ALEXANDER VII
IN ROME

In Rome ten years before, Bernini had completed his astonishing sculpture of *The Ecstasy of St Teresa* – a more modern annunciation, but no doubt modelled, consciously or subconsciously, on the biblical one. It shows the vision of St Teresa recorded in Chapter 29 of her autobiography and cited at her canonisation:

Beside me, on the left hand, appeared an angel in bodily form . . . In his hands I saw a great spear, and at the iron tip there appeared to be a point of fire. This he plunged into my heart several times so that it penetrated

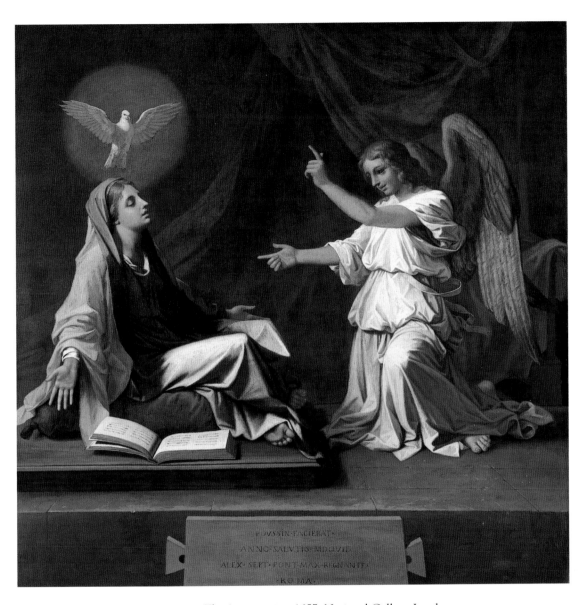

42 Poussin, *The Annunciation*, 1657, National Gallery, London.

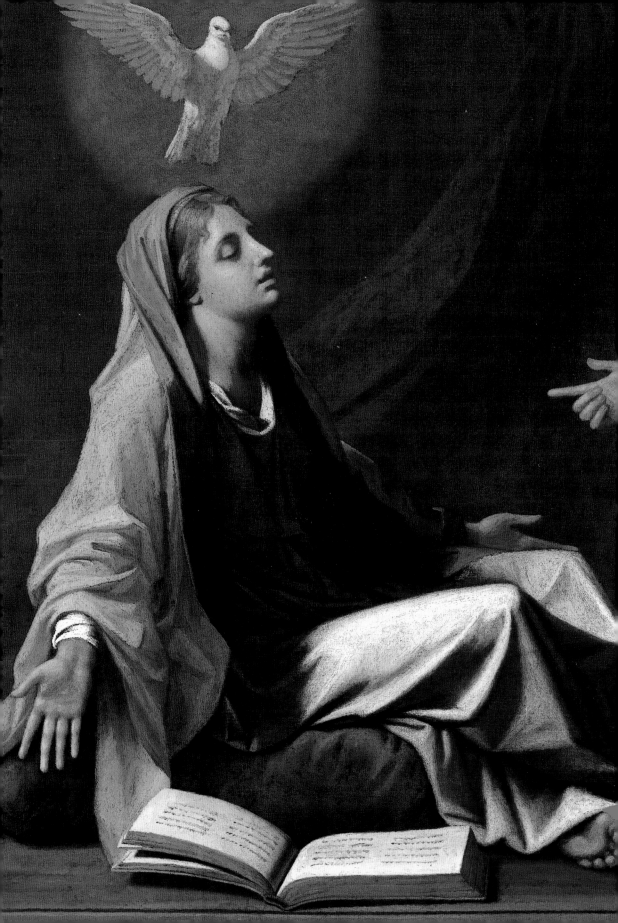

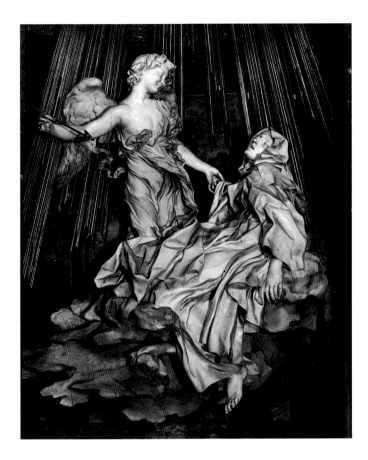

43 (facing page)
Detail from pl. 42.

44 Bernini, *The Ecstasy of St Teresa*, 1644–7, S. Maria della Vittoria, Rome.

to my entrails. The pain was so severe that it made me utter several moans. The sweetness caused by this intense pain is so extreme that one cannot possibly wish it to cease, nor is one's soul then content with anything but God. This is not a physical but a spiritual pain, though the body has some share in it – even a considerable share. So gentle is this wooing which takes place between God and the soul that if anyone thinks I am lying, I pray God, in his goodness, to grant him some experience of it.

The mixing contradictions of pain and pleasure, physicality and spirit, in this extraordinary text were so brilliantly realised by Bernini that it could never be read again without bringing his masterpiece to mind. Art historians see Poussin's *Annunciation* as his classicist response to Bernini's Baroque theatricality. Anthony Blunt congratulated Poussin on the 'restraint' with which he answers Bernini: 'Poussin's virgin does not swoon; she sits with eyes closed and with her hands in a gesture of submission to the divine will . . . There is no Baroque movement' (*Poussin*, 1967, p. 307). Richard Verdi deals in straight contrast too: 'Whereas Bernini conveys mystical experience in a

sensual and near-convulsive manner, the ecstasy of Poussin's Virgin is one of sublime tranquillity' (*Nicolas Poussin*, 1995, p. 305). We might go further than Blunt and Verdi by noticing that St Teresa and her angel are airborne on a bank of clouds, with a foot dangling in mid-air below, whereas Pousin's Virgin and Gabriel are very much set on a solid stone floor – which gives them gravity in both senses of the word. But both these critics are so keen to distance Poussin's classicism from Bernini's Baroque that they let their eyes wander from the images.

Poussin's Virgin most certainly does swoon. Bernini's St Teresa is not convulsive but post-convulsive. She is collapsing in a dead faint. And 'sublime tranquillity' does not fit the dramatic gestures of the two pairs of hands in Poussin's painting: Gabriel's hands pointing animatedly up to heaven and straight at the Virgin's heart, the Virgin's flung aside in abandoned surrender. The movement of Bernini's group consists in the contrast of the diagonals of the angel's spear and St Teresa's body set against the vertically descending rays of grace. But Poussin's picture is not all 'tranquillity', still less immobility. Its monumentality harnesses powerful movement.

What is it that gives us the peculiar sense that the Virgin is sliding, even flying, when she is set on her cushion so composedly? Her hands, for one thing. Just as the wings of the dove over her head have momentarily spread horizontally outwards from its upright body, so her arms have just completed a horizontal backward sweep which exposes her vertical torso. Each opening, level gesture echoes the other. And there is more. The opened wings of the dove above the Virgin are matched by the opened pages of the book below her. Her self-opening is bracketed by other openings above her and below her. Now imagine closing the book. The pages to our left would not nearly cover the pages to our right. Poussin has made one set longer than the other. An odd book, and yet so deliberately so! The effect is to nudge the balanced symmetry which we expect into the surprise of a horizontally impelled movement. And this is parallelled by the dais on which the Virgin and the book are set. If we could see its left-hand end and the floor beyond it there, we would have no doubt of its immoveable repose. By hiding this from us, Poussin assists the sense of sliding which the things above it have suggested.

45

Poussin has achieved a movement of Mary which, her eyes being closed and her body seated, is more a movement – or vertigo – of the mind, tacitly conveyed to the spectator's eye by a set of cunning devices, than a bodily movement. It is a more painterly presentation than Lippi's, because it is more hidden in the matter of the picture; not so much to be 'read' with intellectual curiosity as to be seen by the eyes without the mind necessarily noticing what is going on.

There is a similar, dug-in symbolism at the picture's heart. Mary is sitting cross-legged on a green cushion: a conventional 'Madonna of Humility' or perhaps a detail of ancient life and customs such as Poussin learned from Cassiano del Pozzo – in biblical times chairs were rarer and people often sat like this. But in either case, convention or historical accuracy, it is not merely inserted. It works. This posture allows something to happen which the posture of sitting on a chair would not. Mary's opening out of her knees along with her hands makes the middle of her body, from breast to thighs, into a dark and open cave. It is answered by another. In the background, the huge curtain of her bed parts to expose a profound inner obscurity.

> There is in God, some say,
> A deep but dazzling darkness . . .
> O for that night! where I in him
> Might live invisible and dim.
> <div align="right">Henry Vaughan, 'The Night'</div>

The sense that this other cavern is to be associated with God's presence is seconded by the way in which its darkness is the supportive background of Gabriel's gestures. One hand points towards the heavenly dove, the other towards Mary's body. Between them they make the conjunction of flesh and spirit which is the divine purpose of the Incarnation. It would be particularly appropriate to a tomb, not least the tomb of a dear friend, to picture the world beyond as a darkness which is not a void but the dwelling-place of God who 'made darkness his secret place, his pavilion round about him' (Psalm 18.11/17.12 in the Vulgate *posuit tenebras latibulum suum, in circuitu eius tabernaculum eius* – Poussin's tabernacle or pavilion of a bed). And it would be appropriate to a Christian tomb that this tented cave should be the pictorial counterpart of the darkness of the womb from which Christ came to life and light at Christmas, as he was to come to life and light from the darkness of another 'secret place', the tomb, at Easter. The light here is made of limpid and courageous colour: red, blue, pink, green and, above all, yellow.

45 Detail from pl. 42.

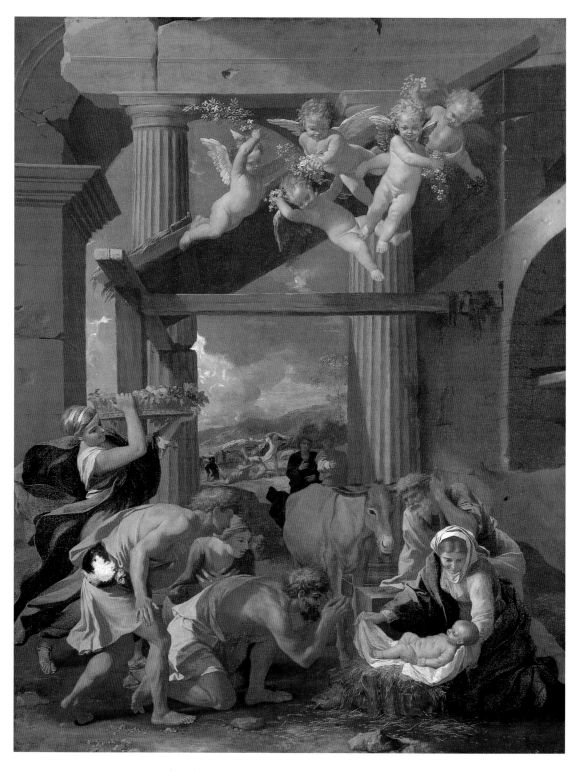

46　Poussin, *The Adoration of the Shepherds*, c.1634, National Gallery, London.

4

The Birth of the Redeemer

The same sacred writers provide texts for Christ's birth as for its annunciation. Once again, most of what we see in paintings comes from St Luke's Gospel: leisurely narrative rich in the circumstantial detail of times and places, human beings and angels, homely scenery and the momentous fulfilment of ancient prophecy. And once again, the radiance of St John's semi-abstract myth of the divine Word's descent into the world as light, his incarnation to redeem humanity from sin and darkness, suffuses Luke's more realistic tale.

St Luke made Christ's birth visible to the reader's inward eye – his swaddling clothes and the manger which had to serve as his cradle because the inn was full. He told of the shepherds, surprised out in the nearby fields by the divine glory illuminating the night sky: 'and the glory of the Lord shone round about them' (Luke 2.9). It chimes with the triumphantly visual conclusion of St John's mythic vision: 'the Word became flesh and dwelt among us and we beheld his glory' (John 1. 14). But with Luke, John's general 'we' is a particular group of shepherds, the glory a visible shining in which an angel appears, telling the shepherds of the birth of 'a Saviour, which is Christ the Lord', to be joined by 'a multitude of the heavenly host, praising God and saying, Glory to God in the highest, and on earth peace, goodwill towards men' (2. 13–14). The shepherds resolve:

> Let us now go even unto Bethlehem, and *see* this thing which has come to pass . . . And they came with haste, and found Mary, and Joseph, and the babe lying in the manger. And when they had *seen* it, they made known abroad the saying which was told them concerning this child.

The italics are put in to emphasise the point that this is a much more visual narrative, not only than John's myth, but also than Luke's previous Annunciation which consisted largely of dialogue. Combined with John's affirmation of the divine flesh, it gives painters plenty to do. The familial intimacy and country kindliness of Luke's story makes it a good subject for domestic pictures. And in fact none of the three pictures of it which we shall look at seems to have been painted for a church, but rather for somebody's home.

Poussin, *The Adoration of the Shepherds*

46

Here is a thoroughly organised and thought out painting by the man who said 'I have neglected nothing.' Attention to its discipline is the way to its delights.

The colouring is restrained. A warm, earth-red is the ground which supports subtle greys, and only the deep blue, left and right, is at full blast. Architecture takes up and organises most of the space. It comes in two kinds. There is the old, grand and labour-intensive. And there is recent, makeshift do-it-yourself. Two great fluted columns support a heavy entablature. Behind them is a massive arch and to the right of them a thick brick wall. But a crude modern shelter has been let by rough hands into these splendid ruins, and its lines cut right across the noble old buildings which support it. All this deliberate structure is not just formal control of the picture space. It is the religious poetry of the new life born into the old world which St John's Gospel and St Luke's had both suggested and which Poussin's predecessors had long made a feature of their Nativity paintings. As an inhabitant of seventeenth-century Rome, Poussin did not need to use these precedents as more than a cue, nor did he have to exert his own imagination. The city was dominated by the ruins of its greater, ancient days. In particular, the old Imperial Forum was now the Campo Vaccino – a cow pasture as well as a famous landscape with classical ruins.

47

49

The striking thing is that Poussin sets the Nativity in his own Rome with its battered and venerable ruins. He had the historical curiosity and awareness to avoid such anachronism. He had already taken pains to set ancient events, such as the death of Germanicus, in the pristine ancient settings which they would really have had. And when, ten years on, he painted a series on the sacraments, Roman ecclesiastical primacy suggested making the background to *Ordination* – Christ giving authority to Peter, the first Pope –

48

a careful reconstruction of first-century Rome. But here he deliberately put the birth of Christ into the Rome he knew and left it to the costumes of his characters to suggest antiquity. So he added to the traditional symbolic mixture of old and new, and mixed the timeless contemporaneity of myth with St Luke's sense of history.

The static poetry of the architecture makes a moral and religious point: for all its grandeur, it serves. It sets off the mobile energy of the people. The left-hand column is altruistic. It supports the beam of the cowshed and marks with its dignity a group of country people: two male shepherds and two women. From the woman with the magnificently blown blue cloak, holding aloft her present of a big winnowing basket (as used in pagan sacrificial ritual – a nicely syncretistic touch), full of luscious fruit, the figures drop down, one by one and all in worship, to the point of the praying hands of the shepherd who kneels lowest. Their bodies follow the delighted gazes of their eyes

47 Detail from pl. 46.

48 Poussin, *The Sacrament of Ordination* (detail), 1647, private collection, on loan to the National Gallery of Scotland, Edinburgh.

49 Poussin, *The Death of Germanicus*, 1626–8, Minneapolis Institute of Arts.

towards the more peaceful and settled group. This is the holy family, set off by the right-hand column, which rises clear in its lower half and without the interruption suffered by the one on the left. Its lines are emphasised by Joseph's yellow cloak.

And as the grand old pillars support the humans below, so the all-too-human carpentry supports the heavenly flight of angels. We are helped to believe in the airborneness of this light tornado of cherubs, swishing their garlands about, by the line and shadow of the shed's roof. The horizontal beam below the cherubs is left to distinguish them from the mortals below. But they are connected to them by the fluted column on the right, from which they seem to burst like champagne. In particular, this column connects the busy babies in the sky with the baby sleeping on earth. The little cupids, pagan angels of love, match the single baby below them. They do more than match. They chuck their garlands at him, looking down at him as rapturously as the lowly shepherds look across at him. All eyes are on the Word made flesh: to be precise, on the middle of his naked body which confirms his manhood. Placed low in the bottom right-hand corner of the picture, he is the focus of the ocular worship which it is all about. The groups of shepherds on the left and of angels above both form conglomerate arrows, the one with praying hands and the other with two pairs of feet making the arrows' tips. Both indicate the child adored by his delighted mother. He is

50

50 and 51 Details
from pl. 46.

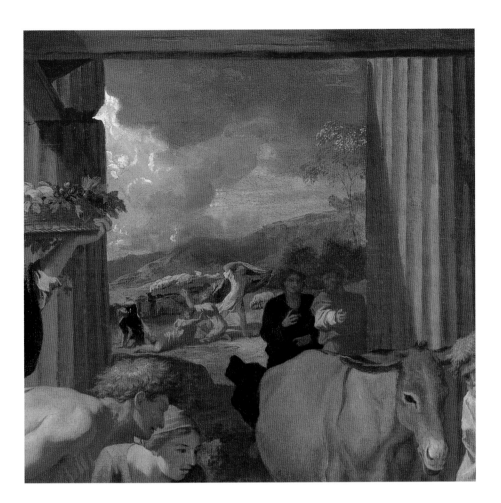

very big for a newborn baby. His size and his majestic repose make him like a young Jupiter – one of Poussin's favourite pagan themes – and indicate his status in forthright physical terms. The swaddling clothes mentioned by Luke are nowhere to be seen and he is as naked as the day.

The donkey's adoring eyes are on him too. The undulating back of this humble beast carries our eyes back into the far distance of the picture, which is as full of energetic action as the foreground. Our gaze travels past the two men approaching with urgent gestures, to the distant scene of the angel appearing to the astounded shepherds. This angel melts into the dawn light which the old column, self-denying as ever, reveals by the nick of decay in its joint. Far away are the flocks and the hills. We have been taken by the donkey into a whole extra picture and we realise another point, raised at the beginning. There is a path going through the columns, a road along which the people in the story can come from the far distance to Christ, who is so

thoroughly and availably among them that his home is by the common way. There is nothing between us spectators and him but a little rock on which only the proud and unbelieving, with their heads held high, might stumble: 'for they [unbelieving Israel] stumbled at that stumblingstone; as it is written, Behold I lay in Sion a stumblingstone and rock of offence: And whosoever believeth on him shall not be ashamed' (Romans 9. 32–3).

The availability of God is Poussin's theme. As with all important messages, just how it is delivered sets how it should be received. Poussin has worked carefully and *con brio*, with discipline and with delight. Each enables the other. Care and intellect, put to the service of John's incarnate Word and Luke's homely legend, mark every inch of his design. And just how gladly and festively this care is given, is something that can be seen in every detail which contributes to its unity.

Rembrandt, *The Adoration of the Shepherds*

Poussin and Rembrandt were contemporaries. Poussin was brought up in Normandy but made Rome his home, and he left it only once for a visit to Paris. Rembrandt never set foot outside Holland. The difference between living in southern and northern Europe marks their two Nativities. In one, sunburnt and lightly clad bodies move in daylight with the sprightly ease of dancers. There is blue. In the other, heavily clothed figures huddle in the chilly dark. Yet it is the same subject and each draws on the same Gospel texts and uses a restricted basic range of earth-colours to interpret the humble scene.

St John's myth of the descent of the divine light appealed strongly to Rembrandt as a poet of the light and the dark, an artist as happy to etch or draw as to paint. St Luke's story of peasants coming to the manger appealed to him as a dedicated recorder of ordinary folk, gathered at home or in the street. He also liked barns and often drew them on his walks into the country around Amsterdam. Luke's manger implies a barn, and the Dutch put up bigger and better barns than the ramshackle Italian shed in Poussin's picture.

Shortly before Rembrandt painted this picture he had done a version of the same scene for the Prince of Orange. From St John he had taken the image of the Christ child himself being the light, illuminating St Luke's excited shepherds. It was a bigger picture, designed to go with a grand series which he had done a decade earlier. It is bustling and baroque in a cheerful, folksy way. In this smaller, second version, he had some rather different religious ideas which he wanted to work out: ideas about light and dark, God and people, and how in each of these opposites there was a belonging-together. His preoccupation with these well-used Christian ideas can be deduced from the manner of his working, as recovered by recent analysis. It

52 Rembrandt, *The Adoration of the Shepherds*, 1646, National Gallery, London.

53 Rembrandt, *The Adoration of the Shepherds*, 1646, Alte Pinakothek, Munich.

is a difficult picture to read because it combines obscurity and dazzle so realistically that we have to train our eyes to see things, as if we were actually there. The second cow, the third infant-in-arms and the face looking in through a window at the back do not disclose themselves instantly.

Rembrandt took a canvas about twenty-six inches high and twenty-two inches broad (65 by 55 centimetres) and covered it with brown umber paint – a warm earth-colour. Poussin had done much the same. But when it had dried, he did something else and put a simple layer of pure black over the top half and sides. A modern abstract painter might feel inclined to leave it there, a satisfactory religious painting as it was and a fine image of St John's theme of light shining in darkness. But Rembrandt's Christianity was not abstract mysticism. It was St Luke's sort of biblical humanism, full of people and their goings on. So he had only begun.

His next step was to work on the dark figure of the kneeling shepherd with his back to us. He made many careful adjustments to him. So this humble man was Rembrandt's own way into his picture. He can aptly be ours too. Because he is the nearest figure to us, because he is almost a silhouette and because he is the only person whose face we cannot see, we can, as it were,

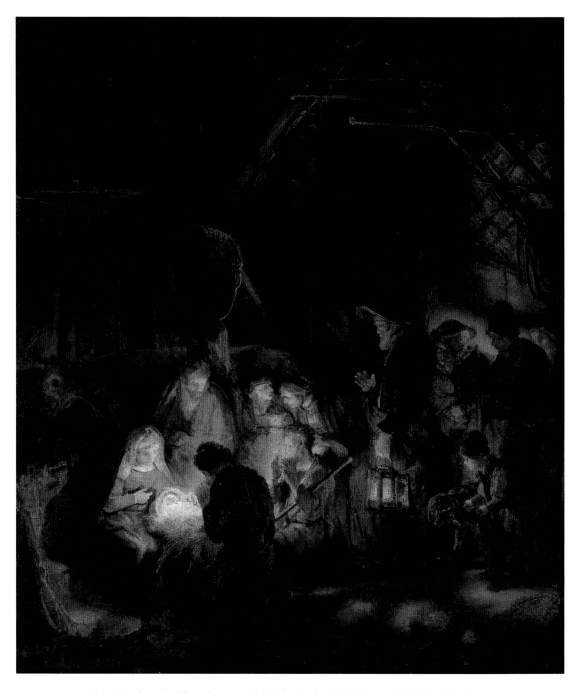

54 Rembrandt, *The Adoration of the Shepherds*, 1646, National Gallery, London.

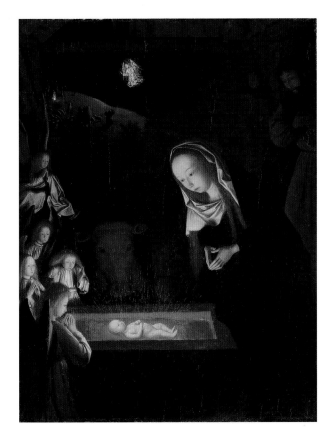

55 Geertgen Tot Sint Jans, *The Nativity, at Night*, c.1480–90, National Gallery, London.

slip into him. Or, more circumspectly, we might advance into the space to his left, indicated by the line of his stick on the floor and the well lit broom at the picture's edge. He is also very important to his neighbours in the picture, for Rembrandt did not work on him in isolation. His brushwork consisted of modest dabs, and with these he painted the other figures in this group including the bright baby, going right up to the edge of our dark shepherd's body and stopping there. This obscure worshipper is the gathering point for the worshippers inside the picture as well as outside. It is a bold thought, to make so much depend on this unimportant countryman in a scene to which the Christ child is surely central. The care and deliberation with which this apparent displacement of the religious centre is worked out and balanced with the traditional doctrinal centrality of Christ will emerge with the exploration of the great theme of light.

It was a stock-in-trade of Nativity pictures, with Christmas set near the dark winter solstice, to follow St John and make the child Jesus the source of the light, his little body a miraculous lantern – as in Geertgen Tot Sint Jans's endearing, if mildly hysterical, panel; and Rembrandt himself had

55

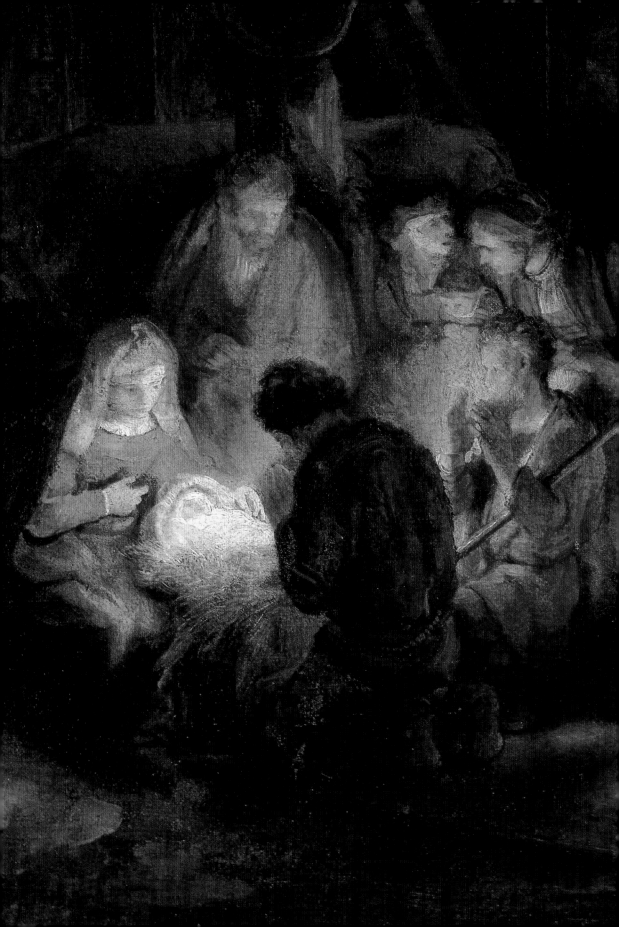

recently done that for the Stadtholder. Here too the baby is far the brightest figure in the picture. St Luke's swaddling clothes, which Poussin omitted, are restored to warm the child and refract the light. Refract it – for if we peer attentively into the dazzle, we discover that the child is not the light's only source. His own left cheek is a little brighter than his right, indicating strong light falling upon him rather than shining from him. The stooping figure of Joseph is clearly lit from somewhere very near his bent left elbow. This all-important point, the source of brilliant light, is hidden from us by the silhouette of the kneeling shepherd. Careful inspection of his praying hand reveals that each finger is outlined in pink: the usual effect of holding one's hand right up against intense light.* And that is as near as we can get to the invisible light source. But it is enough to show that the light of Christ as 'God with us' is something communal, with a source somewhere in the space between the shining child and the breast of his dark worshipper.

Where can such a notion have come from? In St John's Gospel Christ himself is the light, and in St Luke's glory and radiance are associated with the shepherds in the fields rather than the baby in the manger ('the glory of the Lord shone round about them: and they were sore afraid'). Neither of these quite fits the placing of light in this picture, though both may have contributed to it by association. We have to look further – but not at all far.

Across the street from Rembrandt's studio lived Menasseh ben Israel. He was prominent, and a figure of some dispute, among the Jews of Amsterdam, who lived un-ghettoised in that tolerant Christian city. He was a rabbi, a publisher and a prodigiously learned scholar. Rembrandt had certainly consulted him ten years before when he was painting *Belshazzar's Feast*. Being ignorant of Hebrew (his education had been in the pagan classics), he wanted to know how to do the mysterious writing on the wall which, in the story, warns the king of his downfall. This was a problem, because the story tells how neither Belshazzar nor his wizards could read it. It took the Jewish wiseman Daniel to do so. Why the difficulty? Rembrandt's answer is to arrange the characters written from top to bottom instead of from right to left, with minor errors betraying his lack of

57 Rembrandt, *Belshazzar's Feast* (detail), *c*.1636–8, National Gallery, London.

* Rembrandt also uses it in *The Denial of St Peter* in the Rijksmuseum, Amsterdam.

56 Detail from pl. 54.

mastery of them. They appear in the same arrangement in a book by Menasseh called *De Termino Vitae*. It was published later than Rembrandt's painting, which suggests that the painter got the solution to his problem from the scholar's mouth. Ten years after the painting of this Nativity, Rembrandt etched illustrations for a book by Menasseh about the coming of the Messiah ('Christ', in Greek) called *Piedra Gloriosa*, the glorious stone. Menasseh then associated the Messiah, whose coming he believed to be imminent, with mysterious stones mentioned in the Bible. These included Isaiah's stumbling stone (which St Paul picked up for Christian purposes and Poussin seems to have used in his Nativity), the stone which was Jacob's pillow and the stone with which David killed Goliath. But all that lay in the future when Menasseh's restless messianic obsession got out of hand and became egregious and eccentric. If Rembrandt had asked him for a Jewish understanding of the presence of God among humanity and the coming of the Messiah at the time when he was working on his Nativity, he would probably have got a more spacious and orthodox answer – and one that appealed to his preoccupation with *chiaroscuro*. Throughout rabbinic lore the radiant light of the *shekhinah* (we saw it earlier in Tiepolo's altar sketch – p. 6) was the means of God's dwelling among us. It is numinously – glowingly – present between husband and wife, or when a few are gathered for prayer, or when one reads the Bible. There may be a trace of it in Christ's saying that 'where two or three are gathered together in my name, there am I in the midst of them' (Matthew 18. 20). Some believed it to be a real, divinely made physical light, while others thought it spiritual and internal – an endemic argument in religious affairs. The great twelfth-century poet Judah Halevi, for example, thought that it was absent from his own times but would return with the coming of the Messiah.

The divine nature of the brightest light in our picture can be confirmed by comparing it with the artificial lights there. The most obvious is the open lantern held by the grand old shepherd wearing a hat. There is also a hidden lantern at the back on the right. The divine light is far more brilliant than either of these. It is also common, in the sense of being shared. It illuminates the seven people clustered around it, whom its lustre makes into an intimate group, united in gazing at the shining child in the hay. The dark shepherd serves as a sort of lampshade for the spectator, set at the centre of the group and shielding us from the full glare. Rembrandt had made a similar use of the contrast between artificial and spiritual light five years before in his double portrait of *The Mennonite Preacher Anslo and his Wife*, now in Berlin. The candle in the stick beside his Bible is extinguished, but the pages of the Bible glow with their own light and this, along with the daylight from the invisible window, illuminates Anslo and his wife as they study and discuss the scriptures together in good, domestic Mennonite style. It could be an instance of the presence of the *shekhinah* when the Bible is read, and another of Rembrandt's debts to his friend Menasseh.

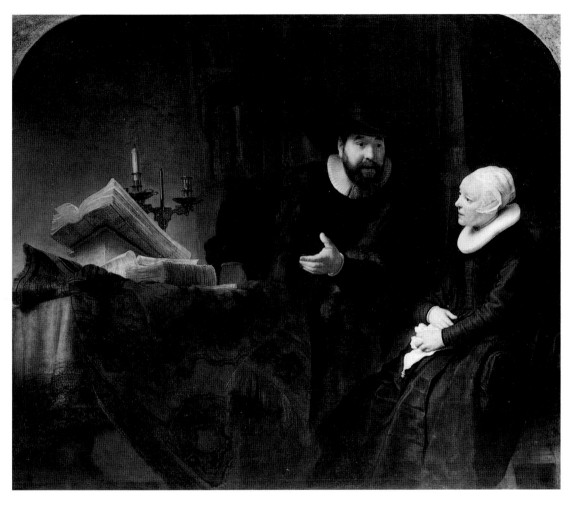

58 Rembrandt, *The Mennonite Preacher Anslo and his Wife*, 1641, Gemäldegalerie, Berlin.

To the right of the holy family are people whom we have not yet scruti-
nised. Behind the well-lit shepherd with raised hands, the light falls on a
little wall. Two women are leaning over it, one of them talking volubly. 60
Between them they hold a toddler in a cap, who gazes at Jesus with the curi-
osity which the very young reserve for their own kind. They are very like the
trio in a sketch by Rembrandt in the British Museum, dated at the same time. 59
These three are looking out over the half-door of their home at the brilliant
star-lantern hung on a pole and held by the heavily shaded boy. The gang of
rough kids to which he belongs is exploiting the popular winter commemo-
ration of Epiphany, the visit of the star-led kings to the Christ child which
is told in St Matthew's Gospel. The men on the right look apprehensive of
their touting. As often with Rembrandt, a dog is hanging about. The

59 Rembrandt, *The Star of the Kings*, 1645–7, British Museum, London.

60 Detail from pl. 54.

dazzling light, the dark figure and, above all, the two women with the child, all connect it with our painting where Rembrandt has provided a wall especially to accommodate them. At the base of this connection is Rembrandt's religious feeling for ordinary human reality, his conviction that peoples' goings-on in the street participate in the divine. He takes the custom seriously. Among these all-too-human types, the glory glows.

We get more of this interplay of people and light, so much more pervasive than in Lippi's *Annunciation* with its little golden dots, as our eyes move to the right. The old shepherd's open lantern throws a warm, mundane light on his hands and face, and casts a beautiful radiating pattern on the earth floor. It picks out the boy in a tall cap who is controlling the disagreeable looking dog. It glows softly on the fourth child, carried in from the right by the woman talking to the depressed person in a tall hat. The face of the woman with the child is illuminated by the third and softest of the light sources: an unseen lantern, probably carried by the person whose face we see on the extreme right.

Light and company enhance one another in a series, too informal to be called a procession, making a crescendo from right to left – the direction

62 Detail from pl. 54.

taken by the visitors. Light and company are great benefits in a wintery world and the picture endears itself by presenting them, each enhancing the other. There is another much-needed benefit: shelter. It belongs, obviously enough, to the top half of the picture. Its structure is worth noticing. Once again, we start with the dark, kneeling shepherd. Above him and Joseph and two dim cows, there rises the post which supports the ridge of the barn's roof. A strut branches from it to the right to steady the roof's side. The same point is intersected by a ladder to the hay loft. At this crucial point, where the apex of the bright triangle of people below and the downward apex of the dark triangle of the shelter above coincide, a merry flight of naked cherubs would be called for in Italy. That is what Poussin did, and Rembrandt's Flemish neighbour Rubens usually considered it the thing to do, even in the chilly north. Rembrandt thought otherwise. The light of the old shepherd's lantern reveals a large rush basket, an ordinary thing for carrying tools and provender, hung on the post. It has something of the outline of a human head with its handles resembling ears, and the shadow of the woman crouching over the wall is cast over it. Its quasi-human aspect suggests that a certain symbolism is attached to this decidedly unsymbolic and practical object. Humility and ordinariness as the dwelling-place of the divine is Rembrandt's theme, inherent in every modest brush-stroke, in the careful placing of lights and of muffled figures. The exalted placing of this workaday thing is its crowning instance.

62

63
64

65

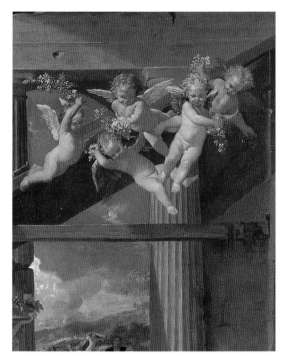

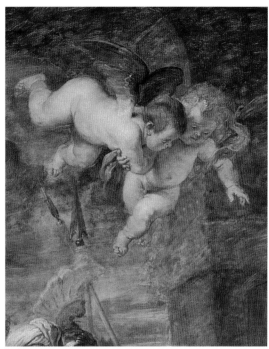

63 (*above left*) Detail from pl. 46.

64 (*above right*) Rubens, *Adoration of the Magi* (detail), 1634, Kings College Chapel, Cambridge.

65 Detail from pl. 54.

Piero della Francesca, *The Nativity*

The humility and availability of God incarnate in Christ, the religious themes which governed Poussin's Nativity and Rembrandt's for all their differences, attain a calm lucidity in Piero's panel which calls for the lightest commentary. Here is no complex interplay of lights but a broad and even morning; no architecture planned with pondered intellect but a delapidated, skewed shed which just supports a flimsy roof. For all its imposing size, this seems to have been a picture for a room in a house, like the previous two. Piero painted it in his old age for the home in Borgo San Sepolcro of his nephew Francesco and his bride Laudomia. It was in her richly furnished chamber when she died, a widow, eighteen years later. He was a citizen of Borgo San Sepolcro; she came from the small town of Montevarchi in the Arno valley. So he puts a valley on the left and the little town of Bethlehem on the right. In their house, domestic music making found its counterpart in the group on the left, domestic conversations in the group on the right. And in between the painted and the actual there is that most domestic of Christian mysteries, the affectionate exchange between a child reaching for his mother and a mother contemplating her child with fond and reverent contentment. It could hardly be simpler or more open.

Nor could the composition of the picture. It is structured by two halvings. The group of musical angels reaches the picture's vertical axis with the right-hand angel's imposing left leg. The horizontal axis runs across the belt of his tunic. Having set these easy axes, Piero softens and plays with them a little. The shed is slightly askew from the picture plane, so the division of the smooth and sandy ground into two parts is diagonal. Where the angels stand and the baby lies, grass and plants grow. Mary kneels on bare earth. It is all enclosed by a relaxed and leisurely line which marks its left-hand edge, turns, scrapes along the bottom of the picture until it drops below it, then reappears and turns upwards in the right-hand corner. It is like a cupped hand, reached down to sustain the happy action within it. The looseness of its path, as if it were drawn with a dangled string, is perhaps the abstract key to this accomplished piece of disciplined letting-go. Only a master draughtsman could make a line like that. Piero had been able to do it since his *Baptism* twenty years earlier, but here the curve which marks out the ground is softer and more dispersed. Its gently protective quality is confirmed by a similarly dropping curve which goes the other way: Mary's cloak, which in terms of colour is the rich climax of a symphony of blues to the left, folds as it reaches the ground and then runs along it, crossing the division of the ground into bare and fertile parts, to provide a bed for her baby. The divine humility is realised literally. Incarnate divinity lies naked on the ground (Latin *humus*). It was a trope which had often been used before. But Piero modifies it tenderly. Mary's maternal care provides the comfort of her robe.

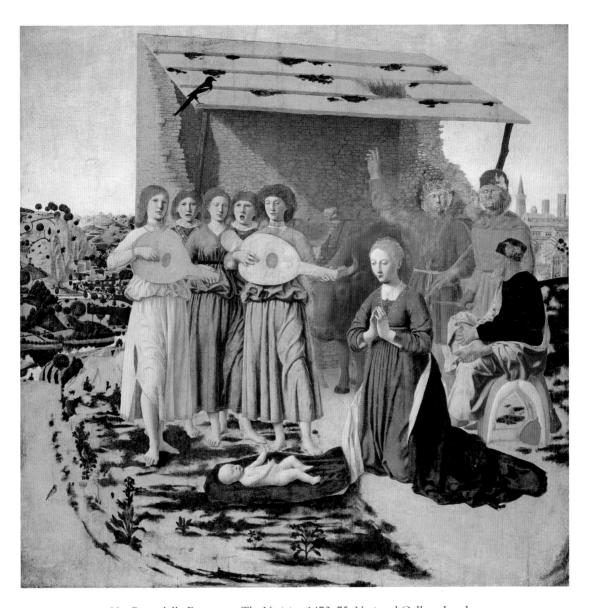

66 Piero della Francesca, *The Nativity*, 1470–75, National Gallery, London.

67 Alesso Baldovinetti,
The Nativity, 1460–62,
SS Annunziata, Florence.

68 Hugo van der Goes,
The Nativity, c.1475,
Uffizi, Florence.

Piero's groundedness, his way of placing figures solidly and precisely on the earth, distinguishes even his angels. Conventionally being winged, celestial creatures, in most Nativities some of them at least are shown flying. In
Baldovinetti's fresco in the cloister of the Annunziata in Florence, generally agreed to be a source for Piero's, they are all airborne. In Hugo van der Goes's
Nativity, which arrived in Florence after 1475, when Piero was probably painting his, some have landed to kneel around the child on the earth while
others worship in flight. But Piero's are wingless, and all stand on the ground as only Piero and a few great sculptors could make figures stand: with an assured monumentality which combines gravity and grace. They are set with

67

68

69

69 Detail from pl. 66.

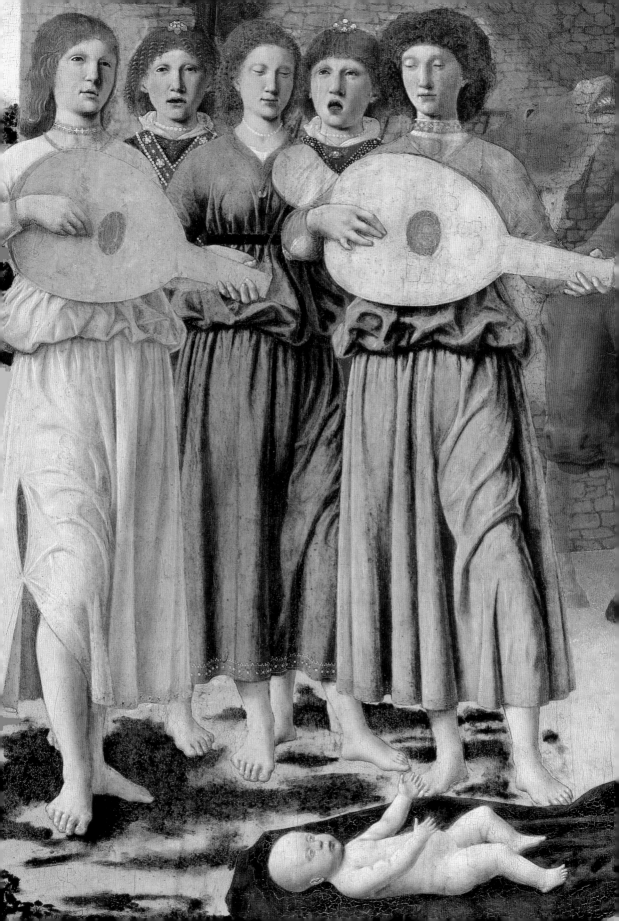

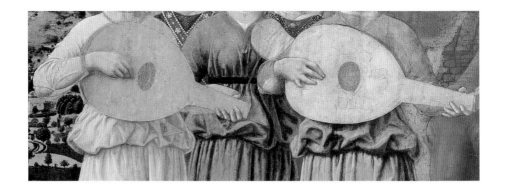

his characteristic sense of order in a square formation of two, one and two. The hands of the lute players at the front are perfectly observed. The singers at the back are joined by the raucous braying of the donkey. And the problem of representing music in the obstinate silence of a picture is alleviated by the rhythmical pattern of the angels' feet, which is music visible.

70

71

The music on the left is matched by the conversation on the right. One 74 of the shepherds is telling Joseph about their extraordinary experience out in the fields. His narrative has just reached the point of the appearance of the angels in the sky, which he indicates with his raised right arm and hand. His colleague is dumbstruck, keeps his wary eyes on the heavens for further wonders, and grips his staff more tightly. Joseph listens attentively, seated on the saddle which had brought his pregnant fiancée to Bethlehem. His water bottle is tipped against it. The superb delineation of his hands and the travelsore foot resting on his knee show Piero's mastery of the seated, as well as the standing, figure.

70–74 Details from pl. 66.

Our eyes come back, as they should, to Mary. Her contemplative beauty realises the verse with which Luke rounded off his nativity story: 'But Mary kept all these things, and pondered them in her heart' (2. 19). And they return to her baby, raising his little arms to her in defenceless need. When his redemptive mission is over he will again lie naked on the ground before her, dead and awaiting burial. We notice, finally, three birds. On the left are two goldfinches, the bright little birds bearing red marks on their heads which 72 associated them with Christ's passion. An ominous single magpie perches on 73 the shed roof. These are light hints of terrible things to come. In Piero's great *Baptism of Christ*, painted twenty years before, the fatal intimations of sacrifice are stronger.

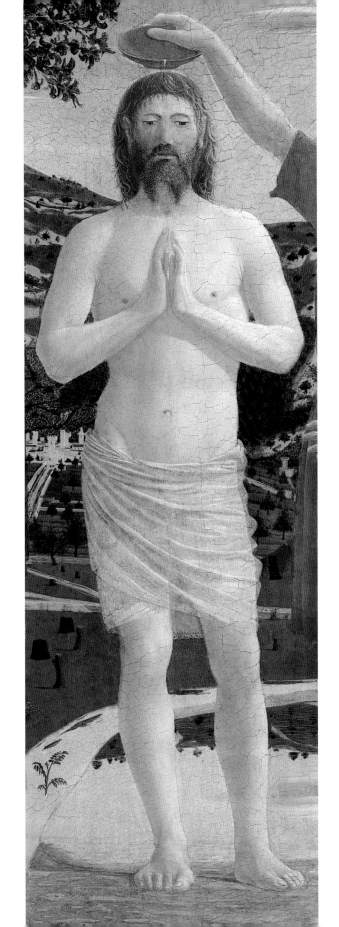

5

The Sacrificial Body

For Christian painting, the rediscovery of Greek and Roman sculpture in the Renaissance was a momentous leap forward. Its importance for Christian art is comparable to the importance for Christian life and thought of St Paul's establishment of sacramentally based Gentile churches, and the subsequent emergence of the doctrine of the Incarnation. The classical Renaissance opened a cornucopia of resources for the visual representation of God's incarnation in Christ's body. Apollo, the pagan god of light, had been taken into Christ by early Christian painters and teachers. A poem by Rilke, 'Archaic Torso of Apollo', is therefore, and not suprisingly, a wonderful commentary on one of the great works of Christian Renaissance painting, Piero della Francesca's *The Baptism of Christ* (c.1460). Rilke's statue has become headless

> and yet his torso
> is still suffused with brilliance from inside,
> like a lamp, in which his gaze, now turned to low,
>
> gleams in all its power. Otherwise
> the curved breast could not dazzle so, nor could
> a smile run through the placid hips and thighs.

> trans. Stephen Mitchell (Picador Classics, 1987)

Piero della Francesca, *The Baptism of Christ*

Piero painted it for the Camaldolese monks in his native town of Borgo San Sepolcro. They were hermits given to individual contemplation in their cells. But they met together for Mass, and this panel was painted to go over the altar of the chapel of St John the Baptist in their communal church. One sacrament, Baptism, is shown at the moment of its foundation, in a picture to go over an altar and so preside over the other sacrament, the Mass. The sacred body in which God dwells, central to both sacraments, is placed with exact centrality in broad daylight. Christ's eyes are introspective. It is the solid grace of his luminous body that addresses us. He stands apart, naked in the open air which surrounds and isolates him. All the other bodies overlap

76

75

75 Detail from pl. 76.

one way or another. His is separate, holy and being washed for his holy work of redemption as victims were once washed for the great exchange of sacrifice. By sacrificial death the life of the isolated one becomes the life of the many, the foundation of a new community or integrated plurality – the social body of the next chapter. Christian baptism is a separation, a ritual death which is a passing-over into new life. So Christ stands there, defencelessly and purely present. He is naked, apart from his loincloth, as he will be when his sacrifice is consummated on the cross: that is the destiny which his unprotected pose must bring to the spectator's mind and which we may well suppose to be the object of Christ's own inward gaze, as recollected and absorbed as that of any Camaldolese hermit in his cell or at the altar.

This is a monumentally vertical picture. Everyone in it is standing, and the axis of it all is Christ. For all his deliberate isolation he contains and reconciles the two contrasting kinds of presence which flank him to left and right.

On the left, all is presence in its mode of stillness. There are two trees. The nearest is solidly rooted in the ground. Its white trunk corresponds to the colour of Christ's body. Its leaves turn downwards and make a canopy over the central action of such dignity as to suggest a metaphor of the invisible, presiding Deity whose declaration 'Thou art my beloved Son, in whom I am well pleased' is a text which defies more direct pictorial representation than the protective majesty of this tree. Behind this tree there is another: similar, but with a darker trunk and leaves which grow some upwards and some downwards. Presence as stillness is most impressive in the figures of the three angels. Rapt and column-like as caryatids in classical architecture, more stable than the angels in the Wilton Diptych, their settled concord is like that of the three Graces in classical tradition.

On the right, presence is in the mode of action. The leaves of the two trees there have a bristly upward growth. The people move busily. The tones of the body of the man pulling on his shirt correspond to those of Christ's body. The Son of God is of one substance, flesh, with humanity. This statement made by colour, and the clear implication that this man has just been baptized, make up a reminder of the communality of the sacrament beyond the individual Christ. The man's back makes a bowed curve which is continued along the line of St John's right arm which does the baptizing. St John's left arm makes a diagonal and, with the parted fingers of his hand and the other diagonal of his left lower leg, tells of his tense concentration on his work. Behind the bending man are four Pharisees and Sadducees – according to Matthew 3.7, present at John's baptisms and denounced by him. They are heavily clothed and hatted. No question of their being baptized! They are active Jewish theologians, busy questioning the meaning and propriety of St John's activity. One of them points upwards at the dove with strenuous surprise.

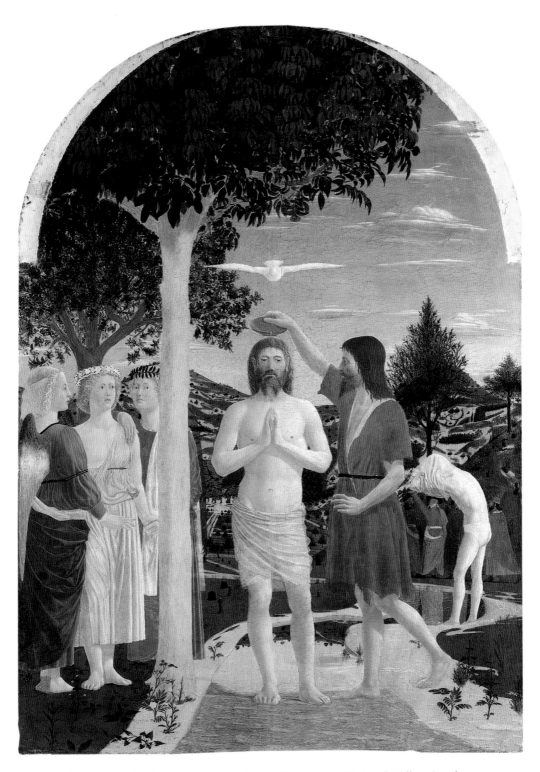

76 Piero della Francesca, *The Baptism of Christ*, 1450s, National Gallery, London.

77

That dove is beautifully shaped to match the shapes of the clouds in the sky. This gives stillness and calm to the energy of its hovering. Here is a mixture of activity (the characteristic of Tiepolo's and Poussin's doves) and rest. This combination is strong in Christ's body, in which the two are reconciled. Christ's head, chest, arms and hands are set in the stillness of prayer – the Camaldolese ideal. Below them, his hips are asymmetrically skewed – a suggestion of movement emphasised by the darkness of the background. It enables the walking tilt of his legs as he advances towards us. Yet the soles of his feet are set steadily in the stream. He stands. And he moves. Which? Both.

> At the still point of the turning world . . .
> at the still point, there the dance is,
> But neither arrest nor movement.

<div align="right">T. S. Eliot, 'Burnt Norton' II (1935)</div>

78

Christ's feet are placed where the water of the stream changes from being a calm mirror of the hills above to a shallowness which lets us see its stony bed. According to the Gospels it was as Jesus came up from the water, in that crossing-over, that God declared him to be his only Son. It is a moment of definition, but also a moment of transition. In terms of the past, it recapitulates Israel's exodus. In terms of the future, it prophesies Christ's own passing from death to life. Although he is now as naked as he will be at his death,

77 and 78 Details from pl. 76.

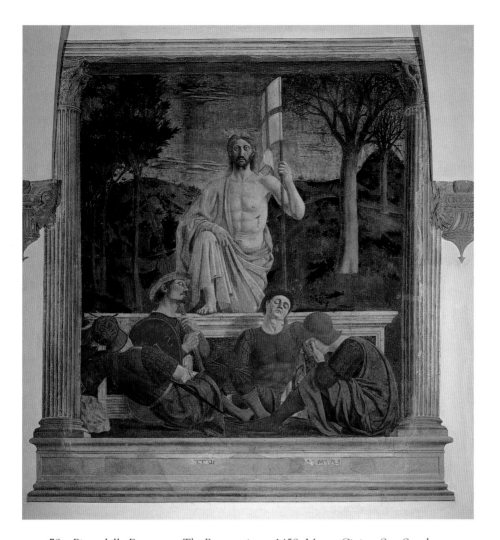

79 Piero della Francesca, *The Resurrection*, c.1458, Museo Civico, San Sepolcro.

to which his baptism commits him, the pink cloak, which he has left with the angel nearest to him, will clothe his resurrected body as he rises omnipotent from his tomb in Piero's fresco in the Town Hall at Borgo San Sepolcro, his sacrifice complete.

79

* * *

The beginning of Christ's redemptive working life corresponds to its end, baptism to resurrection. This is a sign that we are touching the symmetrically patterned fabric of myth, where 'in the beginning' matches 'in the end'. But the Gospels are full of in-between incidents waiting for their painters:

miracles of all sorts, arguments, pictorially vivid parables, adventures on sea and land. Altarpieces show us less of them and more of the beginning and end events – annunciations, nativities, madonnas, or crucifixions, resurrections and the final joy of heaven – where all is held firm in the structure of completion. When we do see the events in between, it is often in response to a special commission. Or they are on the panels below or behind the main image, and so subsidiary to it. But when Christianity escapes from churches into houses, they may stand on their own. Pictures for private devotion and contemplation could show whatever the patrons chose. They could be conventional and order yet another Madonna and Child, or they could choose a less depicted gospel incident which appealed to them because it told a story about the intermediate hesitations, agonies and uncertainties of ordinary life. In the gospel accounts of Christ's last days, these stories are connected to one another in a more overtly continuous way than in their accounts of his previous ministry. As we turn to pictures of some of these incidents, we shall therefore be in a sequential and unified stream of narrative. Incidents will be connected to one another by a story-line with tragic inevitablity.

Mantegna and Bellini, *The Agony in the Garden*

Christ's agony in the garden of Gethsemane on the night before his death is just such a scene of intermediate tension and conflict, set in an unrolling plot. In the National Gallery in London there are twin versions of it according to two brothers in law and in art: Andrea Mantegna and Giovanni Bellini. As with the New Testament Gospels themselves, we can be sure that one maker is using the other's work, but cannot be entirely sure who is following whom. But the undoubted connection between the two pictures gives a fine, firm ground for comparison which lets us see imaginations at work and poetry in the making. Neither is the sole true version. Each is rich in the truths of a particular imagination.

We are at Christ's Rubicon, the crossing that he must still choose to make, although he had assented to it by implication in his baptism. As then, momentous words that we cannot hear are spoken: not his prayer to be spared, 'Let this cup pass from me', nor his chiding of his sleeping disciples, nor his final acceptance in the spirit of his mother at the Annunciation, 'Thy will be done.' Again, the body, by means of which it is all done, must tell it all.

With the same intensity which we should bring to a picture of such a crisis, Christ in both pictures gazes at his own destiny. It confronts him in visionary images, fears made visible. Bellini sticks to the Gospels and has the metaphorical cup of affliction proffered by a floating, diaphanous cherub. Mantegna goes further. Five solid and aggressive cherubs lean over the cloud on which they very much stand, to push the instruments of his death at

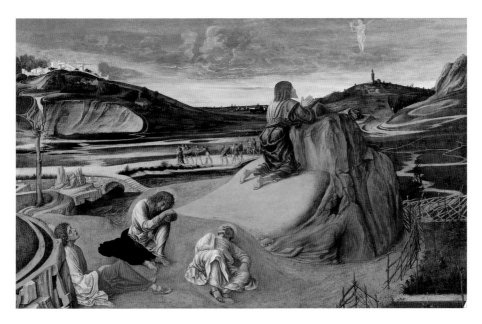

80 Giovanni Bellini, *The Agony in the Garden*, c.1460, National Gallery, London.

81 Mantegna, *The Agony in the Garden*, c.1460, National Gallery, London.

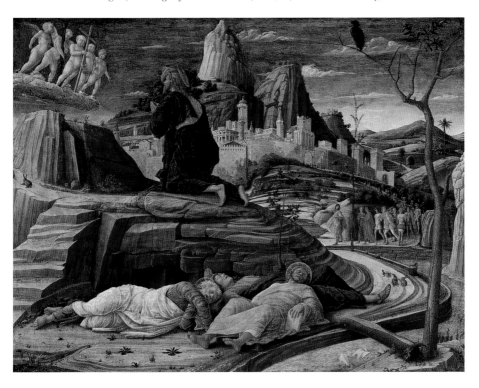

82 Detail from pl. 81. 83 Detail from pl. 80.

him. In both pictures, the earthly bringers of Christ's fate, Judas the betrayer with his posse, are in the background. They, the incidental means of it, are only accessory to heaven's will. Bellini has them emerging from beyond the kneeling figure of Christ: a contiguity with the outline of his lower back suggests their auxiliary participation in his drama. He could see them from his rocky eminence if he cared to. Mantegna has them quite separate from him and advancing more from behind. The shock of encounter will be the sharper.

Mantegna is a grim painter, not least in his obsessive love of stone. He imagines the scene accordingly. Altars, being for sacrifice, were made of stone. And in the natural order, the rocks had been there all the time. Animals and vegetables came and went, their bodies being quickly perishable. But the rocks had stood from creation and the year dot. Mantegna's *Crucifixion* in the Louvre is an immolation set on a stone stage which looks as if it had been hewn flat by God for this very purpose at the foundation of the world. Dreadful sockets have already been cut in it for crucifixions past or yet to come. Here in Gethsemane, the rock on which Christ kneels seems to have been turned on some cosmic lathe by unimaginable tornadoes. It has steps, half natural and half artificial, and a rough but unmistakable altar. What immortal hand or eye framed such a thing? It has been waiting for this day, as things do in mythical time, for millennia.

This is an unusual altar in another way. It stands at a unique point in time. The Last Supper, when Jesus foresaw his death and called the bread and wine his body and blood, has just happened. The cross, on which his body will be broken and his blood spilled, impends. Gethsemane links the two in a soli-

84

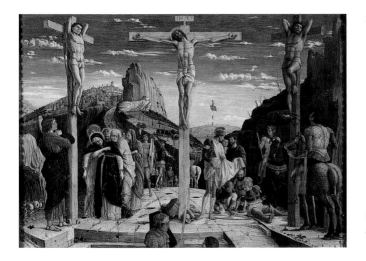

84 Mantegna, *The Crucifixion*, 1506, Louvre, Paris.

85 (*below*) Van Eyck, *The Adoration of the Mystic Lamb*, 1432, St Bavo, Ghent.

tary and agonised crisis, resolved by Jesus' lonely assent. Its association with the Mass is marked by the group of cherubs. They challenge Jesus with the cruel implements of his coming immolation: the scourging pillar, the cross, the spear and the sponge on a cane. In the minds of people of Mantegna's time, these were firmly associated with the Mass. We can see them in the greatest of eucharistic paintings, Van Eyck's Ghent altarpiece, where angels 85 hold them around the central altar. Van Eyck was working in mythical time, so, quite regardless of historical time, he made the saints of all ages present

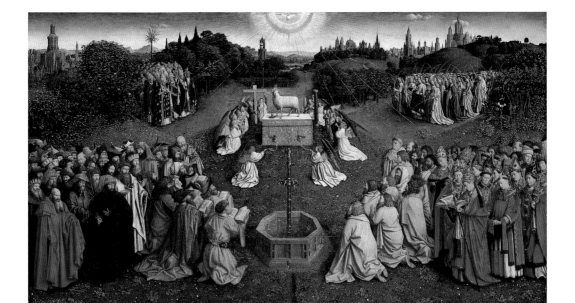

in his masterpiece. And, for the same reason, Christ could be on the altar as at a celebration of Mass – but symbolically, as the sacrificial passover lamb. Mantegna, however, works in historical time. At the particular moment of history which he shows, Christ's body cannot be among the instruments, or wounded by them, or set on the altar. It has to be apart from the instruments, still free to go on or to retreat, and below the altar. We are looking at a sort of proto-Mass at a bare altar (no bread, no cup) because the events which brought the Mass into being are still momentously and critically in train. They are not yet complete. It is remarkable and appropriate that we have to be very precise indeed about time and the order of events – as precise as any detective – to get Mantegna's symbolism right.

Bellini imitated Mantegna's way with rocks, but his heart was not so much in it. On the left of his picture, a circular rock is splitting in a rather unconvincing way, like wood losing its bark. There is a rocky cliff in the left background, but its curves are entirely natural and it is surrounded by the footpaths which meander everywhere. People have walked all over Bellini's landscape. In Mantegna's there is only one, fateful path. Bellini has his version of Mantegna's altar, but it is natural enough and bears the gentle signs of long weathering rather than the dire intimations of Mantegna's primal carving. Also, and tellingly, this altar is below the skyline. In fact, it is not an altar at all. We have only thought it to be one because we are still under the strong influence of Mantegna. It is that much less important article of ecclesiatical and domestic furniture, the *prie dieu* or prayer desk. Jesus leans his elbows on it. You don't lean on an altar. Nor does Jesus have to kneel on rock. Bellini has provided a cushion of earth. The little angel brings him the chalice of his destiny, complete with its paten on top, as if he were a priest at daily Mass.

As well as being a quieter picture, Bellini's is more optimistic too. On this lovely evening, with the terrors of the nocturnal trial still to come, the clouds which hover over Jesus have pink and golden linings. Light bathes the little town on the skyline. It is a far cry from Mantegna's Jerusalem, crammed with pompous heathen monuments and girt by its war-battered and patched up wall. Bellini allows Jesus' head to escape from the lassitude and danger below the horizon into the tender sky and air. Mantegna kept it below the horizon, trapped between the ghastly rock behind (and the black vulture) and the instruments of torture before. He enveloped it with dark trees and seemingly clamped a rock to its brow. For Bellini, God's favourite medium, the material favoured by divinity for artistic work, was not rock but light – the light of the ordinary heavens. The religious significance of this steals over us gently. It dawns on us that this is not an image of agony so much as of reconciliation – Jesus to his Father's will, humanity to God – even of peace. And that, after all, is what sacrifice is for and what all its stress and violence is in aid of. Bellini, dwelling on that end while Mantegna stuck with

86
87

88

94

86 (*above left*) Detail from pl. 80.

87 and 88 Details from pl. 81.

the terrible means, offers religion not as tragedy but as the divine comedy in which every hurt will be healed in the end and all will be bathed in Christ's light. The Bible tells him so, and it is not necessarily serious to be menacing and grim, even in religion. For Bellini, the reconciliation being achieved by Christ's work transcends its pain.

The way to the sacrifice was through judicial process. Ritual and all its mythology were subjected to an ordeal in historical time. First, Jesus was brought before the Jewish High Priest at night. He convicted Jesus of blasphemy, but was unable to impose a death sentence. So he sent Jesus on to the Roman governor Pilate, who sealed his fate. These scenes present human injustice as responsible for Christ's death, rather than divine will. But there is no contradiction. Both work to the same end. There is, rather, irony. And of that the Gospel writers were masters, particularly John. The two trial scenes are occasions for sounding the ambiguous depths of human nature and institutions and the seamier side of sacrifice.

Honthorst, *Christ before the High Priest*

A nocturnal trial was a good subject for Honthorst, a Dutchman exploring Caravaggio's stark lighting effects in Rome, where they were on view, in the early seventeenth century. Using the light of a single candle, centrally placed, Honthorst achieved an image of haunting power and simplicity. The verse illustrated is John 18. 19: 'The high priest then asked Jesus of his disciples, and of his doctrine.' From his wide-open eyes he gazes at Jesus over the tip of his raised finger. It is brightly lit, as is the book of the law below which gives him a legal armoury of chapters and verses for his interrogation. Jesus listens to him with serious but easy attention, his lips parted for his calm reply: 'I spake openly to the world . . . in secret have I said nothing. Why askest thou me?' The white robe, which follows the relaxed pose of his body and is rich with the play of light, is falling from his shoulder, but his bound hands do not move to adjust it. Honthorst's contrast between the High Priest's volubility and the quietness of his prisoner will remind readers of Dostoyevsky of his fable of the Grand Inquisitor in *The Brothers Karamazov*. There Jesus' quietness is made into complete silence. The Inquisitor goes on at Jesus for ten closely argued pages, insistent on the disaster which his offer of freedom will bring upon weak and irresponsible humanity, which rightly prefers to live in obedience to the church and its order:

> When the Inquisitor finished speaking, he waited for some time for the Prisoner's reply. His silence distressed him. He saw that the prisoner had been listening intently to him all the time, looking gently into his face and evidently not wishing to say anything in reply. The old man would have liked him to say something, however bitter and terrible. But he suddenly approached the old man and kissed him gently on his bloodless aged lips. That was all his answer.

The patient sympathy with which Christ gazes at his interrogator in Honthorst's picture suggests that Honthorst's meditations on St John's Gospel had led him a little way along the line of thought which Dostoyevsky took to the electrifying point of that kiss. Amongst the many copies of this popular and influential picture, there had been one in the Hermitage in St Petersburg since 1831. From 1850 it was on view to the public. But there is no record, only the lively possibility, of Dostoyevsky seeing it. Like Dostoyevsky, who had the Gospels with him when he was a prisoner in Siberia, Honthorst has read St John well. It is a remarkable feature of the story of Christ's passion in that book that Jesus seems to suffer less than his restless accusers and judges. He is majestically in control, firm in the confidence of alone knowing what is happening and its divine inevitability. The two figures lit by one candle realise St John's contrast unforgettably.

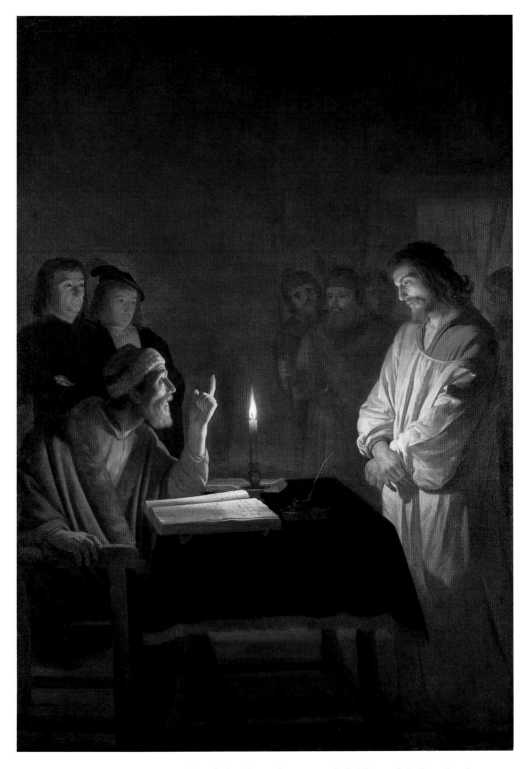

89　Gerrit van Honthorst, *Christ before the High Priest*, c.1617, National Gallery, London.

Rembrandt, *Ecce Rex Vester*

Rembrandt is interpreting St John too, but has made no attempt to represent Christ's serene calm. His compassion for the sufferings of the innocent and his love of the human Christ may well have led him to show him in a pose of distress. But he has read St John carefully on Pilate's agony of indecision. In the lead-up to the moment in St John's text shown by Rembrandt, Pilate is caught between his own persuasion of Christ's innocence ('I find in him no fault at all') and the relentless pressure of the Jewish clergy who arraign him. He fails to persuade them to take the case back to their own court. They insist on the death penalty which it cannot impose. He questions Jesus about his ambitions, to be told 'My kingdom is not of this world.' Pilate then goes back to the Jews with the suggestion that the custom of releasing a prisoner at Passover be used in Jesus' favour. They refuse. Pilate has Jesus scourged and shown to them, clad in a crown of thorns and a purple robe, a parody of monarchy, 'and Pilate saith unto them, Behold the man!' The priests insist on crucifixion. Pilate questions Jesus again, this time to be told 'Thou couldest have no power at all against me, except it were given thee from above.' He is sufficiently impressed by this invocation of a power above his own to want to release Jesus, but the Jews thwart him. They invoke another power superior to Pilate – not God, but Caesar: 'If thou let this man go, thou art not Caesar's friend: whoever maketh himself a king speaketh against Caesar.' At this point, 'about the sixth hour' as Rembrandt's clock tells, Pilate goes to his judgement seat

> and he saith unto the Jews, Behold your King! But they cried out, Away with him, away with him, crucify him. Pilate saith unto them, Shall I crucify your King? The chief priests answered, We have no king but Caesar. Then delivered he him therefore unto them to be crucified.

This is the moment of climactic disaster which Rembrandt shows – an ugly picture for an ugly moment. It should properly be called *Ecce Rex Vester* ('Behold your king'), rather than *Ecce Homo*, after Pilate's earlier exclamation. An enormous, hideous bust of Caesar gazes imperiously down on the weak and whiskered Pilate across the seething square. Pilate has risen from his judgement seat to kneel abjectly on the stool in front of it. He rats on his responsibility for justice, the Jewish clergy on the unique status of their nation as subject to God alone. A priest turns to conduct the bayings of the bloodthirsty crowd of citizens which spills from the dark archway like an infested river issuing from a stygian cavern. Rembrandt augments the hostile references to the Jews in St John's narrative by inscribing the divine names in Hebrew characters on the head-dress of the nearest priest. This horrible character tells Pilate to get on with his job by forcing on him the rod of justice (a feature of executions in seventeenth-century Holland), which Pilate tries to ward off.

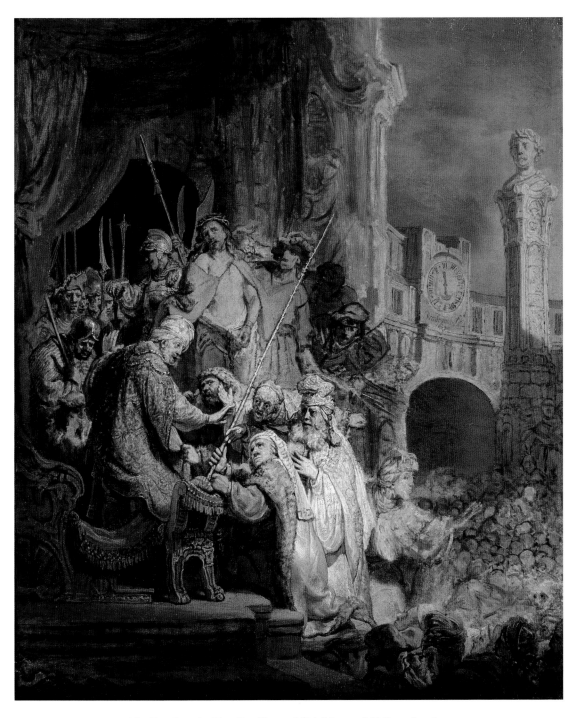

90 Rembrandt, *Ecce Rex Vester*, 1634, National Gallery, London.

When St John wrote of the Jews, he meant the 'old believers' who had not recognized Jesus as the Christ and had outlawed the Christian sect in their midst. St John was not a racist, but, without knowing it, he had given some terribly dangerous hostages to fortune. The anti-Semitism which disgraced Christian Europe and Christian consciousness drew on him to justify its irrational cruelties, culminating in the Holocaust of our own century. That revelation of the evil of which humanity is capable has been given a name which denotes 'a sacrifice wholly consumed by fire' (Oxford English Dictionary). Unfortunately, from the religious point of view which it assumes, it is apt. For although we have deployed high religious ideas of sacrifice when looking at the pictures by Piero, Mantegna and Bellini, there is also a base aspect which Rembrandt's unpleasing image thrusts at us. It is necessary and fundamental to sacrifice that there should be unanimity about the victim. Everyone must fasten on some merely unfortunate and arbitrarily selected animal, person or group and agree to its death. This is what drives the appalling human tide which breaks over the pathetic Pilate and overwhelms him. Here is the indispensable, seamy side of sacrifice.

Rubens, *The Coup de Lance*

91 In this sketch for an altarpiece in Antwerp, more turbulent than the finished work, Rubens shows human violence's last blow at the body of Christ. Once again, St John provides the text. The soldiers came to break the legs of the three crucified victims:

> But when they came to Jesus, and saw that he was dead already, they brake not his legs: but one of the soldiers with a spear pierced his side, and forthwith came there out blood and water. And he that saw it bare record, and his record is true: and he knoweth that he saith true, that ye might believe. (John 19. 34–35)

It is typical of St John's Gospel that its long metaphysical discourses are punctuated by moments of startling physicality: the stink of the dead Lazarus, Jesus sitting exhausted by the well in Samaria and his injunction to his followers to eat his flesh. The doctrine and the physicality, which can be gruesome, are not contradictory but combine to detonate symbolic disclosures. This trait of St John reaches its climax in two connected incidents which are the most disturbing of all: Jesus' body gratuitously pierced by the spear, and doubting Thomas later putting his finger in the same wound to assure himself of the reality of the resurrection. So Rubens's physicality, a bar against taking his religion seriously for some people, is a confirmation of his Christianity – particularly if St John's Gospel is the criterion. It is also inherent in Rubens's sacramentally based Catholicism.

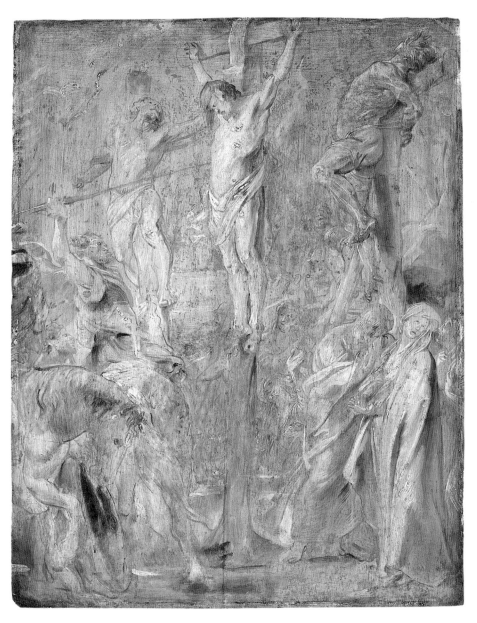

91 Rubens, *The Coup de Lance*, before 1620, National Gallery, London.

The second sentence of the text is the testimony of an anonymous 'witness'. We can correctly take it to mean that he or she was there. But that is not all. The witness is a guarantor of the religious significance of the event as well as its actuality. 'He has borne witness that you also may believe.'

Believe what? In the belief of the church's commentators, and very probably in St John's belief too, the blood and water have the powerful Christian significance of being the elements of the church's two great sacraments, Baptism and the Mass. So the brutal incident which Rubens shows is a foundation moment of catholic Christianity, with Christ's pierced side as the source of its spiritual life. Rubens grasps John's collision of brute force and redemptive self-offering and makes it visible. Christ's body hangs limp and vulnerable. The mounted soldier is not giving it the casual prod which an unimaginative reading of the text would allow. Rubens's poetic energy makes him rise from his saddle and thrust with the same concentrated fury as a hunter spearing a lion in his earlier sketch *A Lion Hunt*. St John, the witness, recoils from what he has seen, head in hands. The Virgin swoons. It is as if they themselves had suffered the blow. Yet this traumatic moment is the origin of the sacraments which sustain the church. So it is a moment of sacrificial exchange: peace for violence and life for death. And it seems to have waited for sixteen centuries for the Baroque master to bring out its full physical-cum-spiritual force in the impassioned calligraphy of this sketch.

Antonello da Messina, *Christ Crucified*

The impact of this little panel (17 inches by 10, 42 by 25.5 centimetres) comes from the emptiness which surrounds the pale and exhausted body of the victim. Setting Christ on a much taller cross than sheer reality and necessity dictated was a way of realising the phrase 'lifted up from the earth' which Jesus used to prophesy his own death in St John's Gospel. By raising him into the heavens, painters gave his torments a certain transcendant monumentality which suggested his Heavenly Father's acceptance of his sacrifice. (Modern spectators may be reminded of images of the Buddha, seated in serenely compassionate contemplation on the lotus flower which rises above the water from its roots in the murky depths.) But Antonello refuses the further step, taken by so many more famous painters, of giving Christ's body a beauty to delight the eyes. The taut arms are emaciated, the head hangs low, and trunk and legs taper down to the nailed feet without ingratiating or interesting curves.

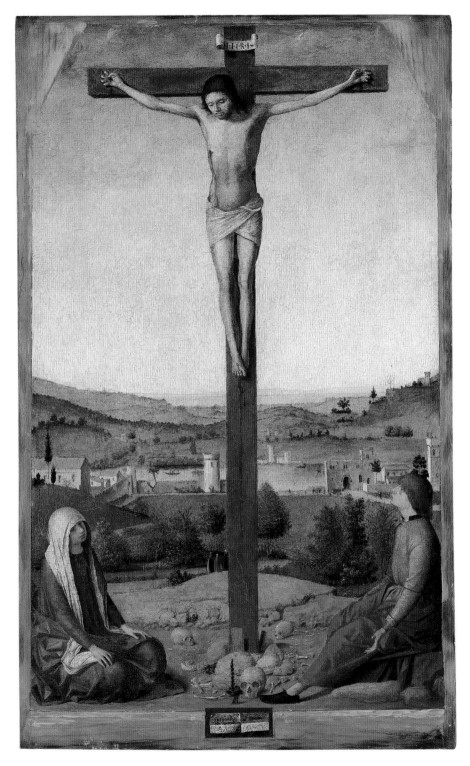

93 Antonello da Messina, *Christ Crucified*, 1475, National Gallery, London.

He also resists the tradition of having Mary and John standing on either side of the cross in attitudes eloquent of devout and wondering pathos. Here are two people for whom it has all been too much and too long, so they sit on the bare ground or the rocks. Their scooped figures are slumped into the corners, opening up the wide and deep space between them where the cross stands. John has the aspect and posture of someone who has gazed for a long time at his dying master for some sign of grace or meaning. His raised head and hand pose the eternal 'Why?' which is always put to loss and affliction. Mary lacks even that residual expectancy. Her legs are tucked under her, her hands are turned down on her knees, her covered head lolls down and aside and her eyes look nowhere. She may be rocking herself from side to side in her sorrow, or she may be dead still. Hers is a body and mind filled with nothing but a grief which sees no end to it all.

And so the pathetic human relics on the ground before her tell us. One of the skulls is no doubt Adam's, signifying the redemption of his primal fault and explaining the name of the place: Golgotha, the place of a skull. But the others have no such mythical dignity of meaning. Like the poor little broken human bones which are mixed with them, they announce nothing but their own fragility.

94 From beyond the rocky hill, three women approach. They are too distant for certainty, but are probably the three 'women looking on from afar' at Christ's death, according to a poignant verse in Mark's Gospel (15.40). They are rarely depicted, but Antonello's very sparing filling of space lets them be visible though far away. Beyond them is a fortified harbour, a range of hills,

94 and 95 Details from pl. 93.

the sea, and more hills beyond. We can see for miles. The people at the port attract curiosity. Some are out in little boats, some congregate around the gateway in the usual Italian way. A mounted party sets out, back to town. They are quite unconcerned with the tragedy in the foreground. There is no exchange of significance between us and them.

> About suffering they were never wrong,
> The Old Masters: how well they understood
> Its human position; how it takes place
> While someone else is eating or opening a window or just
> walking dully along . . .
>
> <div align="right">W. H. Auden, 'Musée des Beaux Arts',
Collected Poems (1991; p. 179)</div>

Antonello has borrowed this motif of discontinuous goings-on in the far distance from the works of Flemish painters which were in southern Italy in his time – and turned it into his own poetry of the alienation, the annihilation of meanings, hopes and coherences, which pervades Good Friday. He shows the culminating sacrificial moment of exhaustion when the victim dies, disregarded and apart, taking everything away with him and leaving the world to begin all over again.

96 Rubens, *The Descent from the Cross*, 1611, Courtauld Institute Galleries, London.

6

Partakers of the Altar

Rubens, *The Descent from the Cross*

Christ's dead body drops down from the cross in a diagonal stream of light. 96
It is made brilliant by the cascading flow of the white sheet which protects
its luminous pallor and is stained here and there by his blood. There is a clear
recapitulation of his original descent as the divine light, to be incarnate in
a dark world. There are even delicate hints of birth. Steadied by the strenu-
ous work of the men above, the body is received by the women below as the
most precious of gifts. For it is marked by the wounds of the completed
sacrifice in which human cruelty and failure are atoned. Such is great tragedy:
the death of the hero exhausting and escaping the powers which destroyed
him, and laying the foundation of renewed community. Strangely but essen-
tially, tragedy and sacrifice are both occasions of joy because of the new life
and society which they achieve. So Nietzsche: 'Affirmation of life even in its
strangest and sternest problems, the will to life rejoicing in its own inex-
haustibility through the *sacrifice* of its highest types . . . that is what I recog-
nized as the bridge to the psychology of the *tragic* poet' (*The Twilight of the
Idols*, trans. Hollingdale, 1968).

If we allow ourselves a profane reflection (which certainly did not cross
Rubens's mind) at this moment of recapitulation and release, it is as if the
body of the greatest of dancers, exhausted by his ultimate performance, is
being received by his enraptured and sorrowing devotees; only Christ's face, 97
ravaged and spent as that of any victim
of the Nazi holocaust, and the eloquent
pallor and sorrow of his mother's,
plumb the depths of suffering entailed.
At least, the centrality of the body to
that balletic simile gives it an appro-
priate point. For this is a sketch for
Rubens's great panel for an altar in the
chapel of the Guild of St Christopher
the Christ-bearer in Antwerp Cathe-
dral. Below it, the faithful received the
same body, in the sacramental form of

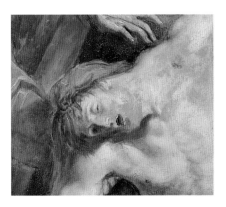

97 Detail from pl. 96.

broken bread, as the most valuable thing in the world. It fed them with the means of salvation and made them, too, Christ-bearers. It gave to mortals the eternal life of God, released to them by the death of the divine Son. Voluntarily sacrificed, his single body became the life and soul of the corporate community of his followers.

'It is finished': Christ's last word from the cross according to St John, and the reason why Tiepolo could show Christ with his cross in such an easy pose in *The Vision of the Trinity appearing to Pope Saint Clement*. The last chapter began with Christ's body set apart in Piero's *Baptism* and it ended with its suspended isolation in Antonello's *Christ Crucified*. Now Rubens shows it, following on the sacramental symbolism in his *Coup de Lance*, restored to human society. It is received and adored as it was at its birth, but now still more ardently because it has submitted to the ordeal of sacrificial death in complete obedience. How was it that sacrifice was and is understood by so many religions, not just Judaism and Christianity, as the foundation of society? The question puzzles historians and anthropologists, but some answer to it is needed in order to understand Christian paintings which depend upon it. It is a large category which includes most of the pictures considered already and many of those still to come.

Excursion: Sacrifice and the Loss and Return of Value

The word 'body' can be used in two different ways. In the title of the last chapter it stood for an individual body. In the next it will stand for a social body. Ambiguity is a settled and omnipresent characteristic of the world of symbols. It made the structure of Piero's *Baptism*. The interchange of life and death was integral to Rubens's *Coup de Lance*. In Rembrandt's *Ecce Rex Vester* and in the pictures of the *Agony in the Garden* by both Mantegna and Bellini, historical and mythical time co-existed enigmatically: the eternal will of God and the tangled contingencies of human politics were the twin sources of the drama. Ambiguity was at the heart of St Paul's thinking, which lies at the base of Christianity. For him, both bodies, the single and the social, were 'the body of Christ'. They were fastened together, the one always implying the other, by means of sacrifice. But what is sacrifice? At this turning point in Christ's story, set between his death and the renewal of his life, we need some understanding of the difficult but apparently indispensable category which governs its telling.

We began by examining vision, the whole business of looking, both within pictures and at pictures from outside them. It was concerned with 'how': how people look. In Christian paintings, what they look at has turned out, time and again, to be sacrifice or to have sacrificial overtones. There is objectivity here, something to see. But there is subjectivity too. For there is inward-

ness to sacrifice. Indeed, to the serious and reflective religious mind, this is essential and substantial: the motives and aspirations behind sacrifice, the moral ends it serves. So when St Paul wrote about the ritual memorial of Christ's sacrifice, he soon turned from a reminder of its historical base to injunctions about the spirit in which its participants should take it. 'How' mattered as much as 'what'.

The Christians of the congregation which St Paul founded in Corinth met often to commemorate Christ's death in their common meal of bread and wine:

> The cup of blessing which we bless, is it not the communion of the blood of Christ? The bread which we break, is it not the communion of the body of Christ? For we being many are one bread and one body: for we are all partakers of that one bread. Behold Israel after the flesh [ie, in St Paul's parlance, old and traditionalist Israel as opposed to the new, spiritual Israel of Christianity]: are not they which eat of the sacrifices partakers of the altar? (1 Corinthians 10.16–18)

The simplicity of the ceremony seems to have led some participants to take it superficially. St Paul rounded on them, insisting on the subjective rigour of self-examination and a proper sense of the deep significance of Christ's body, single and social. Without that, the sacred matter – having a power which would exert itself one way or the other, since it could not be ineffective – would act on its consumers to their destruction rather than salvation:

> For as often as ye eat this bread, and drink this cup, ye do shew the Lord's death till he come. Wherefore whosoever shall eat this bread, and drink this cup of the Lord, unworthily, shall be guilty of the body and blood of the Lord. But let a man examine himself, and so let him eat of that bread and drink of that cup. For he that eateth and drinketh unworthily, eateth and drinketh damnation to himself, not discerning the Lord's body. (1 Corinthians 11.26–29)

Such are the simple origins of the ceremonial of the Mass. Or not so simple. The homely and familar materials, bread and wine, were taken into the complexities of the heart and mind. Ritual entailed ethics and spirituality. And from the historical angle, there is a complexity in the origins of the Mass which is worth exploring for the light it brings to the many paintings associated with the sacrament. Behind the Mass stands the Jewish Passover, and behind them both, like a memory which never really goes away, stands the still older shadow of human sacrifice, even child sacrifice. The well of the past is, as Thomas Mann said, very deep – fathomless. And in this instance, murky and horrible in its deeper reaches too. Which is why reformers and prophets have constantly refined the bloody ceremonies of the priests into something more limpid and edifying, and sought to save the moral

significances from the butchery. Most of all, like St Paul, they tried to resolve the symbolic ambiguities of ritual into simple good conduct, springing from sincerity of heart.

The animal sacrifices of the Jerusalem Temple were still going on in St Paul's time. But for him they no longer mattered. They had been changed by Christ's death, the ultimate sacrifice which relegated them to the past, into the Christian common meal. The trigger of this change was an historical fact – but an historical fact attracting a swarm of symbolic and mythic significances. Christ was crucified at the time of the Jewish Passover. As a result, his death was promptly understood by his followers in its terms and as the resolution of all that it stood for:

> Christ our passover is sacrificed for us, therefore let us keep the feast, not with the old leaven [Paul's habitual swipe at traditional Judaism], neither with the leaven of malice and wickedness [a swipe at quarrelsome Corinthian Christians], but with the unleavened bread of sincerity and truth. (1 Corinthians 5.7–8)

The Greek word *pascha*, which is translated as 'passover', the Jewish spring festival, was also used for the victim at its centre: the paschal lamb sacrificed by the priests at the temple for every family to eat roasted with unleavened bread. For Christians the paschal lamb had become Christ. St Paul's identification is matched by John the Baptist's in St John's Gospel, which later found its way into the words of the Mass: 'Behold the lamb of God which taketh away the sin of the world' (1.29), God being the donor here rather than a human family. The unleavened bread, associated with the lamb, had become an image of simple, unadulterated truth. In becoming Christian, the Jewish foundation-rite was simplified and humanised. We saw its birth in Rubens's *Coup de Lance* – but unconsciously, because then the quotation from St John about the piercing of Christ's body stopped short at 19.36. The next two verses quote texts from the Jewish Bible which fix the paschal significance of Christ's body being pierced rather than broken, and expose the implications of the Baptist's proclamation of the Lamb of God:

> For these things were done that the scripture should be fulfilled, A bone of him shall not be broken.
> And again, another scripture saith, They shall look on him whom they pierced. (John 19.37–38)

These verses conceal two features of the foundation story of the Jewish Passover which were carried, domesticated into symbolic references, into Christian ritual. They are the slaughter of lambs and the death of first-born children which was darkly associated with it – and they take us into the exchange of death and life, loss and restoration, which sacrifice shares with tragedy. The first comes from Exodus 12.46 and refers to the killing of the

paschal lamb: 'neither shall ye break a bone thereof.' The second comes from Zechariah 12.10 and refers to the death of the first-born: 'They shall look on him whom they have pierced, and they shall mourn for him as for an only son, and shall be in bitterness for him, as one is in bitterness for his first-born.' We need to see them both in historical and cultic context. Passover is a national, not to say nationalistic, festival, commemorating Israel's exodus from Egypt through the water of the Red Sea – the crossing alluded to in Piero's *Baptism of Christ*. On that night, long ago, God was out for blood. He killed all the first-born of Egypt, so that there was 'a great cry throughout all the land of Egypt, such as there was none like it, nor shall be like it any more' (Exodus 11.6). But he 'passed over' the houses of Israel when he saw the blood of the lambs apotropaically sprinkled on their doorpost and lintels. So the killing of the lambs was accompanied by the shadow of the slaughter of the first-born. There is exchange and substitution in this dreadful transaction. Out of it Israel was born as God's nation and, in the biblical phrase, his beloved and only son.

Another story involved the sacrifice of a son and the destiny of Israel in an even more disturbing way. Long before the exodus, God promised Abraham that, though old and without a child of his marriage, he would become the father of a great nation. The promise was kept by the birth of Isaac. But only to be soon contradicted. God commanded Abraham to sacrifice Isaac – then called it off at the very last moment and subsituted a ram (appropriately, a fatherer of lambs) caught in a nearby thicket (Genesis 22). Isaac, the repository of Abraham's hopes and God's, the object of their loving care, was snatched from the jaws of death. Value, sense and society were restored through the narrowest of scrapes – all the more precious for the ordeal of consenting to their loss. This took place on the mountain where the Temple was later built and became the place for Passover sacrifices and the background of Christ's death. If much about sacrifice strikes us as remote, this near-loss of an only child touches the sensitive nerves of love and hope, the desire that one's own bit of history should make some coherent sense: the sort of particularities which lie beneath the skin of the general category of value itself. Parental love is not historically relative. A child, and most poignantly a beloved or only child, is always the point at which life's chancy contingencies result in a living focus of hope and care: someone who is unfathomably significant and valuable, who gives significance and value to the whole of life. Yet the willingness to let the child go for other loves and other benefits is also a part of parental love – and one which the Christians were to attribute to their Father God. In Judaism and Christianity this love is the tender core of their sanguinary traditions.

For St Paul it was an essential part of Christ's atoning sacrifice that it was a condemned, accursed death on unhallowed ground. Because it entails some kind of death, sacrifice is always a move into the unknown. But this removal

98 Rembrandt, *Lamentation over the Dead Christ,*
 c.1635, National Gallery, London.

99 Rembrandt, *The Woman taken in Adultery,*
 1644, National Gallery, London.

of sacrifice from its accustomed, sacred context did more. It shifted the whole
thing from the Temple to the place of common executions. Hence, for
St Paul, its power and availability to all and sundry. It released God and
humanity into spiritual freedom. Rembrandt built that point into his *Lamen-*
98 *tation over the Dead Christ* (1635). In the space inside the capital L of its struc-
ture, made of the crosses and the bodies on the ground, is Jerusalem. The
barrack-like shape of its Temple is bisected by the body of the condemned
criminal – who so tellingly might be taken for Christ at a first glance at the
100 picture. To its right are two free-standing pillars which, according to the
Bible, marked the boundary of the sacred precinct. In another painting, *The*
99 *Woman taken in Adultery* (1644), Rembrandt put them indoors, but to serve
101 much the same purpose. They mark the bar of sacred justice where a sorry
couple kneel to hear the sentence of the High Priest on his pompous throne.
Christ releases the woman before she can be taken there, and does so in the
secular concourse outside its scope. For all its great debt to Judaism and
derivation from it, Christianity was not meekly continuous with it – at least
where St Paul and the Gospel writers were concerned. It broke its bounds,
taking as its entitlement a divine rupture of hitherto divine insitutions which
the Gospels symbolise by the tearing of the Temple veil, which hid the inner

sanctum, at the very moment when Jesus died 'with a loud cry', such as arose when the first-born died at the original Passover. God had let his son go, near the very hill where he had once spared Isaac and the future of Israel. From St Paul, the memory of it evoked a cry of gratitude as rapturous as the gestures and glances of the women in Rubens's *Descent from the Cross*: 'What shall we then say to these things? If God is for us, who can be against us? He that spared not his own son but delivered him up for us all, how shall he not with him also give us all things?' (Romans 8.31–32).

For all this, which may amount to a happy issue out of all the violence and desperation inherent in sacrifice, its bloody ritual is not something a decently humane moral sense has ever been able to contemplate with equanimity, let alone approval. Revulsion against sacrifice is not a liberal prerogative. The Hebrew prophets denounced it in God's name: generally, as being morally futile, and child sacrifice particularly as being abhorrent. In the face of such well based criticism, sacrifice was transformed into more acceptable modes which were more in tune with the welfare which it was meant to bring about. Lambs took the place of children; bread and wine the place of both; devout prayer and moral obedience to laws which promoted social welfare were preferred to the whole business. Along the way, moral sense required that the

100 Detail from pl. 98.

101 Detail from pl. 99.

victim should not be simply set upon but should be willing. Only self-sacrifice proved to be morally positive. Hence Jewish thought around the time of Jesus came to believe that Isaac was ready to be sacrificed by his father. Jesus' hard-won willingness for sacrifice was the point of the Agony in the Garden in the Gospels and Mantegna's and Bellini's pictures of it.

To sum up. Looking is, of course, the centre of what we are about – in more ways than one. But sacrifice comes before it, is inherent in it, and follows on after it. In Christian pictures it is, time and again, what was there before we looked, both as the subject of painting after painting and of the sacrificial work of the painter, his offering of skill and imagination, in making it. Then it is what we look at, in the same analytical and imaginative spirit. And thirdly, it is what is indicated by the picture as the way to live, individually and socially, as the subsequent and continuous result of our looking: the going beyond self which is inherent in looking is realised in action by altruistic deeds. Language like this, used to describe personal experience such as looking at pictures in a general way, matches the language of myth which is its corresponding grand poetry. In the Revelation of St John, Christ is 'the lamb slain from the foundation of the world' (13.3), there in myth from the beginning of time. In the middle of time, where mythical time coincides with historical time, the lamb 'stood on the Mount Sion' (14.1), the place on earth of the sacrifice of Isaac, of the Passover lambs and of the death of Christ. At the end of time, myth closes the all-embracing cycle. The lamb is the light of the heavenly community, the means and object of its looking, and is married to every member of it. That vision of social perfection was taken over by the 'Perle' poet (see Chapter 1, p. 12) and depicted by Van Eyck in *The Adoration of the Lamb* at Ghent – a picture with a claim to be the paradigmatic masterpiece of Christian painting, not least because it integrates the joy and social peace achieved by sacrifice around its crucial trauma.

The whole palimpsest and its complex, ambivalent story is remarkable for the raw poetic energy, the sheer *chutzpah*, of the religious mind as it confronted the inter-relations of life and death, the loss and gain of value – packing the inarticulate moment of their crossings-over with intertwined myths, sagas, rites and symbols. It is aesthetically awesome enough. And the drive to distil all the reeking complexity into something pure and simple is morally impressive. It shows itself in the First Letter of St John. Its preoccupation, first and last, is with love: 'Beloved, let us love one another' (4.7). But the exhortation is not quite direct. The writer adds 'for love is of God', and this is a God who 'sent his son to be the propitiation of our sins.' Sacrificial symbolism refuses to go away. But the life which grows from the value-creating exchange which it points to is transparent – 'God is love, and he that dwelleth in love dwelleth in God and God in him' (4.16) – so transparent, in fact, that it sees through the boundaries of religious law and cult, leaves all sacred institutions standing, and lives happily in the secular world.

85

It is as if the final distillation of all the myths and paraphernalia of the cult, which had brought religion to so many awesome moments of climax, is the quiet sacrifice of sacrifice itself and even of religion. They fall away when they reach their fulfilment. Love is their surviving meaning; and it was already there in the kind regards of Chapter 2. It lives where person meets person and sees the beauty of the world. And this pervades the picture which comes next in narrative sequence.

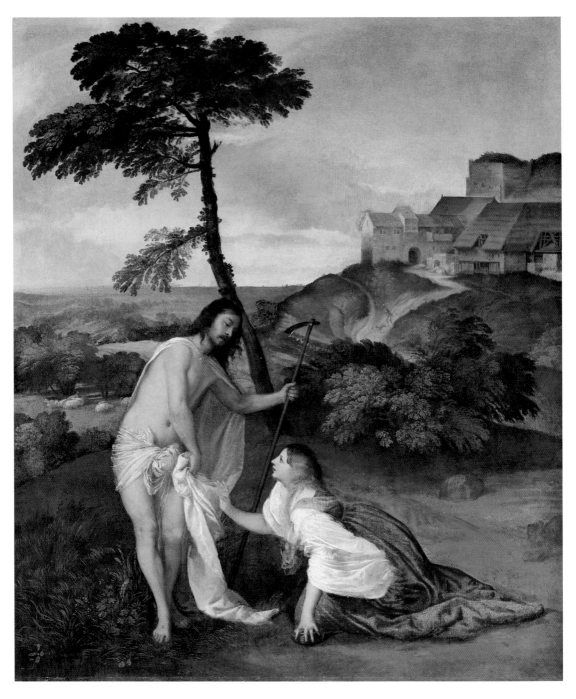

102 Titian, *Noli me Tangere*, c.1510–15, National Gallery, London.

7

The Social Body

Titian, *Noli me Tangere*

Painted in Venice when Titian was in his twenties, this picture represents the moment in Chapter 20 of St John's Gospel when Jesus, risen from the dead, forbids Mary to touch him. It is of moderate, domestic size, about four feet by three (109 by 91 centimetres), and was probably intended for a room, perhaps a chapel, rather than a church. But it was certainly made for religious reflection.

102

Its content can be put in two words: landscape and love. They are treated together and religiously. The landscape conveys a happy love of nature, particularly the tree against the sunlight which prophesies so many such trees by the nature-worshipping Turner who, it is very likely, saw this picture when it was in the London salerooms in 1798 and 1802. The relation of this tree's stately vertical to the turbulent bush at its foot echoes Jesus' relation to Mary. Landscape and love are in harmony. For whatever is going on between the two people here, it is something to do with love. Their postures speak it. Mary approaches Christ with humble and eager longing. He both withdraws from her and bends tenderly over her. Which is love, time and again.

It was a subject much discussed in Titian's day, and he returned to it constantly. The famous Ficino, who promulgated the idea of Platonic love, had written that 'The soul is inflamed by the divine splendour, which glows in a beautiful human being as in a mirror, and is mysteriously lifted up, as by a hook, in order to become God.' (*Theologica Platonica*, Basel 1576, p. 306). Or as St John had more succinctly written, 'God is love' (1 John 4.16). Thinkers of Titian's time discounted what we often call love – unintelligent, sensual lust – and concentrated on the two more fulfilling kinds which were left: earthly and heavenly love. The question which mattered was how these two were connected. Love of a spring landscape comes naturally and easily. Harder, but more valuable, is the love which the Bible calls charity or grace. Can one become the other? If so, by what sort of change or exchange? Since they share a name, we can hope for continuity or traffic between them.

The title is *Noli me Tangere* – in English, 'Do not touch (or hold) me.' It is a mysterious ban, mysteriously explained by Christ: 'for I am not yet ascended to my Father . . . to my God and your God.' It clearly implies that

Mary was trying to touch or hold him, continuously with her sad searching for his body which had led her to mistake him for the gardener and ask him where it was. Titian has added a hoe to excuse her mistake. Also clearly, Jesus' ban puts a boundary between himself and her. Titian marks this barrier by the shroud which hangs between them, like the veil which hides the living from those who have died. Titian does this, although St John says clearly that Jesus left his graveclothes in his empty tomb, because it makes his spoken ban visible. He gathers the shroud to himself to ward her off.

So there is a marked distinction in the structure of the picture. The picture itself is a space set between two opposites. The rising sun, bringing life and new light to it all, is outside the left of the picture, behind Christ. The tomb is outside it on the right, behind Mary. Within the picture, on one side is the holy and naked body of the heavenly love which gave itself to die for humankind. On the other side is the earthly, natural love of the sumptuously clothed body which longs for his.

Yet these loves interact. A mysterious, deep exchange is going on between Jesus and Mary. It must contain the answer to the riddle of how the two loves connect. This exchange has been beautifully described by Neil MacGregor in an unpublished sermon:

> Even after death it is through physical contact, by honouring his body, that she seeks to express her love of Christ. And when he appears she reaches out to touch it. Yet the time of bodily love, of the love she understands, is past. Christ draws back from one kind of contact and leans forward to offer another, for which the time has not yet quite come: he is not yet ascended. With a Mozartian subtlety of movement, the two figures express a perfect equivalence of yearning. Mary's gesture concedes that what she loves is now unattainable in the terms familiar to her, that the fulfilment of her love will be not physical, but spiritual. And her anguish of a few minutes before is resolved; because a lord who cannot be touched is a lord who can never be taken away.

Mary kneels low on the ground in the posture of humility, derived from the Latin *humus*, earth. But the gesture of her right hand is the point at which her earthly love changes into the other. She has turned from looking into the tomb, pivoting on the jar of ointment under her left hand, which shows her earthly love's care for the body of the dead – turned to look from the dark and empty tomb into the light of the rising sun and at the risen master. And at the end of her right arm, her hand has turned upward on her wrist, from eager reaching-to-touch into open wonder at the lord she cannot grasp.

The meaning of this momentous gesture suffuses the whole painting, where it is not just a matter of a hand, but of a whole structure of change which includes bodies and landscape. The transformation of love, revealed in a gesture, brings a whole new world with it.

103

103 and 104 Details from pl. 102.

The structure of the picture, which can easily be traced by the eye or finger, consists of two curves. One of them begins at Jesus' pierced foot (a reminder of his sacrifice), set in the lush grass. It goes up along the line of his bowed body and head. Then it grazes the sunlit gable of the gatehouse and the top of the ruined castle in the background. So, having started steeply it gradually flattens to the horizontal. The other curve starts at the tip of Mary's trailing crimson robe. It follows the line of her body under the robe to her head. Then it shoots heavenward up the tree-trunk. So, unlike the first curve, it starts shallow but ends steep.

Each curve carries first a figure, then landscape. The remarkable thing is that the curve, which is set off so vertically by Jesus' legs, then turns down with his hips and follows along his back and head, into a decline which gently covers the hill-top town where people live. We can see one of them, out early walking his dog. The town is part of the mundane world on Mary's side of the veil of death. Yet the curve of Jesus' kind of love is projected to touch

104

119

and hover over it. Equally remarkably, Mary's curve begins with her nearly prostrate body on the bare earth but turns with her raised head to sail up the tree trunk into the very heavens, the infinite abode of the invisible Father. By means of some transforming exchange, the heavenly and heaven-bound love of the one who is to ascend to the Father, has a trajectory which protects the finite world of mortal humanity; and the earthly love of the earth-bound Mary is freed to rise to heaven.

105

This exchange turns on the point at which the curves intersect. It is where the top of Christ's head touches the crossing of the tree-trunk over the line of the blue horizon. In relation to the whole canvas it is a 'golden section'. This was something which fascinated writers and painters of Titian's day. A few years before this picture, a Franciscan mathematician wrote a book about it and called it 'the divine proportion'. It divides a space unequally. But it does so in a way which, oddly enough, makes a satisfactory balance. This is because it so divides a line that the relation of the larger section to the smaller section is equal in proportion to the relation of the whole space or line before it was divided to that larger section. The golden section has an elusive and enigmatic quality. It needs to be put visually rather than verbally to be understood at all. Part of its fascination was that it was found in nature and that, like the mysteries of religion, it was hard to grasp but easy to enjoy. Its importance is that it creates a more mysterious, lively and

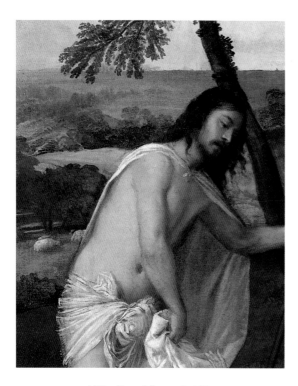

105 Detail from pl. 102.

interesting balance than is obtained by just cutting a thing in half. It can be sensed, and the geometry left to Titian, by referring to the crossroads point in the picture's composition where the two curves intersect. Up-and-down-wise it is on the line dividing earth and sky. Side-to-side-wise it is on the line of the shroud dividing the two figures. This reveals the heart of the matter: a balance which contains inequality, an asymmetrical but just exchange. It puts things which are at odds on good terms with one another: here, the relation of Christ to Mary, and of their two kinds of love. It is where unequals meet and exchange – the refinement of sacrifice into a mathematical parable of the pivot of love.

Caravaggio, *The Supper at Emmaus*

It is worth recalling the unravelling of the very deliberate time sequence in which Mantegna's *Agony in the Garden* was set (see p. 94). The altar there was bare of bread and wine, because the sacrifice on which the sacrament of the Mass depends had not yet happened. Christ had not yet died on the cross. But the Last Supper had happened, and there Christ had given his disciples the bread and wine by means of which he would be present to them after his death. It was a poetic (in a very strong sense) initiative which provided for their future after his death. They might not understand it there and then; indeed it was too early for them to do so, but its significance would dawn on them later. And sure enough, two of the Gospels match the fraught and mysterious meal before Christ's death with calm and revelatory meals with him after it. St John tells of a breakfast of fish by the lake (chapter 21). St Luke (chapter 24) tells of a supper at a house on the road, the text for Caravaggio's picture.

It was three days after the crucifixion. Two grieving disciples of Jesus had been joined on their travels by a stranger who seemed to have heard nothing about the death of their master and the rumours of his resurrection, but to have an extraordinary grasp of the significance of these events in terms of the Jewish scriptures. They reached a village. The stranger

> made as though he would have gone further. But they constrained him saying, Abide with us: for it is toward evening and the day is far spent. And he went in to tarry with them. And it came to pass, as he sat at meat with them, he took bread, and blessed it, and brake, and gave to them. And their eyes were opened, and they knew him; and he vanished out of their sight. And they said one to another, Did not our hearts burn within us, while he talked with us by the way, and while he opened to us the scriptures? (Luke 24.28–32)

Christ's action with the bread here was exactly the same as at the Last Supper: 'he took bread, and gave thanks, and brake it, and gave unto them, saying, This is my body which is given for you.' (Luke 22.19) Having seen that, they recognise this and so, him. It is the first celebration of the Mass, distinguished from all its successors only by the status of the celebrant whose death has sealed what he adumbrated at the Last Supper. The visual revelation had a verbal prelude in Christ's exposition of scripture on the road. It is recalled after his disappearance. But the central revelation is both material and visual, even ocular. Jesus does very deliberate things with a loaf of bread. The two men's eyes are opened, and they recognise him. He vanishes out of their sight. And all this happens, we are told, in the light of late afternoon or early evening.

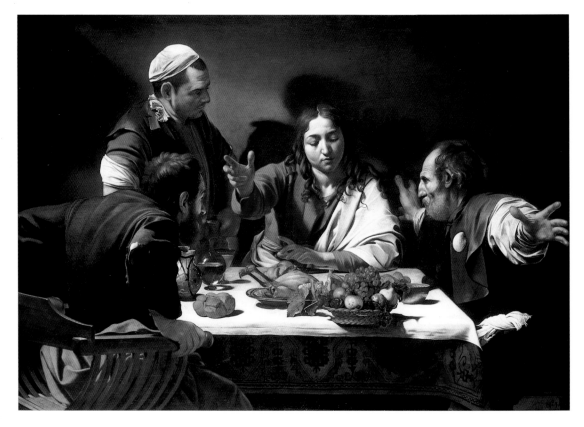

106 Caravaggio, *The Supper at Emmaus*, 1601, National Gallery, London.

106

107

This is the light that floods into Caravaggio's painting from invisible high windows on the left. As it descends into the gloomy room, it lights up four men, a table laid for a good supper with a white cloth over an expensive eastern rug, and a chair. It casts the shadow of the standing cook onto the back wall behind Jesus, so that Jesus leans forward out of its gloom and into the light with manifest clarity. With his raised right hand, a magnet to all eyes, he blesses the bread. There are three loaves, one to each diner. His right hand blesses them all, but his own is sheltered by his left hand and is almost hidden by the roast fowl which is at the centre of the table, unlike the prominent loaf on the left. A hasty eye might suppose that Jesus was blessing the fowl: a clever little visual extrapolation from the interplay of concealment and revelation, error and truth, which is at the heart of the story and the picture. The varied spread on the tablecloth is painted with a virtuoso skill which distinguishes between pottery and glass, bread and fruit, by an eagle-eyed attention to every centimetre of the surfaces and the different ways they catch the light.

107 Detail from pl. 106.

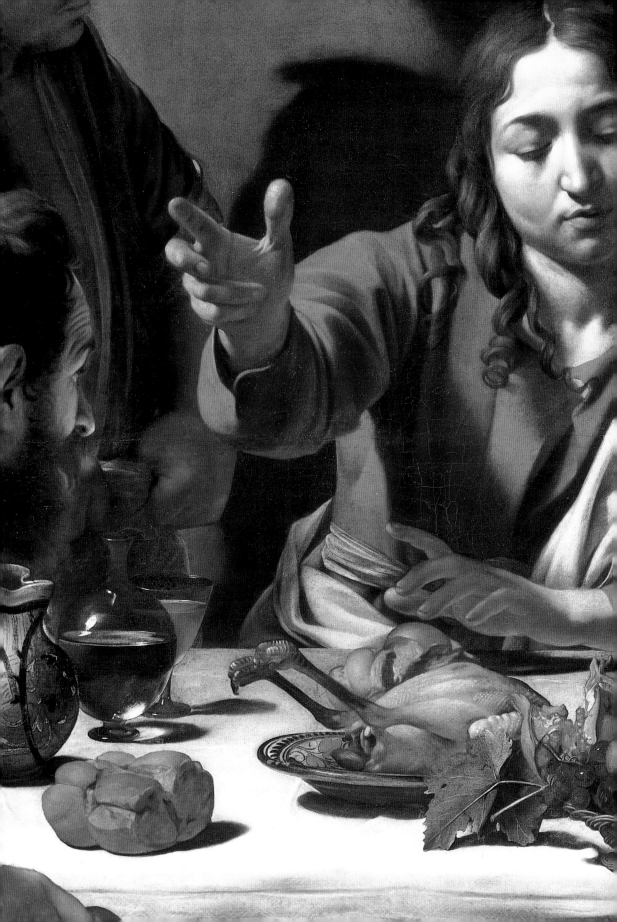

108 Caravaggio, *Boy bitten by a Lizard*, 1595–1600, National Gallery, London.

108

It is a climax to Caravaggio's long study of such ordinary things, often in paintings where they are associated with a figure, as in the *Boy bitten by a Lizard* (National Gallery, London). This was the sort of titillating, homo-erotic picture which appealed to Caravaggio's patron, Cardinal del Monte. It can, nevertheless, be compared to *The Supper at Emmaus*. Both pictures unite still life with sudden, frantic action. Light holds both of them together. But one picture shows a frivolous moment of disagreeable discovery, the other a deep moment of joyous revelation. There is utter difference of tone and import. At the time whem he painted *The Supper at Emmaus*, possibly simul-taneously, Caravaggio was engaged with his supreme pieces of religious

109

theatre, the *Call of St Matthew* and his *Martyrdom*, for the church of San Luigi dei Francesi in Rome. He was coming into his own as the master of stage lighting and action on the grand scale. It is impossible to write about Car-avaggio without using theatrical metaphors, but the meretricious excitement implied by them needs sober correction.

For *The Supper at Emmaus*, correction is readily and centrally available, nothing less than the picture's subject: the first Mass, celebrated by Christ himself, 'made known to them in breaking of bread' (Luke 24.35). If light is the natural unifier of Caravaggio's inanimate things and animated figures,

their supernatural or inward integration is achieved by the Mass itself. For it holds together inanimate and animate nature – food, utensils and people – in the mystery of Christ's presence which permeates both and gathers them into one. So this picture is a religious, and not merely formal, resolution of the two kinds of painting with which Caravaggio was preoccupied: of lowly things which have no important history, and of people caught in a turning point of Christian history. *The Supper at Emmaus* is a fusion of epic theatre and domestic still life. It has high-definition homeliness and high drama, held together by Christ's blessing of food. This is decidedly and completely the Mass – and the archetype of all subsequent celebrations of it. Held in this moment of the transubstantiation of inert matter by energetic spirit, Caravaggio can show a community of strongly differentiated and individual people and, like a priest at the altar, invite the spectator into it. The individuality and community of sacrament mark it everywhere.

109 Caravaggio, *Call of St Matthew*, 1599–1600, S. Luigi dei Francesi, Rome.

110 Michelangelo, *The Last Judgement* (detail), 1536–41, Sistine Chapel, Vatican, Rome.

Christ's beardless face is unusual, but not a problem. Michelangelo had shown him so, for all Romans to see, at the centre of his *Last Judgement* in the Sistine Chapel. It was, perhaps, a way of distinguishing the risen and eternal Christ from the Jesus of history, without falling into the gross heresy of changing the substance of his body. Or perhaps it doesn't much matter. What is a problem, however, is the unclassical, unconventional and extremely marked individuality of this face. This Christ is very much some particular man compared with Michelangelo's Christian Apollo. No doubt one of Caravaggio's male models is presented here with courageous fidelity. But that doesn't take us far. Nor does the speculation that Caravaggio may have preceded Rembrandt in showing Jesus as a young Jew. For a really persuasive answer to the riddle of the individuality of Christ's face we have to go into the picture itself, rather than circling round it with extraneous ideas. There, this astonishing individual actuality is not at all exceptional. The other men are each represented with such personal character and such special

110

111

111 Detail from pl. 106.

realism that we would recognise them straight away if we met them in some other inn – even the man with his back to us, of whose face we can see so little. This common individuality, these individuals in communion, are held in table fellowship. In a Roman picture, surprisingly, the altar of sacrifice has become the table of communion, which includes each dish, jug, loaf, leaf and fruit, scrutinised and valued for its own self by a meticulously faithful representation of its beauties and blemishes. Everyone and everything is itself. And everything and everyone is in common.

One of these things has the function of almost performing the impossible and admitting us into the pictured communion. The wonderful basket of fruit attracts us in a forcefully practical way, above and beyond the skill of its painting. It is about to topple off the table, and any person with ordinary domestic instincts wants to rush forward to steady it. This genially trivial trespassing beyond the picture plane (not unprecedented) is matched by more profound ones, impelled by the sudden recognition of Jesus in his blessing of

112

127

the bread. The man on the left pushes his chair back at us with involuntary force. The man on the right throws his arms aside with such abandoned amazement that his left hand seems to break through the bounds of the picture space and come out into the air between him and us. These effects are irresistible and famous and seem to put us in the path of the oncoming vehicle of Christ's action; but they have a serious function which is less often noticed. The pushed chair and the wide gesture are conductors of revelation. They carry Christ's self-declaratory gesture out into the spectator's world as urgently as the poised basket of fruit invites every spectator into the company within.

The cook is a less favoured spectator. He lacks these visual bridges or free-ways over the gap between us and the action. He is also at a disadvantage from the narrative or textual point of view. Not having been at the previous supper with Christ and with them, only four evenings ago, he cannot under-stand Christ's tell-tale gestures over the loaf. But sensing the excitement, he looks at Christ's face with questioning attention. It is how we felt and where our eyes first went when we happened on the picture: faces have the first call on our eyes, always and from infancy, not the fall of light. The question posed by the riveting individuality of Christ's face leads into the communion which the picture makes and mediates. With the cook, it starts all over again.

112–15 Details from pl. 106.

Cima and Guercino, *The Incredulity of St Thomas*

76
116
The centrality of Christ's body in Cima's work reminds us of Piero's *Baptism*. It has the same grace of divinity. But here the pose is easier and more relaxed. Christ has gone through the death which his baptism prefigured. His wounds have been reduced to delicate punctures and his torn and disjointed frame is as whole and immaculate as on the day of his birth. This is

> Christ the uncrucified
> Christ the discrucified, his death undone,
> His agony unmade, his cross dismantled.

> Edwin Muir, 'The Transfiguration',
> *Collected Poems* (1960; p. 200)

His followers are reunited around his miraculous restoration. There could be no more quietly real reminder that Christianity sees Christ's body in the mythical terms which describe spiritual exchanges, that it has distilled all the mythical speculation and ritual which it inherited into this physical body and its fate, the transformations which it went through and enabled. The body, not money, is our chief means of exchange and society.

As an altarpiece, this picture belongs to the place of Christian sacrifice. Below Christ's feet, a priest would daily have consecrated bread to be Christ's body and given it to the congregation to see, touch with their mouths, and eat. In particular, it would have been given to the body of people, the Guild of St Thomas, which had paid for the painting, and in whose chapel at Portogruaro near Venice it stood for three hundred years: a model of penitence, the change of heart and mind, for a penitential fraternity to gaze upon. The word 'body' is here used in a different sense: for a society rather than an individual. This change of usage marks the point of the crucial exchange from the singular to the plural, from the isolated one to the community.

Two communities meet and participate with each other here. The first group is the eleven apostles – twelve less Judas, the traitor and suicide. Christ's body is their light, shining amid their darker and tenser bodies and robes. They begin to comprehend it and to glow in their sombre tones. St 117 John, the mystic and theologian on Christ's right, understands already and is appropriately light, relaxed and exposed like his master. Doubting Thomas leans forward to touch Christ's ivory side with his brown finger. He wants to check for himself that he has come back, that it is really so. The bald and officious Peter moves across from the other side like an anxious warder swooping on somebody touching the unique and precious exhibit. He is the prototype of episcopal guardianship. The rest of them are behaving much as people do around a famous painting, just back from restoration. Some talk 118 among themselves. Some are abstracted. Some gaze. And one, the second from the left, looks straight at us.

116 Cima da Conegliano, *The Incredulity of St Thomas*, 1502–4, National Gallery, London.

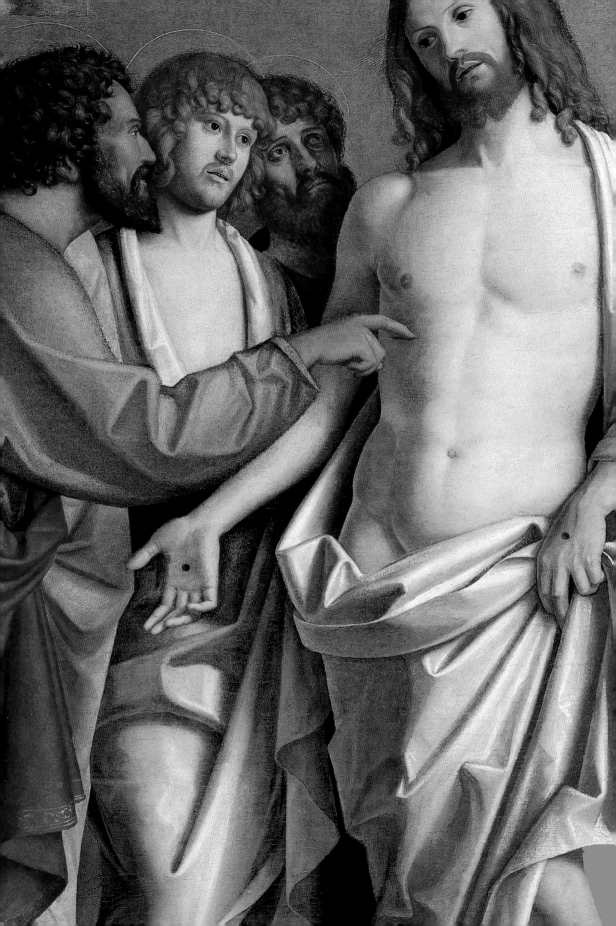

117 and 118 Details
from pl. 116.

His eye contact brings in the second group. It was once the penitential
Guild of St Thomas, gathered for Mass in its chapel. But now it is whatever
temporary congregations of people gather in front of it in a gallery where the
contact and exchange by means of bread is not available. But the exchange
of looking, which is no less vital, remains. Christ's eyes are not introspective,
as they were in Piero's *Baptism*. They look at Thomas, whose own eyes light
up in recognition. It is the image of what happens when a person or a picture
delights us by a recognition which dissolves worries and arouses faith. It is
the joyful looking which leads us from isolation into participation with one
another and the world. We first learned it in infancy. It is recalled in family
photograph albums and fastens all social bondings. At the end of Chapter 2
it was claimed as the source of society. Right at the other end of human life
and beyond it, happy looking is the social bliss of heaven in Christian hope.
The dead on medieval tombs wake up to it, their smiling heads lifted by little
angels. In the traditional myth of comedy too, the end of life's agonising
drama is seeing one another at last without disguise and with the complete
mutual recognition which is the resurrection of society. This cheerful myth
is plausible, in spite of not being a fact, because there is incarnate beauty and
we are capable of enjoying it. Exchange is possible because there is society
between us and the subjects of our attention.

119 Guercino, *The Incredulity of St Thomas*, 1621, National Gallery, London.

119 Guercino's version of the same scene from a hundred and fifty years later puts a stop to such happy thoughts. Visually, intellectually and emotionally, it is set in a darker and more troubled world. Reformation theologians, suspiciously critical of the physicality of transubstantiation, had made Christ's presence in the Mass into a centre of dispute rather than the assurance of unity. The spirit of Michelangelo and Caravaggio had troubled the calm waters of Christian Renaissance painting. The thrust of Thomas's hand, with a finger penetrating the wound, is like the rough hands which grasped at Jesus on the night of his arrest. Peter's hand on the left is raised in recoiling astonishment. And two other heads on the right, dark like Thomas's, press in with the ferocious light. The similarities are planned and deliberate. The picture

120 is one of a pair. The other, now in the Fitzwilliam Museum in Cambridge,

120 Guercino, *The Arrest of Christ*, 1621, Fitzwilliam Museum, Cambridge.

shows Christ's arrest. Here too, Peter recoils, rough men pile in from the right, and impious hands are laid on the sacred body. Where the banner of victory flutters over Christ's head in *The Incredulity of St Thomas*, a lassoo is looped to catch it in *The Arrest*. The scene with St Thomas is no longer a serene resolution. It is one more episode in the long tale of the trials and tribulations provoked and suffered by the presence of incarnate God among faithless and benighted humanity, a more than formal counterpart to his arrest.

Cima's harmony has broken down. Guercino seizes on the force of doubt, stripping Thomas of the diffident courtesy which Cima gave him and endowing him with a straining, muscular neck as well as a much more spectacularly intrusive hand. Christ opposes the power of doubt with the power of

135

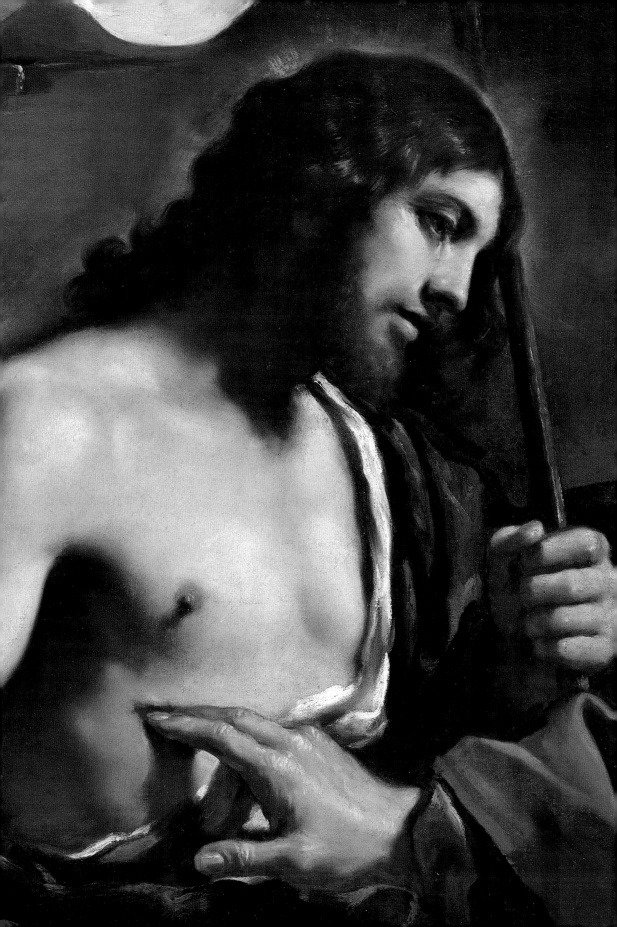

evidence. His arm is flung away to present his side. Above it, prominently and with most disconcerting physicality, the light grazes his nipple, which casts a long shadow. This is not a happy reunion. It is arousal and conflict – a fraught encounter in which the strength of physical evidence is set against the strength of disbelief and overwhelms it. The physical undertow is dangerous and dark. Christ is not happy. His head is hung in grief. He has the half-closed eyes, touched with tears, and the half-open mouth, of someone afflicted and near to death, albeit on the other side from the rest of us. There is no forgetting what he has gone through, only to reach this faithless reaction from his own.

The harmony of Christianity had broken. The church's unity had shivered into fragments, each arguing with one another and tormenting the evidence of scripture and tradition to justify itself, each ready for devastating war with its opponents. Religion itself, and not least the Christian sacrament, were under mounting intellectual pressure. Cima's heavenly morning showed a happiness with mythical time which Guercino abandons. Instead, he takes on the alarming contingency of historical time, to which Christ has returned for a while. Over this confrontational moment, the banner, whose pole Christ grips, is whipped by a blast of wind and light. Doubt will surely be conquered by the evidence of the divine. But not without stress. Even the light here has the transient and turbulent quality which accompanies high wind. It is a world away from Cima's placid room with its richly protective coffered ceiling where the faithful gather around their Lord. This is society in agony, up against Christ rather than settled in his fellowship.

Rubens, *St Bavo receiving the Monastic Habit at Ghent*

No great painter was as actively concerned to heal the conflicts of his time as Guercino's Flemish contemporary, Rubens. He was born in exile because his Protestant father had fled Antwerp when Catholic Spain tightened its grip on it. After his father's death his mother brought herself and her children back there and back to Catholicism. It was 1588, the year of the Spanish Armada, when Spain turned on England, having cowed Antwerp and the southern Netherlands. The city was depressed and depopulated. But when Rubens was twenty-one, Philip II of Spain decided to lighten his own workload a little and sent his daughter Isabella and her husband Albert to govern the southern Netherlands on his behalf. They were only regents, in a dependency which was still an armed camp for war with the rebellious, Protestant north. But they were a civilised and pacific couple, in contrast to some previous Spanish envoys to the Netherlands.

Their main project was religious and, with Rubens's help and friendship, they brought it to a success which benefited everybody. They set about

122 Rubens, *St Bavo receiving the Monastic Habit at Ghent*, before 1612, National Gallery, London.

making their province into a showcase of Catholic culture. New churches were built; old ones which had been vandalised by Protestant iconoclasts were fitted with new pictures; the convents of the religious orders were filled and busy. After the recent, murderous past, Christianity was to show itself as a benefactor of the human race rather than its worst misfortune, as life-enhancing rather than lethal. Two years after Albert and Isabella arrived, Rubens felt able to leave for work and study in Italy. When he returned, the Regents were waiting for him – and Rubens was ready to work for them in a cause which he believed in, heart and soul, and for which his Italian years had equipped him magnificently. Following the immense success of his *Descent from the Cross* at Antwerp, the Archbishop of Ghent wanted a Rubens for his own cathedral. The Archbishop died before he could see the project through, but this sketch was completed as grandly and thoroughly as the Antwerp sketch. 'I can affirm upon my conscience as a Christian', wrote Rubens to Albert in a plea for his influence to get things moving, 'that this design for Ghent is the finest thing I have done in all my life.'

It is a paradigm of all that the Regents stood for: a display of protective and benevolent regional Christianity, standing up for itself in a world threat-

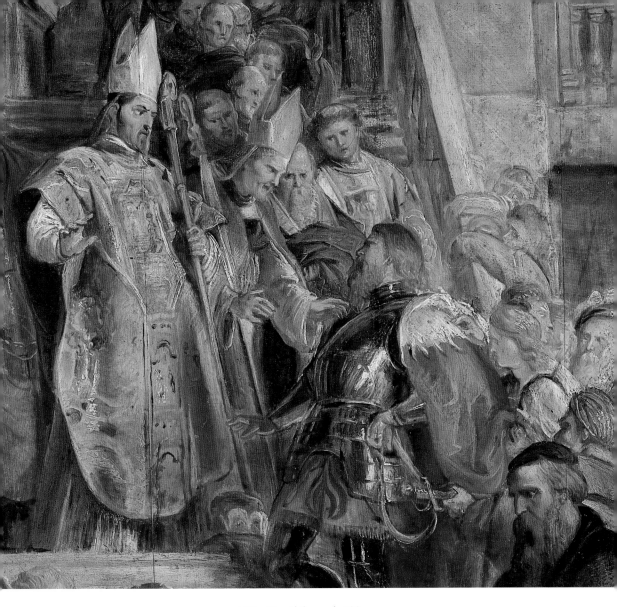

123 Detail from pl. 122.

ened by armed force and the interference of remote authority. The narrative
is set in the contingent world of historical time, legendary but believed as
fact and quite distinct from myth. Ghent cathedral was dedicated to two local
Christian heroes, St Bavo and St Amand. This is their story and its founda-
tion legend. St Bavo is shown on the steps in his armour, caught there at the
moment of transition when he renounced his military career to receive the
clothing of a monk. It is held ready by the priest above him, his discarded
sword by a man below. St Amand, mitred and chasubled, welcomes him from
above.

123

124–6 Details from pl. 122.

124

125

The flight of steps centres the drama. It elevates the church above the secular world below. The clergy have graciously ventured down to receive the candidate. But they meet resistance. Officials, backed up by armed men, are coming up the steps behind Bavo to intervene. The business of this threatening delegation is to enforce the emperor's edict banning soldiers from becoming monks. This edict is being pressed on the kings below. They dispute it – in the spirit of Albert and Isabella's shielding of their province from Madrid. The other mitred figure on the steps who stands behind St Amand is St Floribert, the abbot of the monastery to which Bavo aspires. He indignantly shoos off the intruders who dare to challenge his religious authority and St Amand's – who gives them a sidelong look. A tense moment, and all very apt to Rubens's homeland where pious local governors championed holy church and restrained the effects of faraway despotism. The church triumphs, not by force, but by accepting Bavo's renunciation of the profession of arms for the monastic life of worship, study and charity.

Rubens presents the movements of hearts and minds which drive the story as paths of physical energy traced by bodies. The religiously positive path of force renounced sweeps up from the horse's tossing neck, past the kings stalling the edict, to Bavo surrendering himself to Bishop Amand. Behind it the path of the secular threat to Christian vocation surges up with the imperial troops. Both meet at the point occupied by the two ecclesiastics who sort out the contradiction. Abbot Floribert's hand excludes the intruders. Bishop Amand's hand accepts Bavo. Then, down from this point of decision, charity

140

126

descends on the beggars below. While the dog barks, as dogs do when the
beggars have come to town, they get money from golden vessels held by chil-
dren. Bavo has bestowed his worldly goods on the poor. Above them, noble-
women are moved by Bavo's example. One takes off her necklace and gazes
up to heaven, the source and goal of the whole drama. A wimpled nun gives
encouragement and a lapdog gets excited.

The church is affirmed as human society's protector against the brutal
forces which threaten it. It is not a body devoted to its own religious inter-
ests. It comes out, in obedience to Christ's commands, to welcome the peni-
tent. It is called to champion the worship of God and the practice of charity
in a dangerous world. 'The gods love us more than we love ourselves.' Rubens
had that maxim of Juvenal carved on his garden gate. His generous Catholi-
cism included pagan wisdom when it reinforced the Christian's duty to seek
peace in a world under the shadow of war. And when the Christian leaders
of Europe were frightening each other away from that duty, their respect for
pagan antiquity could be another way of reminding them of it and its impli-
cations if they had become inured to the Christian story of the loving God
who had let go what was most valuable to him and sacrificed the divine son
for the peace of the world.

Part III

8

Two Worlds/One World: Rubens

Robert Venturi's Sainsbury Wing at the London National Gallery has done much to make amends for the exile of Christian devotional pictures in a secular institution. No longer need they hang on the walls of quasi-aristocratic saloons. The rooms, with their grey columns and arches, lend a sense of being in church, and sometimes provide sanctuary-like spaces for altarpieces. But at one important point something other than settled, or resettled, seriousness is evident. The visitor ascends Venturi's grand flight of stairs to the galleries above. The long climb up this stone escarpment is lightened by the sight of Botticini's *Assumption of the Virgin* at the top. It is a witty stroke of hanging, implying that up and beyond our laboured, pedestrian ascent, there is, or was, or might be, a further airborne escalation. From the

129 View up the staircase in the Sainsbury Wing of the National Gallery, London, with Botticini's *Assumption of the Virgin*.

128 *(facing page)* Detail from pl. 136.

empty tomb at the centre, her exit from the world in which lilies miracu-
lously grow, Mary has risen to be crowned in the golden heaven, among saints
and angels, by her Son.

Freud has taught us that jokes usually spring out of discomfort or embar-
rassment. The wit of the Gallery's curators, a very sympathetic body indeed
where the Christian religion is concerned, in their placing of this vast panel
(about 10 foot by 12, or 3 metres by 4) is grounded in our modern estrange-
ment from the two-world cosmology of orthodox Christendom. Granted that,
as Milton knew, heaven was forever concerned with our trials and predica-
ments on earth, that it was the focus and guarantor of the values that we
unquestionably need in order to make a decent shift of our terrestrial lives
and are forever losing, still the clock cannot be turned back, even by Venturi.
Secular science controls cosmology now. So when we get to the top of the
staircase and contemplate Botticini's panel, for pure, unironical and unam-
biguous enjoyment we shall fasten, not on the golden heaven and its
denizens, but on the landscape below where the donors kneel and Florence
and Fiesole are gratifyingly recognisable. It is a telling moment. For if we turn
right, instead of left into Venturi's revived Christendom, we meet the
devoutly Catholic Rubens putting the sum of his piety into his landscapes,
or the Protestant Rembrandt exploring the depths within the human face.

130

130 Botticini, *The Assumption of the Virgin* (detail), *c*.1475–6, National Gallery, London.

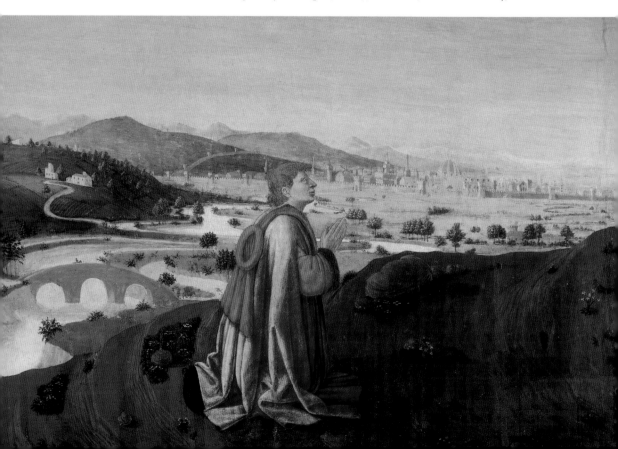

Like the sacred bread in the Eucharist or the sacred Word in the scriptures, the myth has been consumed into the real, the other into the familiar, and has made it wonderful.

The sanctification of the ordinary is Christianity's birthright. It pervades the teaching of Christ in the Gospels, which is radical in this respect. It is secured in the arch-doctrine of the Incarnation and is the *sine qua non* of Christian art. As well as a settled base, Christianity has an adventurous means of living out its belief through the crises of history – individual, intellectual, social or political. Sacrifice, as refined into the sacraments of Baptism and the Mass, is its ritual paradigm. Moral sacrifice is its practical realisation – Amand and Floribert leaving the security of their sanctum to expose themselves to risk in the world outside, Bavo giving himself to the religious life and his goods to the poor. In such deeds, the affirmation of history in the doctrine of the Incarnation, with all its mythical content, comes into its own – the historical and natural world. It is a fulfilment. But the means of it, sacrifice, shows that there is no fulfilment without concomitant loss, no solution without attendant problems. And these can be drastic enough to amount to a death.

Christianity's positive attitude to the world of nature and history, inherited from its parent Judaism, entails such gain and loss. By pinning all the airy apparatus of myth down to history, particularly the story of Jesus, it provided in the long run a base for measuring up to its own myth, recognising it as such and criticising it by exposing its historical relativity – first with dismay (in the Enlightenment of the eighteenth century) and then with sympathy (from nineteenth-century Romantics) – as the very reason for its vivid religious relevance and use. Secular history, history as we identify it in bookshops and academies, is the child of the Judaeo-Christian tradition with its historically packed and packaged Bible: a child which has now made its parent part of its subject matter and research. By believing the world to be divinely created, it provided a stimulating reason for curiosity about its structure and multifarious contents. As with works of human art, the moral character of the Maker could be inferred and enjoyed by analysis of his handiwork. Science is such a busy child of religion that it has very little time to spare for the study of its own past, let alone its infancy when biblical psalms (particularly Psalm 104) praised God by listing the items of the natural world, from clouds and winds to rabbits and rocks – and so laid out a sort of primitive agenda for science.

In the seventeenth century these latent forces started to exert themselves more strongly than before. The Bible began to be read by sophisticated men like Spinoza and the Earl of Clarendon as an historical record of long ago: a cool study to dampen the fanaticism of others who used it as an armoury of mandates for the present. Biblical chronology, and the difficulties for orthodoxy entailed in analysing it, preoccupied Newton along with his analysis of

light, God's primal creation, which superseded the Baconian ideas used by Lippi in his *Annunciation* (see Chapter 3, p. 51). It was a century of extraordinary ripeness and power for Christian art, with such painters as Poussin, Rubens, Rembrandt and Velazquez. We have noticed early traces of an historical approach to the Bible in Poussin's work (see Chapter 4, p. 62). With Rembrandt it is not so much an historicising of the Bible as a radical humanising of it, carried across into the ordinary world by the religious depth of his late self-portraits, which signals the tipping of the intellectual balance from the humane Christianity of the Renaissance to the Christian humanism of the seventeenth century. Rubens is a wonderful example of the devout and orthodox Christian, Christendom man at his best, drawn by love of it into the celebration of sheer nature. With Velazquez, the subject of the next chapter, a profoundly this-worldly Christianity, with heaven vestigial and myth pared down and subjected to secular realism, is in control.

Rubens and Landscape

<div align="right">131
132</div>

Rubens painted *Landscape with a Rainbow* and *An Autumn Landscape with a View of Het Steen* to hang together, probably opposite each other, in a room

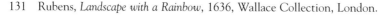

131 Rubens, *Landscape with a Rainbow*, 1636, Wallace Collection, London.

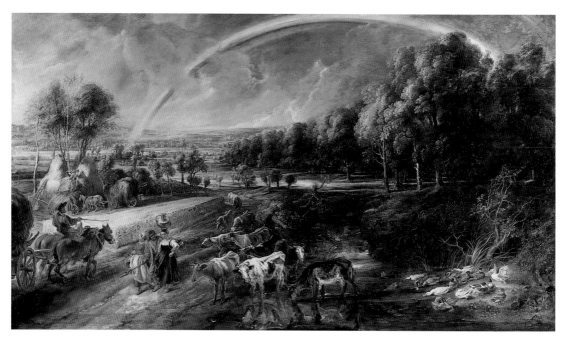

of the country house, Het Steen, to which he retired in 1635 for his last five years with his second wife and their family. They are symptomatic of his sense of fulfilment in the Indian summer of his career: not painted for the world of commissioned art which he dominated, but for love and the enjoyment of his art and home acres – for his family and friends. To our secular eyes, the *Rainbow* picture is no more ostensibly religious than its *Het Steen* partner. We are in Flanders. A storm has just passed over and the haymakers in the middle distance resume their work in sunshine. A herd of cows, driven by a cowman and accompanied by milkmaids with an admirer, streams towards the spectator under a magnificent rainbow. But this is not our sort of rainbow, Newtonian or romantic. These conceptions were not available to Rubens. It is biblical.

When Noah emerged from the ark in which he, along with his family and pairs of every kind of animal, had survived the flood which destroyed life on earth – God's cathartic punishment for human violence and wickedness – he offered a great sacrifice. In response, God promised never to devastate the earth again, and sealed the covenant with a sign:

> I do set my bow in the cloud, and it shall be for a token of a covenant between me and the earth. . . . and I will look upon it, that I may

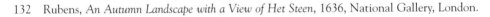

132 Rubens, *An Autumn Landscape with a View of Het Steen*, 1636, National Gallery, London.

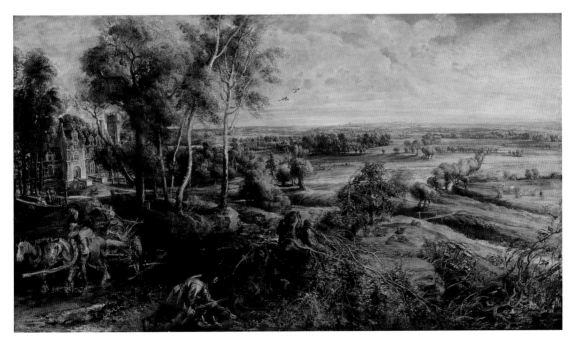

133 and 134 Details
from pl. 132.

remember the everlasting covenant between God and every living crea-
ture of all flesh that is upon the earth. . . . While the earth remaineth, seed-
time and harvest, and cold and heat, and winter and summer, and day and
night shall not cease. (Genesis 9.13 and 16, 8.22)

So this is a picture which implies God as an appreciative spectator within it
of his latest artefact, the rainbow, and of his whole creation. It is also Rubens's
own offering of thanks for his fulfilment as painter and *parvenu* landowner,
in a country restored to economic prosperity under benevolent Christian
regents after war and depression. As spectators we stand before it as receivers
of blessings. We should hesitate to advance and tangle with the cows. Better
to stand still and let all this abundance pour into our laps – or rather, eyes.

The Het Steen picture invites us to advance and explore. Human activity
is mostly confined to the bottom left-hand corner. Our eyes move from the
crouching sportsman to the cart going to market and about to disappear off
to the left, then settle on the gentlefolk taking the air under the trees by the
sunlit house. The man holds a gun, intending a sporting excursion. Rubens
loved to ride or walk in the mornings and evenings with, as he wrote 'their
horizons'. To the sportsman's right he has indicated a path with a bold streak
of yellow. We could take it and wander off, choosing between the way by the
woods on the left or across the footbridge on the right. Either way, we can
pause at the little knoll below the two flying magpies: 'two for joy' in folk-
lore, so possibly a light symbolic touch alluding to Noah's pairs or Rubens's
happiness with Helena. And then we can roam off into the distance where
land and sky melt together.

135 Rubens, *The Watering Place*, c.1615–22, National Gallery, London.

These are emphatically horizontal pictures, generous and easy. Sixteen
years earlier Rubens had gone for the vertical. *The Watering Place* starts off
on the left looking Flemish enough, but as he worked across to the right
Rubens added a crag which supports a clump of trees, straining up in a storm
of tossing lines and effulgent colour, and put a dark chasm on the other side.
This is the young Rubens with Italy and Carracci in his mind, erect and ener-
getic. In contrast, the horizontal relaxation of *The Rainbow* and *Het Steen*
speak of a serene letting-go, whether to receive the gifts of nature or explore
them, by a man approaching his eternal rest, *requiem aeternam*, with grati-
tude rather than fear – as a Christian should. In the little *Evening Landscape
with a Shepherd and his Flock* the horizontality of those two big landscapes
with which we began is even more pronounced. The tops of the trees no
longer reach the top of the picture and the quiet passivity of the scene, lit
by the declining sun between two church spires, suggests the readiness of the
man who had stood up to the world with such painterly and public-spirited
vigour to lay him down and die.

135

136

128

136 Rubens, *Evening Landscape with a Shepherd and his Flock*, c.1638, National Gallery, London.

Rubens's late dedication to pure landscape is a momentous sign of how a devout Christian of the mid-seventeenth century saw the world when he was free to paint it as he wished. To put it bluntly, it was just the world. In the two-world structure of apocalyptic cosmology and in paintings based upon it, heaven was the predominant realm of value and the fulfilment of vision, earth a subordinate place. Rubens could do that too, whether with a moral generosity or a bourgeois biddability to aristocratic commands, which could even show the Duke of Buckingham's being assumed into the heavenly realms. But in the freedom of his final years the balance was, without the least trace of apostasy from the Catholic Church, the other way. If cosmologies and systems have their day and cease to be, love, as St Paul taught, abides. Its descent into mundane existence is the dynamic of Christ's story, the Christian arch-myth with the world as its destination. Taken on by Christ's followers, it survives and finds plenty of work to do in our world where Christ's religion has lost its monopoly over systems and interpretation, and its poetry can be understood as such. In Christian doctrine and devotion, dying (metaphorically including any kind of loss) is a gate into new life when love is its motive. It applies as much to Christianity itself as an historical phenomenon as to the individual Christian such as Rubens.

153

9

Two Worlds/One World: Velazquez

Rubens met Velazquez in Madrid in 1628. Desolated by the death of his first wife and motivated by his belief that 'the interests of the entire world are intimately linked', Rubens accepted the commission of the Regents of his southern Netherlands to visit Spain and England and restore the diplomatic relations between them which had been wrecked by his patron, the Duke of Buckingham. Enmity between Spain and England was threatening to the southern Netherlands, the colony of one and neighbour of the other. And Rubens, like Dietrich Bonhoeffer and Dag Hammarskjöld in our own century, was a Christian who regarded himself as 'one of those who are called forth, not regarding ourselves from a religious point of view as privileged, but rather as belonging to the whole world' (Bonhoeffer, letter of 30 April 1944). In Madrid, Velazquez showed him the king's Titians, which he copied. In London the object of his mission was secured. Spanish envoys were received in the Banqueting House at Whitehall and he left his magnificent manifesto for peace, the painting known as *Peace and War*, as a present to be pondered by Charles I. He went home, twice knighted (by Philip IV and Charles I), to marry Helena and enjoy the life a of a country gentleman at Het Steen.

138

This chapter is about Velazquez – not all of his career, but only his work in Seville up to the age of twenty-three, before he met Rubens in Madrid in 1628. It takes it in historical sequence. The paintings he did then pre-date Rubens's landscape by a decade, but they exemplify the same movement of Christian painting into the secular. Up to now, we have been juggling mythical and historical time, as Christianity always has. But now historical time takes the lead – and not just in a formal way, but in content and in piety too.

137 Detail from pl. 158.

138 (*right*) Rubens, *'Peace and War'*, 1629–30, National Gallery, London.

Kitchen Scene with Christ in the House of Martha and Mary; and Kitchen Maid with the Supper at Emmaus

That long-winded title, *Kitchen Scene with Christ in the House of Martha and Mary*, is needed to cover this double-yolked composition. Here is pictorial synchrony. The cooking in the foreground is going on simultaneously with the argument in the background, although the cooking belongs to Velazquez's own present and the argument to the biblical past. Interpretation must focus on the links between the two, looking for the strength and content of the coupling 'with' of the title. The coupling rests on the Christian use of ancient scripture as instruction for contemporary living. Given that basic interaction, just how does the biblical incident, seen through the serving hatch on the right, relate to what is going on in the kitchen in front? What carries between them? The bipartite composition poses these questions deliberately. This is a problem picture in a radical and searching sense of the phrase: strong religious implications lurk within it. They are radical and gather to a head, lit-

erally, in the cook's deeply troubled face, which is close to tears. She tells us that the relation of biblical instruction to present actuality is not an easy matter. As with all problems, hasty speculation can lead up blind alleys. To

139 Velazquez, *Kitchen Scene with Christ in the House of Martha and Mary*, 1618, National Gallery, London.

crack this one, we shall have to take several steps away from the picture and its content in order to return to it and discover its meaning. The search for the linkage between its two parts had better begin where there is certainty. We know a good deal about life in Velazquez's Seville, which bears on the foreground. We have the text of St Luke, which is represented in the background. So we shall begin by getting our footings in both of these.

Contemporary prints and paintings of Seville show its busy port, the leading entrepot of Spain's trade with Europe and

140 Detail from pl. 139.

141

the New World, alive with shipping. Beyond are the towers of the numerous churches, monasteries and convents. There were no less than sixty-four religious houses in seventeenth-century Seville. It was an emphatically and abundantly Christian city. Commerce and prayer were its major preoccupations. It also had its seamy side. The open ground between the port and the city was no-man's land and everyone's land: a place for rubbish tips, bivouacs and hucksters' stalls, haunted by the poor from the other bank, duellers settling differences and the rich in the security of their carriages. In Seville energetic sacred and secular activity was accompanied by the existence of a large underclass of servants and casual labour – and all three of these obviously bear on our picture.

141 Simon Frisius, *Panoramic View of Seville* (detail), *c.*1700, British Library, London.

The story in Luke 10.38–42 which Velazquez illustrates is another point of certainty. It was particularly apt to the actualities of Seville, because it turns on the contrast between the active and the contemplative forms of the Christian life – between material exchanges in kitchens, houses and markets and the spiritual exchanges at the heart of churches and religious communities. St Luke tells of Jesus' visit to Martha's house. Her sister Mary

> sat at Jesus's feet, and heard his word. But Martha was cumbered about much serving, and came to him, and said: Lord, dost thou care that my sister hath left me to serve alone? bid her therefore that she help me. And Jesus answered and said unto her, Martha, Martha, thou art careful and troubled about many things: but one thing is needful: and Mary hath chosen that good part, which shall not be taken away from her.

Jesus' answer to Martha's resentful questioning of her sister's leisure is negative and clear. Mary's passive attention to his discourse is the 'one thing needful'. He ranks her quasi-monastic concentration on 'his word' above Martha's active care for 'many things'. The convent is better than the market. His response to the thrust of Martha's request – 'bid her therefore that she help me' – is reinforced by the gesture of his raised left hand. It fends off Martha and protects Mary, and so makes Jesus' spoken judgement visually explicit. It is a good place from which to start reading the picture, the point from which its drama springs.

Now we can see how Luke's text is carried into the kitchen in Seville. Jesus' uplifted hand is echoed by the uplifted hand of the old woman in the left foreground. Her relation to both the background and the foreground scene, while clearly telling in some way or other, needs some figuring out. Judging by her posture and gesture, she is an intermediary messenger between the two scenes. She addresses the cook from behind, crooking her index finger round a little so as to indicate the biblical scene in the room beyond. This must be to point up what she has just said to the young cook, who is not looking at her but has been listening to her. Speech is implied, and the old woman is the messenger. The young cook's eyes are turned inward and to the left, where the old woman stands, and her face shows her reaction to the message. She is pondering Jesus' answer to Martha, retailed to her by the old woman, and reflecting sadly on its implications. These are more than enough reason for her to be downcast as she pounds away at her mortar, cumbered with serving like the magisterially rebuked Martha in the background. For her, Jesus' word can only mean that she is either facing a lifetime in a convent or, if she is too poor to afford the dowry which that would demand or disinclined to take the veil, a lifetime of Martha's hard work in the depressing knowledge that it is not Mary's 'good part'. There is a more vestigial Martha-likeness to the old woman: she too wears a veil on her head. And it is noticeable that she passes on the Lord's pronouncement without

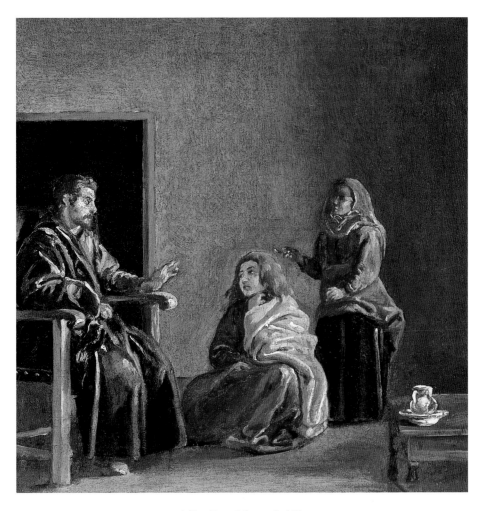

142 Detail from pl. 139.

glee and even with a certain sympathetic melancholy of her own. Velazquez's eloquent sympathy with the women in the foreground, caught and challenged in their Martha-like lives, is striking. His fellow-feeling and charity (the Christian arch-virtue) is extended beyond the more confined range of the canonical Christian evangelist's tale. Precisely as a Christian, with the root of his religion in him, Velazquez is on uneasy terms with his text. Its application to the life he knows is problematical. He is an example of that momentous seventeenth-century, modern phenomenon of which biblical criticism is a part: free intellectual meditation on scripture in study or studio, beyond the reach of orthodoxy.

This reading of the picture took its cue from the gesture of Jesus' hand, but

it has found that it is subsidiary to his speech which, though invisible, would be well known to Velazquez's contemporaries. So speaking and listening are the implied ligatures, transposed to looks and gestures, which hold the whole picture together. They join person to person within each part, and they link the two parts as the message is carried from one to the other.

It is the same with a similarly double-yolked picture from the same period in Velazquez's work. The *Kitchen Maid with the Supper at Emmaus* is another kitchen scene with a scene from St Luke's Gospel visible through the hatch. Here too, speech and hearing are integral, and we have to guess what was said and heard by using our eyes. The black servant, possibly a slave, can only be related to the revelatory event behind her by hearing. She is bent over her pots and pans but not occupied with them. She cannot see Christ and recognize him as can the crouched apostle in the dining room beyond. She turns her head to catch Christ's words of blessing on the bread. There is no intermediary messenger here, she hears directly, so it is a less complex picture. And her hearing of Christ's blessing of the results of her menial work (they have left her table bare of food and gone to the dining room beyond) make this a more positive and unified picture than *Martha and Mary*. Her expression is not distressed, like that of her counterpart in that picture. She is aurally intent and comparatively content. She has served the bread, the means of revelation, and now hears the Lord blessing it.

A brief digression may clarify the possibilities and limits of transposing the

143 Velazquez, *Kitchen Maid with the Supper at Emmaus, c.*1618, National Gallery of Ireland, Dublin.

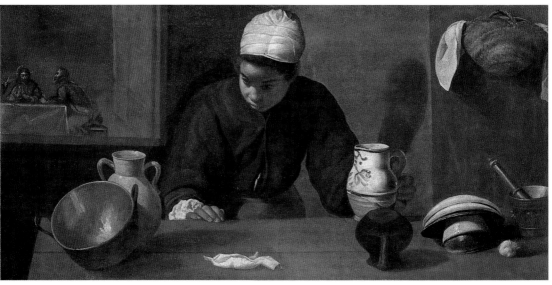

144 After Velazquez, *Musical Trio*, private collection, Barcelona.

oral into the visible. The fact that such transposition must be content with implications has never stopped painters taking it on, not least because they were so often commissioned to paint scenes from the Bible which turned on them – we have examined several Annunciations with this interest in mind. In Velazquez's time, paintings of the five senses were popular. Only two, sight and touch, could be fully represented. Smell and hearing had to be suggested. The senses had come into their own as intrinsically interesting subjects for pictures, not least the two invisible ones. Velazquez's interest in this genre, and in the problem of representing hearing is confirmed by his *Musical Trio* 144 in Berlin (a version of which is in a private collection in Barcelona), also from his years in Seville. The fiddler leans and strains to catch the note sung by the guitarist, who is either blind or looking vaguely up, away and right out of the picture, so as to concentrate on sound, not sight. It is an experiment which takes painting to the end of its tether in the world of appearances, a terminus from which we can only return, with the knowledge that Velazquez's interest in the problem of sound in pictures was conscious and curious.

In the end, painters cannot be quite satisfied with implications as to what might, or must, be being said and heard in their pictures – even when

145 Francisco Pacheco, *St Sebastian tended by St Irene*, 1616, destroyed.

common knowledge of the Bible made such implications certain. The eyes, in silence, must decide. And as our eyes travel from background to foreground in both Velazquez's pictures from St Luke, they trip up on a blatant and quite spectacular discrepancy. The biblical scenes are painted in a quite different style from the foregrounds. To the modern eye, at least, they are simply not so well painted – certainly not in a way which brings out Velazquez's skill and attention as fully as the nearer scenes. In scale and in style they have some of the perfunctoriness of postage stamps on inscribed envelopes. They may authorise, but they are not normally as interesting as the inscriptions of address. What is the meaning of this contrast? The question can be most securely answered by again taking a few steps back in order to track the history of the two kinds of painting (religious and genre) which Velazquez took up and used for each of the two parts, first for the biblical and second for the kitchen scenes. It is likely to throw up valuable hints about the significance of this stylistic discord. Once again, we must *reculer pour mieux sauter*.

The date of the *Martha and Mary* picture is 1618. The *Emmaus* picture is not precisely datable but obviously close to it. Velazquez was two years out of his apprenticeship to Pacheco, but their subsequent relationship was

cemented by his marriage to Pacheco's daughter and by his father-in-law's admiration of his outstanding ability. In the last year of Velazquez's apprenticeship, Pacheco painted one of his better pictures. It is a welcome relief, after seeing innumerable shot and tormented St Sebastians, to see the saint on the mend. *St Sebastian tended by St Irene* (a painting destroyed in the Spanish Civil War) is structured in the same way as his son-in-law's later *Martha and Mary* picture. Sebastian sits up in bed, gratefully receiving a bowl of soup from Irene. His clothes and hat, hung on a chair, are set closest to the spectator and painted with carefully moulded realism – from life, no doubt. Through a window on the right, time has been rolled back and the sacred scene of his previous near-martyrdom by the archers is painted entirely differently: conventionally rather than from life, and with airily loose and mannered strokes of the brush. Pacheco's source for style here is grand and sacred tradition rather than the world in front of him – the source of the bedroom scene. He had visited El Greco in Toledo in 1611, so there may be an echo here of El Greco's religious melodrama, of his bodies twisted and consumed into heaven like sacrificial flames. Or a more distant echo of

145

146

146 El Greco, *Christ driving the Traders from the Temple*, c.1600, National Gallery, London.

147 Tintoretto, *The Baptism of Christ*, 1578–81, Scuola di S. Rocco, Venice.

147 Tintoretto, who haunted the backgrounds of his pictures (which exerted a powerful influence on El Greco) with figures rapidly drawn in white and looking like ghosts from the visions of William Blake. In any case, Pacheco painted the conventionally sacred scene in a conventionally sacred style, the associated and more ordinary scene realistically.

His son-in-law followed him. The picture-within-a-picture composition of Pacheco's *St Sebastian* set interesting problems and was worth taking further. So Velazquez advanced on Pacheco by having the two scenes going on simultaneously. This unity of time tensed up their mutual relations at a stroke. As we have already discovered, it makes the spectator look and think much harder than the follower of a simple sequence like Pacheco's. The surprising thing, in view of the energy and discipline of Velazquez's development of the inherited structure, is the mere following of his father-in-law in the way he paints the biblical scene. A possible reason for Velazquez's sticking with the Tintoretto–El Greco–Pacheco tradition so loyally for the biblical part of his compositions might be that it is apt to what is heard rather than seen by the foreground characters – a picture in their minds, an ideogram. But that is a speculation. What is fundamental and certain is that Velazquez has put much

more into portraying the kitchen, so an approach from the other flank is needed, tracing the tradition of culinary painting which was available to him and what he did with that. Both sides of this internal pictorial argument between two styles have to be heard. So back we go again.

In contrast with his obedient but desultory relation to conventional Christian painting, Velazquez's relation to what we might call 'alimentary painting' was energised by a humanity taken to religious depth, a Christian humanism. He inherited a way of painting life in the kitchen which was gluttonously profuse. The Dutch painter Pieter Aertsen had shown 148 the Supper at Emmaus taking place in a room far beyond a kitchen where a cook talks to a fishmonger's boy and stands at a table loaded with prodigious great fish. The connection of the two scenes is limited to the straightforward and trivial matter of the preparation and eating of food – and prompts the very trivial thought that the meal at Emmaus was a gastronomic *tour de force*. A print after Aertsen's picture was available in Seville in Velazquez's apprentice years (the market-stall was a popular subject there already), and is generally believed to be a source for his work. In Toledo, Sanchez Cotán was painting sparser still life with devout intensity. But in mercantile Seville the leading fashion was for hearty abundance *à l'Hollandaise*. Its

148 After Pieter Aertsen, *The Supper at Emmaus*, British Museum, London.

Cum privil. Sa. Ca. M. IESVS in fractione panis agnoscitur. Jacobus Matham fecit

149 Anon., *Kitchen Scene*, c.1604, Archbishop's Palace, Seville.

149

archbishop had installed just such a kitchen scene in the decoration of his palace in 1604, along with panels of the elements and the seasons. It is still there and shows a larder piled with meat and a kitchen visible through the door – all painted in the same style and all thoroughly worldly.

150

 Velazquez sorted out the clutter. In *An Old Woman cooking Eggs* at Edinburgh, unremarkable foodstuffs and utensils are scattered round the picture space in a circular pattern, separate from each other and each painted with such high fidelity that its particularity or 'this-ness' is given its full worth. The immediate and uncomplicated pleasure, which naturalistically painted food gives to the eye, is all the keener for the austerity of the diet. Velazquez has brought a welcome severity to an overloaded genre. These poached eggs are definitive. This is the sort of painting which people who don't know much about art enjoy as vociferously as connoisseurs because it goes straight to the senses and makes all beholders happily aware of their participation in the material world.

 That participation Velazquez makes real by means of the old woman and the boy. They point up the difference between him and Sanchez Cotán. Cotán ended up in the solitude of a Carthusian cell, and he never included human beings in his still-life paintings. Nor did he show much of their tools, other than the strings from which his unforgettable cabbages and apples

151

150 Velazquez, *An Old Woman cooking Eggs*, 1618,
National Gallery of Scotland, Edinburgh.

151 Juan Sanchez Cotán, *Quince, Cabbage, Melon and Cucumber*, c.1602,
San Diego Museum of Art, Gift of Anne R. and Amy Putnam.

dangle like moons in the night sky. The absence of people and their utensils made for a more intensely 'other' dimension to the ordinary. *Vice versa*, Velazquez, as far as we know, never painted a still life without people and he connected them to their food by the crafted tools which bear the marks of human use. It is evidence of a more compassionate and humane Christianity than the mysticism of Toledo, but just as deep. The old woman and the boy are serious people. What the old woman has said to make the boy so thoughtful is anybody's guess, but the contrast with the hilarity of more light-hearted and picaresque table scenes is majestic. The compassion of Velazquez's treatment of the people, probing into their inmost thoughts, is yet another advance beyond tradition and into life's actualities. Sympathetic psychological realism is piled upon the most accomplished naturalism. Like a slum curate, the young Velazquez as painter worked his vocation out on the level of the poor, refusing to ridicule, sentimentalise or patronise them. The genre is not only purged. It is humanised.

This, rather than the biblical scenes in their backgrounds, is what makes the *Kitchen Scene with Christ in the House of Martha and Mary* and the *Kitchen Maid with the Supper at Emmaus* so deeply and solemnly impressive. The scriptures, like the Sabbath, were 'made for man' and not man for the scriptures. It is the human and material world, to which the Bible addresses itself so continuously and so urgently, that attracts Velazquez's most penetrating attention. Never before had a Christian painter taken the losing side of the hard-pressed cook as his way of interpreting St Luke's story of Martha and Mary. There never were sea bass painted like these: to take them in with the eye is to know exactly what it would be like to take them up with the hand.

It has all been achieved by a demanding process of refinement. Ortega y Gasset wrote about his later work that 'Velazquez's technique is a continuous progress in a negative skill: that of dispensing with more and more.' It is just as true of his earlier work in Seville. He reduces a profuse tradition and divides the visible world into the individuality of each object and person in it so that everything 'Selves – goes itself; *myself* it speaks and spells' (G. M. Hopkins, 'As kingfishers catch fire').

The problem that remains to be entirely solved is unity. The *Old Woman cooking Eggs* and the Martha and Mary picture are both unresolved, the first as a composition, the second as a drama. In the latter picture it is not a fault: it is dominated by the cook's face which speaks the troubled irresolution of her mind, and there is point and energy to the stylistic rift between its two scenes. But it is still a rift; and the quest for unity is as constitutive of art as of religion. Velazquez was still working on it – and it was not made any easier for him by the problems which one of his compositions set him.

* * *

152 Detail from pl. 143.

St John on Patmos
and *The Immaculate Conception*

The Convent of the Shod Carmelites in Seville commissioned Velazquez to paint the Immaculate Conception of the Virgin Mary. The dedicated painter of human and material reality was faced with sheer spiritual vision. The Christian taking the testing incarnational way of descent from other-worldliness into deep and unreserved interest in this world was confronted with a tremendously popular form of devotion, dear to the hearts of rich and poor, learned and ignorant, which went quite the other way. It lifted Mary up from the earthly and historical continuum of reproduction, as her Assumption removed her from ordinary death, and set her conception elsewhere – in the eternal heaven. There was already a convention of how to picture this theological and devotional flight of visionary imagination. Pacheco had followed it for his altarpiece in Seville Cathedral a year or two before. Three quarters of the picture space is given to heaven, where Mary stands crowned and surrounded by angels. Earth is allowed the lower quarter, with a head-and-shoulders portrait of the donor-devotee in the corner. This is the double-decker cosmology of apocalyptic, with heaven overwhelmingly dominant as the realm of glory and power, source and guarantor of value and meaning. Indeed, apocalyptic of a particularly strong and lurid sort was its scriptural base.

153

The vision of St John in Revelation 12 was called in aid by advocates of the Immaculate Conception and taken to refer to Mary, the mother of Christ, as a heavenly woman, a denizen of the divine realm:

> And there appeared a great wonder in heaven; a woman clothed with the sun, and the moon under her feet, and upon her head a crown of twelve stars: and she being with child cried, travailing in birth . . . And there appeared another wonder in heaven; and behold a great red dragon, having seven heads and ten horns, and seven crowns upon his heads. And his tail drew the third part of the stars of heaven . . . and the dragon stood before the woman . . . for to devour her child as soon as it was born.

How was Velazquez to handle this? He painted two companion pieces or pendants instead of a single double-decker. Two pictures instead of one was a spectacular sacrifice of unity. It is a little relieved by an element of overlap: the woman, but not the dragon, in the tiny vision in the corner of one picture is given the whole of the other picture. What is gazed at in one picture is displayed in the other. But it is a sacrifice. The two worlds of the Martha and Mary picture are split apart here. Yet it is a sacrifice with positive benefits from its negative cost. The format enabled Velazquez to continue his programme of affirming the intrinsic value of earthly things, and purging the

153　Francisco Pacheco, *The Virgin of the Immaculate Conception with Donor*, c.1616, Cathedral, Seville.

clutter of convention. Now he had to do it for the Carmelites with a kind of religion which seemed to offer him few opportunities.

In one picture, a robust young St John is shown with his dog-eared books (a chance for still life and the poetry of well-used objects) at his muscular feet. He is writing down the vision which he sees in the heaven above. The apocalyptic text is rendered in an even more trivially conventional style than

155

154 Velazquez, *The Immaculate Conception*, c.1618, National Gallery, London.

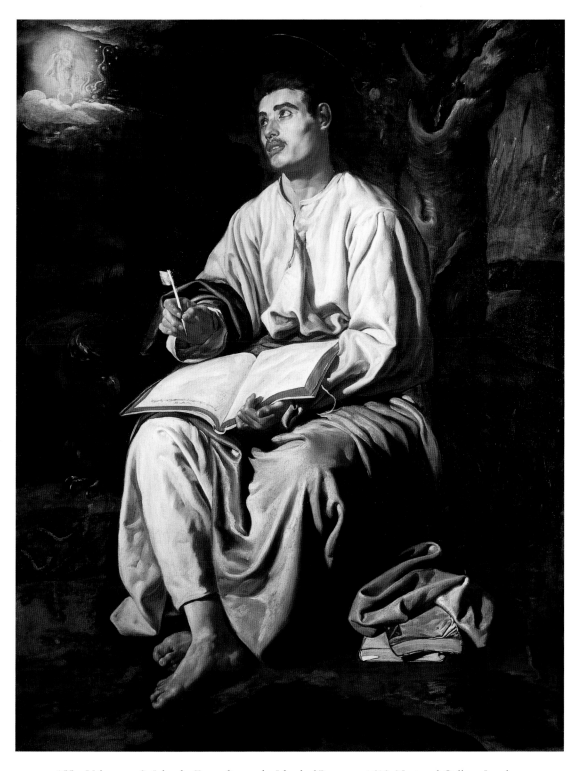

155 Velazquez, *St John the Evangelist on the Island of Patmos*, c.1618, National Gallery, London.

156 and 157 Details from pl. 155.

the biblical scenes in the Emmaus and Martha and Mary pictures and made even smaller in relation to the main subject. The dragon in particular looks more like a pet than a threat, more of an emblem or ideogram than a real monster. The contrast between the handling of it and of the books is even stronger than the contrast between the fish and the biblical scene in the Martha and Mary picture. The overall result is a pictorial redressing of the imbalance inherent in the apocalyptic world-picture. Earth has a whole picture to itself, in which heaven is reduced to the barely visible little emblem in the top left-hand corner. The very real saint, sunburnt, heavy, young and muscular, fills the canvas. He is caught in a moment of rapturous gazing which interrupts his writing, just begun, of what he sees on the page of his book. This is a vast, full-length, amplification of the head-and-shoulders treatment of the earthly beholders of the vision in previous and conventional Immaculate Conceptions like Pacheco's. The human seer and writer has a whole canvas to himself.

The vision that he sees and records has another. As Velazquez changed canvases he changed scriptural texts. For this picture he turned to another biblical proof-text for the doctrine of the Immaculate Conception. It was from the Song of Songs (Song of Solomon), 4.7, with the bride in that erotic rhapsody interpreted – by a hermeneutical *tour de force* long established and gladly assimilated in Catholic spirituality – as a prophecy of Mary's purity: 'Thou art all fair my love / There is no spot [*macula non est*] in thee.'

156

157

154

174

Velazquez's brilliant achievement is to provide handsomely and without reserve for the devotion of the faithful while at the same time giving free rein to his own humane realism and unsparing severity. Here is a Mary as individual as Caravaggio's Christ at Emmaus, 'all fair' with an entirely ungeneralised and unconventional beauty. This is somebody – bone of our bone and flesh of our flesh like the Eve whose sin she cancels. She stands on a transparent moon against a rich ochre sun in a cloudy, moonlit sky. The paint varies thick and thin, wet and dry, with a naturalism which an Impressionist might envy. This is a real night sky with only an orange sunset glow left of the apocalyptic heaven (which for Botticini was a palatial golden auditorium). Pacheco's squadrons of angels have vanished clean away. So has the crown with which he adorned Mary. Her attributes and symbols (the fountain, the enclosed garden and so on) are minimalised and barely visible in the darkness below. And she herself is a girl at the age of puberty, the threshold of virginity and fertility. She is surely painted from life – Velazquez's little sister Juana has been suggested as a model, unverifiably but aptly enough. She is an image to capture affection through the senses, as the bride in the Song of Songs was before the theologians and mystics altered her to suit themselves. The elevated language of their mythology has been radically reduced over the brisk fire of Velazquez's imagination and critique, and she is restored to her own lovely, lowly vernacular. This is no evasion of his duty to his Carmelite patrons who, after all, were themselves no strangers to the virtues of poverty, humility and abstinence which engaged him as a painter. And their mysticism was accompanied, as mysticism commonly is, by a sensuality which contrasted with the abstractions of theology and made the Song of Songs so dear to them as a spiritual book. There is good Christian reason for Velazquez's earthward strategy in Mary's own song, the Magnificat (Luke 1. 46ff.) where she praises God who 'hath regarded the lowliness of his handmaiden . . . and hath exalted the humble [*humiles*] and meek.' But there is no precedent for so radically mundane a realisation of Mary's lowliness or of her teenage maidenhood. Here is an ostensibly conventional Immaculate Conception with the heavenly extras removed or reduced and its central figure become a modest girl whom we would recognise, with delight, in the street.

So we have two equal pictures instead of the usual one, split unequally between earth and heaven. Each is a world of its own, entire in itself. Each corresponds to and balances against the other, seer to vision, vision to seer. And in the process of this achievement, the only traces of pure apocalyptic to survive are the perfunctorily painted little vision contemplated by St John and a beautiful sunset glow of orange glory on either side of the Virgin who stands on the moon and in that marvellously naturalistic night sky. But still, complete unity remains to be achieved.

* * *

158 Finally comes *The Waterseller of Seville* (Apsley House, London): finally in the sense that it was the picture in which Velazquez summed up all his work in Seville and which he took with him when he moved from Seville to Madrid, to live henceforth at the court as the king's painter and friend. This picture is the triumphant resolution and integration of the two projects which Velazquez had pursued and juggled in Seville: the representation of mundane reality and the interpretation of the Christian religion. Both come together in an inseparable unity. This is a secular picture. And this is a Christian picture. The second of these assertions needs some explaining to clear it of special pleading. Most of it will come in the course of looking at the painting, but some is due right away.

Clearly, we do not need, we are not forced or even obliged, to take this for a Christian picture. It does not, like most of those which we have looked at so far, represent a passage of Christian scripture or a focus of Christian devotion. Rather, a Christian looking at this picture is in precisely the same situation (the modern situation) as he or she is in when looking at anything in the world around, such as a landscape or an encounter between people. However, we may see it in the frame of Christian significances. We are free. Looking at this picture is a paradigm of that state of affairs. It is memorably put by Auden in a poem about another apostle of worldly Christianity, Dietrich Bonhoeffer. The 'He' at its beginning emerges as Christ by means of the capital H which it bears in later occurrences:

> He told us we were free to choose
> But, children as we were, we thought –
> 'Paternal Love will only use
> Force in the last resort
>
> On those too bumptious to repent' –
> Accustomed to religious dread,
> It never crossed our minds He meant
> Exactly what He said.

> 'Friday's Child', *Collected Poems*
> (Faber 1991, p. 675)

But the case is rather stronger than the permissive and a little narrower than the entirely open. How we should look at this picture should be governed and continuous with how the people in it are behaving. As Bishop Joseph Hall remarked, 'God loveth adverbs' – 'how' words. Christianity is a way of handling the ordinary and secular in the spirit of its arch-doctrine of the incarnation of the divine, the unreserved presence of God in material flesh, which has the effect of gathering people together in a communion

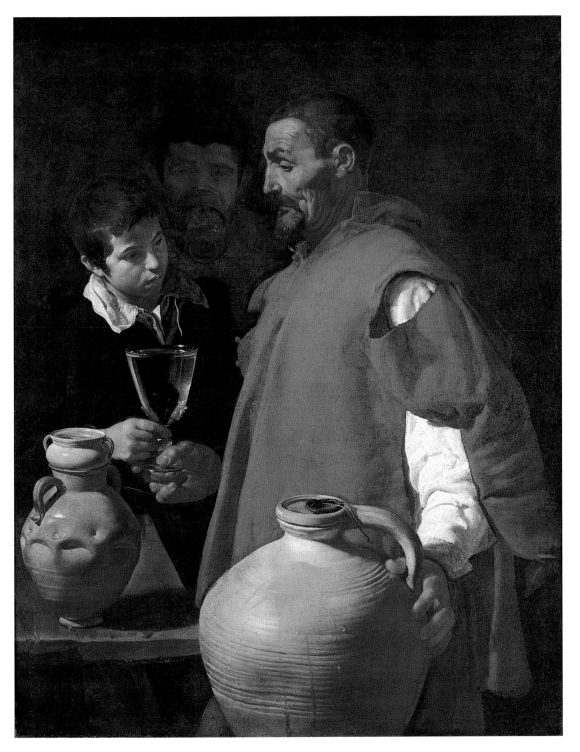

158 Velazquez, *The Waterseller of Seville*, c.1620, Apsley House, London.

which is ritually represented in the sacrament and realised in practical ethics. Charity makes society. That is how we have understood Christianity so far, and it still applies as we look at the people here. They are sharing water, and both the giving and receiving are in a mode of silent reverence, both for the water and for one another, which gives a humble and basic ethical content to the words 'liturgy' or 'ministry'. By making his subject the exchange of water, Velazquez attained the ultimate ascetic refinement of the tradition of alimentary painting which began in such gluttonous profusion: here is the purest and commonest human nourishment. Here, too, is a humanism whose nobility springs from the Christian conviction, proclaimed and practised in all those religious houses in Seville, that poverty and fulfilment are allied in the realm of charity. Tracing the process by which the water comes to be drunk is a parable of Velazquez's painter's parallel to the ascetic way followed in the monasteries around him: his 'continuous progress in a negative skill: that of dispensing with more and more.'

159 In the corner of a picture of an avenue of resort in Seville, the Alameda de Hercules, we can see the beginning of it. The waterseller filled his big earthenware bottles at the public fountain, then loaded them onto the wooden frames carried by his mules. Here the worst has occurred and the mule at the front is kicking the mule behind, dislodging and smashing the bottles. We are supposed to be diverted by this loss of the poor man's means of livelihood – the sort of patronising and unsympathetic portrayal of the poor on which Velazquez turned his back.

159 Anon.,
Alameda de Hercules
(detail), mid-
seventeenth century,
private collection,
Scotland.

178

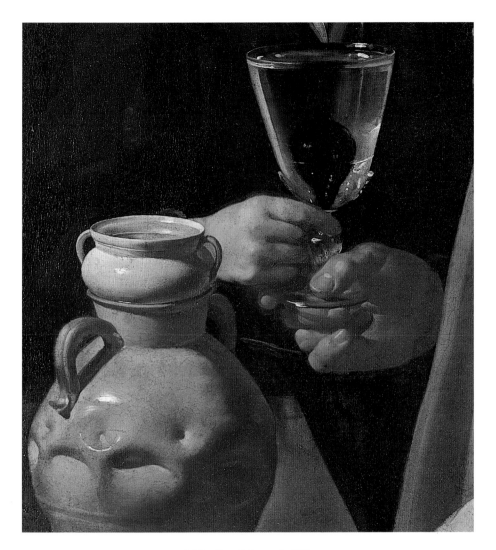

160 Detail from pl. 158.

The next stages are in Velazquez's own picture. Money is conspicuous by its absence. The currency is the good itself, the water. The bottle has been unloaded from the mule. Some of it contents have been poured into the glazed pitcher behind it through the delicately fashioned glazed filter placed on top of it. A little stroke of white from Velazquez's fine brush shows a trace of water between the two, caught there as it filtered down. From the dimpled pitcher it would be poured into the goblet, the finest utensil of all with the bubble of blue glass inside it rising from the top of its knobbed stem and the decorative pearls of glass which adorn the bottom of its bowl. The quality of

160

179

the painting of these things is something to make the most exacting spectator rejoice. The large bottle bulges out of the picture space to invite us into it, attracted by the beads of evaporation on its unglazed surface. It speaks of its making on the wheel: the striations of the potter's fingers and the concavity caused by his lifting the heavy, pliably wet, bottle from the wheel to dry. This, the other two pots and the cold water in the goblet are rendered with an adroit sympathy for the work of their makers – the way the potter dimpled the pitcher with pokes of his fingers is palpable – which makes praise vapid. Solemn silence is in order here, as before the best works of Cotán. But here there are quiet people, to humanise and embody the silence. In his torn, chasuble-like leather poncho, the noble old man has a priestly dignity as he serves ('ministers' is a better word) the water to the intent, reflective boy. It is a simple exchange which quietly resolves the more complicated exchanges in Velazquez's previous pictures. There is no speech or text to guess at. The quasi-liturgical seriousness of it all is a temptation to pick out elements of religious symbolism and inflate them, but that would be almost a kind of sacrilege against the complete unity of it all. The very most that is appropriate is to recollect biblical texts which could, but need not necessarily, have come to the minds of the Christian spectators who first wondered at it:

> For whosoever shall give you a cup of water to drink in my name, because ye belong to Christ, verily I say unto you, he shall not lose his reward. (Mark 9. 41)

> Jesus answered and said unto her, If thou knewest the gift of God, and who it is that saith to thee, Give me to drink; thou wouldest have asked of him, and he would have given thee living water [i.e. water from a spring]. (John 4. 10)

> And let him that is athirst come. And whosoever will, let him take the water of life freely. (Revelation 22. 17)

Like Christianity itself in the face of the secular world, these words do not explain Velazquez's picture of silent and secular communion, but they may indicate the inward values of love and care which are forever contained here in the bodies of people and vessels and their unity. On the other hand, those values are evident without such texts. They are painted. And painted in such a manner as to recall the meditations surrounding Proust's dying writer Bergotte on a gallery sofa, lost in admiration for the perfect 'little patch of

yellow wall' in Vermeer's *View of Delft*, 'painted with so much skill and refinement' as to suggest that 'everything is arranged in this life as though we entered it carrying a burden of obligations contracted in a former life' so that we 'consider ourselves obliged to do good, to be kind and thoughtful, even polite', and an artist feels obliged to dedicate himself to the same rules of perfection, even though 'there is no reason inherent in the conditions of

161 Vermeer, *View of Delft* (detail), *c.*1660–61, Mauritshuis, The Hague.

life on this earth' for her or him to do so. And perhaps, Proust continues, we return there when we die 'to live once again beneath the sway of those unknown laws which we obeyed because we bore their precepts in our hearts, not knowing whose hand had traced them there – those laws to which every profound work of the intellect brings us nearer.' So heaven is not an irrelevance even to one whom Proust called 'an atheist artist.'

More lamely, if a good deal less speculatively, we may return to a reflection which was suggested by the Annunciations considered in Chapter 3: that painters, if they are to be 'God's spies', have to go a good way further than theologians down the ethical road of incarnation, with the silent renunciations, the obedient humility and the love for the world of mortal appearances which it demands, if they are to make the mystery of things visible.

EPILOGUE

The Waterseller of Seville is the end and destination of this book. With it, the incarnational drive of Christianity's eternity has been settled, in a unity without remainder, into a moment in the world it set out to save. In the face of such a work, that note of triumph is justified. But not in the face of the unresolved world and all its distress to which we must return. Perhaps we have only been dreaming all this while in the gallery. Yet our dreams have given us impressive hints of how to cope with our barely manageable lives – religion's constant business in the world, after all. They had moral content. Beauty and ethics have met together, time and again. So, before we leave, we may yield to the temptation to take in just two more pictures. They indicate the kind of spirituality or religion which is open to us in our time.

Cézanne, *An Old Woman with a Rosary* and *The Large Bathers*

Simone Weil wrote a parable of people caught up in the beauty of the world. They enter a labyrinth and are far from the call of friends and loved ones. At the centre of the labyrinth God devours them. After that, all they can do is stand at the entrance and beckon others in.

It applies particularly well to Cézanne and his complete dedication to his art and countryside. His relations with his wife and son were fond but fraught with misunderstanding. His friends the Monets were used to having the parish priest in for conversations about natural history, but when Cézanne stayed with them his going to Mass startled them. It was certainly part of his aggressive self-presentation as a son of the Provençal soil among secular sophisticates, of which another feature was his refusal to use a fork at table. Cézanne soon left for home – rudely and abruptly. Even there he quarrelled with the priest over the organ, that stock *casus belli* in church communities, and kept away. But his Christianity was more than a pose.

Among his great late portraits of humble people there is this image of isolation, *An Old Woman with a Rosary*, profound in fellow feeling. She is an ex-nun who had left her convent, unsettled by religious doubt. Cézanne took her in as a servant and she took up the unsavoury habit of selling him his

164

163 Cézanne, *The Gardener*, c.1906, Tate Gallery, London.

own old underwear re-cycled into dusters. In the convent they would have said that she had lost her faith, abandoned her religion, by this exchange. Cézanne, judging by this portrait, would not have agreed. Her eyes, like the eyes of Christ in another image of isolation, Piero's *Baptism*, are introverted. She may be half-looking into the kitchen fire which glows on her face and hands and the sleeves of her jacket. Its tones suffuse her as the greens and blues of the garden suffuse Cézanne's gardener in his portrait of him in the Tate Gallery, London. Probably she just feels it as warmth in her old body. In any case, she is turned inwards, into the place of memory and imagination, the body's inmost seclusion where everything begins and ends. Her contact with the world is chiefly through the rosary which she is passing through her big hands, recalling the cycle of events which make up Christianity's saving story. We notice, as a sign of how it is to be a Christian in our world and hers and Cézanne's, that the rosary is broken. Its two loose ends dangle. The time-honoured cycle of myth and history has snapped. Yet it occupies, utterly, her heart and mind. As a musical analogy to her condition we might put some words of Dietrich Bonhoeffer, alone in a Nazi prison cell in 1944:

163

162

164 Cézanne, *An Old Woman with a Rosary*, 1895–6, National Gallery, London.

165　Cézanne, *The Large Bathers*, 1894–1905, National Gallery, London.

It's a year now since I heard a hymn sung, but it's strange how the music we can hear inwardly can almost surpass, if we really concentrate on it, what we hear physically. It has a greater purity, the dross falls away, and in a way the music acquires, a 'new body.'

<div style="text-align: right">Letter of 27 March 1994</div>

165　　　One last picture, also Cézanne's (painted 1894–1905), shows him as the classicist or neo-pagan. The Stoic and Christian ethic of the participation of individual bodies in the greater bodies of society and nature, is here carried triumphantly into the modern world. It will be a legacy for Matisse and Picasso. Form and boundlessness mingle and give each other life and strength. The colours of earth, red hair and green leafage, get into the sky. Sky blue and leaf green are on the bodies. It is an exuberance of exchange and sheer painting. On the right, vegetation becomes a tornado. In such cosmic harmony the lack of feet – see the prostrate woman in front – is a positive contribution. To be the clone of the redhead beside you is a way of leaning

166 Detail from pl. 165.

companionably into the glories just beyond. To be alone, like the walking 166
figure on the right, is not to be cast out. How could you be?

In a letter to his friend and dealer Vollard, Cézanne asked a rhetorical question to which he knew the answer. 'Is art really a priesthood that demands the pure in heart who must belong to it entirely?' Piero separated Christ's body only that it might be the ritual integrator of community. Mantegna and Bellini depicted Christ's solitary agony in the same frame of significance. Cézanne took us into the old woman's solitude, where her faith hibernates. Now he can leave us with the solitary walker in *The Bathers* whose surrounding purple shadow joins her to, as much as it separates her from, the back of the woman pulling on her stocking to go home – and joins her to the whole human and natural communion given to us by this doggedly solitary painter.

BIBLIOGRAPHY

Since most of the illustrations in this book are in the National Gallery, London, its *Complete Illustrated Catalogue* (National Gallery Publications (NGP hereafter) and Yale University Press, New Haven and London), 1995, can be consulted for quick reference. Its catalogues by schools of painting give more detailed information. These include: Martin Davies, *The Earlier Italian Schools*, 1961; Martin Davies and Dillion Gordon, *The Early Italian Schools*, (before 1400) 1988; Lorne Campbell, *The Fifteenth Century Netherlandish Schools*, 1998; Cecil Gould, *The Sixteenth Century Italian Schools*, 1975; Michael Levey, *The Seventeenth and Eighteenth Century Italian Schools*, 1971; Neil MacLaren and Christopher Brown, *The Dutch School 1600–1900* (two vols), 1991; Gregory Martin, *The Flemish Schools*, 1970; Neil MacLaren and Alan Braham, *The Spanish School*, 1988. Erika Langmuir's *Companion Guide* (NGP, London, 1994), gives brilliant, short introductions to 200 of the Gallery's paintings. Kenneth Clark's *100 Details from Pictures in the National Gallery* (NGP and Harvard University Press, Cambridge, Mass., and London, 1990), is also exemplary for its eye and style.

For general reading, preparatory to looking, Simone Weil's essay on 'The Right Use of School Studies' in *Waiting on God* (Routledge, London, 1951), is a classic on the fundamental subject of attention. Reading John Ruskin is one of the surest ways of stimulating visual curiosity and pleasure. The Section on 'Art' in his *Selected Writings*, ed. Kenneth Clark (Penguin, Harmondsworth, 1982) is a fine anthology from a writer often best read anthologised. Paul Durcan's book of poems on pictures in the National Gallery, *Give Me Your Hand* (Macmillan and NGP, London, 1994), liberates and nourishes the imagination.

For reference, the Authorized, or King James, Version of the Bible which is used in this book is available in Everyman's Library (London): *The Old Testament*, 1996; introduced by George Steiner, *The New Testament*, 1998, introduced by John Drury. *The Literary Guide to the Bible*, ed. Robert Alter and Frank Kermode (Harper Collins, London and New York, 1997), is likely to be the most congenial biblical commentary for readers of this book. *The Oxford Companion to Art*, ed. Harold Osborne (Oxford and New York, 1970), is a dependable and capacious book of reference. *The Oxford Companion to Christian Art and Architecture* by Peter and Linda Murray (Oxford and New York, 1996), is valuable and lively.

The rest of this bibliography is arranged by chapters.

1 Worlds and Times

Virgil's *Aeneid* is very well translated by Robert Fitzgerald (Harvill, London, 1996) and superbly by John Dryden (Penguin, London and New York, 1997). Michael Stone is a lucid guide to Jewish Apocalyptic: see his *Scriptures, Sects and Visions* (Blackwell, Oxford, 1982). So is Christopher Rowland, whose 'Revelation' in *The New Interpreter's Bible XII* (Abingdon: Nashville, 1998) includes a history of interpretation and references to works of art. The poem 'Perle' is published with *Sir Gawain*, well annotated by A. C. Cawley (Everyman, London, 1962). Dante comes in many translations – Henry Cary supreme in the nineteenth century (Everyman, London, 1994) and C. H. Sisson (Oxford, 1980) in our own. The Princeton University Press/Bollingen 1989 edition has the Italian in parallel with Charles Singleton's English.

For the illustrations in this chapter, *Gianbattista Tiepolo: His Life and Art* by Michael Levey (Yale University Press, New Haven and London, 1994) is a magisterial overview. *Giambattista Tiepolo 1696–1770*, ed. Keith Christiansen (Metropolitan Museum of Art, New York, 1996) contains a valuable essay by Catherine Whistler on his religion. *Making and Meaning: The Wilton Diptych* by Dillion Gordon (NGP, London, 1993), is fundamental. *The Art of Paolo Veronese, 1528–1588* by W. R. Reasick, National Gallery of Art, Washington, D.C. and Cambridge, has good plates and an essay by Terisio Pignatti, the doyen in this vast field.

2 Kind Regards

Duccio's tripytch is clearly and thoroughly discussed in David Bomford *et al*, *Art in the Making: Italian Painting before 1400* (NGP, London, 1989) and in Jill Dunkerton *et al*, *Giotto to Durer: Early Renaissance Painting in the National Gallery* (NGP and Yale University Press, New Haven and London, 1991). The various Vendramins who may be in Titian's picture are considered by Cecil Gould in his National Gallery catalogue.

3 The Incarnation of the Word and the Words

For Duccio's *Annunciation* see *Art in the Making: Italian Painting before 1400* and *Giotto to Dürer*. Filippo Lippi's is the subject of a scintillating essay by Leo Steinberg in *Artibus et Historiae*, 1987. On Lippi generally see Jeffrey Ruda, *Fra Filippo Lippi: Life and Work with a Complete Catalogue* (Phaidon and Abrams, London and New York, 1993). Its plates are good except, unfortunately, for that of the London *Annunciation*, which is falsely hot in tone; but pp. 199–205 have interesting comparisons of Lippi's various uses of rays of light. Richard Verdi includes Poussin's *Annunciation* in his *Nicolas Poussin 1594–1665* (Royal Academy and Zwemmer, London, 1995). The page on it in Anthony Blunt's *Poussin* (Pallas Athene, London, 1995) is less helpful. For Bernini see Howard Hibbard's *Bernini* (Penguin, Harmondsworth 1965). For St Teresa, see *The Life of Saint Teresa of Avila by Herself*, trans. J. M. Cohen (Penguin, Harmondsworth, 1957).

4 The Birth of the Redeemer

Poussin's *Adoration of the Shepherds* is discussed by Verdi, merely mentioned by Blunt. Rembrandt's gets a thorough treatment in Bomford *et al.*, *Art in the Making: Rembrandt* (NGP, London, 1988). For comparison with Rembrandt's other versions of this subject see Christian Tumpel, *Rembrandt* (Fonds Mercator, Antwerp, 1993), and for related drawings see Martin Royalton-Kisch, *Drawings by Rembrandt and his Circle in the British Museum* (British Museum Publications, London, 1992). Rembrandt's religious temper is best caught in Julius Held, *Rembrandt Studies* (Princeton University Press, Princeton, 1991), chs 4–7. Piero's *Nativity* gets a page in *Giotto to Dürer* and more in Ronald Lightbown, *Piero della Francesca* (Abbeville, New York, 1992).

5 The Sacrificial Body

For Piero's *Baptism* see Lightbown and the page in *Giotto to Dürer*. It gets religiously speculative and excited treatment by Carlo Bertelli in his *Piero della Francesca* (Yale University Press, New Haven and London, 1992), ch. 2. The paragraph on the river water in this picture in Martin Kemp's *The Science of Art* (Yale University Press, New Haven and London, 1990) is very acute. *Giotto to Dürer* also deals briefly with *The Agony in the Garden* by both Mantegna and Bellini. For Mantegna generally see the essays by Lawrence Gowing *et al* in *Andrea Mantegna* (exh. cat.), ed. Jane Martineau (Olivetti/Electa, London, 1992); and for Bellini, Giles Robertson's *Giovanni Bellini* (Oxford University Press, 1968), with its gracefully sympathetic treatment of the London *Agony in the Garden* on pp. 32–3. Rembrandt's *Ecce Rex Vester* is closely examined in *Art in the Making: Rembrandt*. For Honthorst see the MacLaren and Brown National Gallery catalogue, pp. 190–92, and for Rubens's *Coup de Lance* see Martin's catalogue, pp. 193–6.

6 Partakers of the Altar

Rubens's *Descent from the Cross* in its finished version is well illustrated and discussed with attention to its sources and context in Christopher White, *Peter Paul Rubens: Man and Artist* (Yale University Press, New Haven and London, 1987). The most relevant discussion to Christian eucharistic symbolism in all the vast literature about sacrifice is the daring and scholarly *The Death and Resurrection of the Beloved Son: The Transformation of Child Sacrifice in Judaism* by John D. Levenson (Yale University Press, New Haven, 1973). Rembrandt's *Lamentation over the Dead Christ* and *The Woman taken in Adultery* are both, once again, discussed in detail in *Art in the Making: Rembrandt*.

7 The Social Body

The ideas about sacred love that were available to Titian are discussed by Erwin Panofsky in *Problems in Titian: Mostly Iconographical* (Phaidon, Oxford, 1969), ch. 5. *Noli Me Tangere* gets a thorough historical treatment, including the history of criticism of it, in Allesandro Bellain's essay in *Le Siècle de Titien: l'Age d'Or de la Peinture à Venise* (Réunion des Musées Nationaux, Paris, 1993), pp. 407–11. The political situation behind Rubens's St Bavo picture is most clearly described in Jonathan Israels, *The Dutch Republic: Its Rise, Greatness and Fall* (Oxford University Press, Oxford and New York, 1995, chs 17–21, although this book is about the northern Netherlands. The cultural history of Flanders under the Regents in the subject of *Albert and Isabella: Essays*, ed. Werner Thomas and Luc Duerloo (Brepols, 1998).

For Rubens see Marie Anne Lescourret, *Rubens: A Double Life* (Allison and Busby, London, 1993), but not as vivid as Christopher White's (basically biographical) treatment. For Caravaggio see Howard Hibbard's *Caravaggio* (Thames and Hudson, London, 1988). For Guercino see *Guercino in Britain*, NGP and Burlington Magazine Publication, London, 1991) and, more substantially, the pioneering and authoritative works on him by Sir Denis Mahon. Cima is discussed in *Giotto to Dürer*.

8 Two Worlds/One World

Rubens and the Poetics of Landscape by Lisa Vergara (Yale University Press, New Haven and London, 1982), lives up to its title by its sympathetic treatment, both of the poetry Rubens read and the poetry of his paintings. It is particularly good on the antiphonal compositions of the *Het Steen* and *Rainbow* pair of pictures. *Making and Meaning: Rubens's Landscapes* by Christopher Brown (NGP and Yale University Press, New Haven and London, 1996) is fundamental to this chapter, finely judged and illustrated. For Rubens generally see Ch. 7 above.

9 Two Worlds/One World

Velazquez in Seville, ed. Michael Clarke (National Galleries of Scotland, Edinburgh, 1996) contains essays by Sir John Elliott and others which deal with all aspects of Velazquez's early work, from context to technique, and make up a rich and illuminating resource. *Velàzquez: Painter and Courtier* by Jonathan Brown (Yale University Press, New Haven and London, 1986) is standard and lively. *Velazquez* (Metropolitan Museum of Art and Abrams, New York, 1989) has essays on his time, art and life and particularly good colour plates. For Cotán see *Spanish Still Life from Velazquez to Goya* by William B. Jordan and Peter Cherry (NGP and Yale University Press, New Haven and London, 1995) and Norman Bryson's beautifully poised mixture of theory and observation, *Looking at the Overlooked* (Reaktion Books, London, 1990). For the opposite pole of high and visionary religious art, see *Visionary Experience in the Golden Age of Spanish Art* by Victor I. Stoichita (Reaktion Books, London, 1995).

Epilogue

Cézanne: The Late Work, ed. William Rubin (Thames and Hudson, London, 1978), includes a treatment of his late portraits by Liliane Brion in an essay called 'The Elusive Goal'. The *Old Woman with a Rosary* is well studied and linked to Flaubert in *Cézanne* (Tate Publishing, London, 1996), pp. 408–9. For Cézanne's various bathers see the capacious, magnificently illustrated *Die Badenden* by Marie Louise Krumrine (Kunstmuseum Basel and Eidolon/Schweizer Verlaghaus, 1996), and *Cézanne* (Tate Publishing, London, 1996), pp. 496–505.

INDEX

NOTE: Saints are entered under their names. Plate numbers for illustrations follow page numbers for textual references. Page numbers followed by n indicate information is to be found in a footnote.

ILLUSTRATIONS

53 Rembrandt, *The Adoration of the Shepherds*, 1646, Alte Pinakothek, Munich. Photo: AKG, London.

54 Rembrandt, *The Adoration of the Shepherds*, 1646, National Gallery, London.

55 Geertgen Tot Sint Jans, *The Nativity, at Night*, c.1480–90, National Gallery, London.

56 Detail from pl. 54.

57 Rembrandt, *Belshazzar's Feast* (detail), c.1636–8, National Gallery, London.

58 Rembrandt, *The Mennonite Preacher Anslo and his Wife*, 1641, Gëmaldegalerie, Berlin. Photo: Jörg P. Anders, © Bildarchiv Preußischer Kulturbesitz, Berlin.

59 Rembrandt, *The Star of the Kings*, 1645–7, © The British Museum, London.

60 Detail from pl. 54.

61 Detail from pl. 54.

62 Detail from pl. 54.

63 Detail from pl. 46.

64 Rubens, *Adoration of the Magi* (detail), Kings College Chapel, Cambridge. Photo: AKG, London.

65 Detail from pl. 54.

66 Piero della Francesca, *The Nativity*, 1470–75, National Gallery, London.

67 Alesso Baldovinetti, *The Nativity*, 1460–62, SS Annunziata, Florence. Photo: Archivi Alinari.

68 Hugo van der Goes, *The Nativity*, c.1475, Uffizi, Florence. Photo: AKG, London.

69 Detail from pl. 66.

70 Detail from pl. 66.

71 Detail from pl. 66.

72 Detail from pl. 66.

73 Detail from pl. 66.

74 Detail from pl. 66.

75 Detail from pl. 76.

76 Piero della Francesca, *The Baptism of Christ*, 1450s, National Gallery, London.

77 Detail from pl. 76.

78 Detail from pl. 76.

79 Piero della Francesca, *The Resurrection*, c.1458, Museo Civico, San Sepolcro. Photo: AKG, London.

80 Giovanni Bellini, *The Agony in the Garden*, c.1460, National Gallery, London.

81 Mantegna, *The Agony in the Garden*, c.1460, National Gallery, London.

82 Detail from pl. 81.

83 Detail from pl. 80.

84 Mantegna, *The Crucifixion*, 1506, Louvre, Paris. Photo: Scala.

85 Van Eyck, *The Adoration of the Mystic Lamb*, 1432, St Bavo, Ghent. Photo: Scala.

86 Detail from pl. 80.

87 Detail from pl. 81.

88 Detail from pl. 81.

89 Gerrit van Honthorst, *Christ before the High Priest*, c.1617, National Gallery, London.

90 Rembrandt, *Ecce Rex Vester*, 1634, National Gallery, London.

91 Rubens, *The Coup de Lance*, before 1620, National Gallery, London.

92 Rubens, *Lion Hunt*, 1616–17, National Gallery, London.

93 Antonello da Messina, *Christ Crucified*, 1475, National Gallery, London.

94 Detail from pl. 93.

95 Detail from pl. 93.

96 Rubens, *The Descent from the Cross*, 1611, The Courtauld Gallery, London.

97 Detail from pl. 96.

98 Rembrandt, *Lamentation over the Dead Christ*, c.1635, National Gallery, London.

99 Rembrandt, *The Woman taken in Adultery*, 1644, National Gallery, London.

100 Detail from pl. 98.

101 Detail from pl. 99.

102 Titian, *Noli me Tangere*, c.1510–15, National Gallery, London.

103 Detail from pl. 102.

104 Detail from pl. 102.

105 Detail from pl. 102.

106 Caravaggio, *The Supper at Emmaus*, 1601, National Gallery, London.

107 Detail from pl. 106.

108 Caravaggio, *Boy bitten by a Lizard*, 1595–1600, National Gallery, London.

109 Caravaggio, *Call of St Matthew*, 1599–1600, S. Luigi dei Francesi, Rome. Photo: Archivi Alinari.

110 Michelangelo, *The Last Judgement* (detail), 1536–41, Sistine Chapel, Vatican, Rome. Photo: The Vatican Museums.

111 Detail from pl. 106.

112 Detail from pl. 106.

113 Detail from pl. 106.

114 Detail from pl. 106.

115 Detail from pl. 106.

116 Cima da Conegliano, *The Incredulity of St Thomas*, 1502–4, National Gallery, London.

117 Detail from pl. 116.

118 Detail from pl. 116.

119 Guercino, *The Incredulity of St Thomas*, c.1621, National Gallery, London.

120 Guercino, *The Arrest of Christ*, 1621, Fitzwilliam Museum, Cambridge.

121 Detail from pl. 119.

122 Rubens, *St Bavo receiving the Monastic Habit at Ghent*, before 1612, National Gallery, London.